A History of Italian Art in the 20th Century

A History of Italian Art in the 20th Century

edited by
Sandra Pinto

Cover
Giacomo Balla, *Insidie di guerra*
(War Snares), 1915
Oil on canvas, 115 x 175 cm
Rome, Galleria Nazionale d'Arte
Moderna
(cat. no. 11)

Design
Marcello Francone

Translation from Italian
Luciano Chianese

Editing
Emanuela Di Lallo

Layout
Sara Salvi

First published in Italy in 2002
by Skira Editore S.p.A.
Palazzo Casati Stampa
Via Torino 61
20123 Milano
Italy

© 2002 Galleria Nazionale d'Arte
Moderna, Rome
© 2002 the Authors for their texts
© 2002 Skira Editore, Milan
© Giacomo Balla, Alighiero Boetti,
Massimo Campigli, Giuseppe
Capogrossi, Carlo Carrà, Felice
Casorati, Sandro Chia, Giorgio de
Chirico, Filippo De Pisis, Federico
Fellini, Renato Guttuso, Osvaldo
Licini, Alberto Magnelli, Piero
Manzoni, Giorgio Morandi,
Giuseppe Penone, Fausto Pirandello,
Mimmo Rotella, Alberto Savinio,
Mario Schifano, Gino Severini,
Mario Sironi, Giulio Turcato
by SIAE 2002

Printed and bound in Italy.
First edition

ISBN 88-8491-259-8

Distributed in North America and
Latin America by Rizzoli
International Publications, Inc.
through St. Martin's Press, 175 Fifth
Avenue, New York, NY 10010.
Distributed elsewhere in the world
by Thames and Hudson Ltd., 181a
High Holborn, London WC1V 7QX,
United Kingdom

*The publication of this volume
has been made possible also
thanks to the generous contribution
of Nihon Keizai Shimbun, Tokyo*

A History of Italian Art
in the 20th Century

Catalogue edited by
Sandra Pinto

Texts
Sandra Pinto
Rita Camerlingo
Mariastella Margozzi
Anna Mattirolo

Photographic Credits
Photographic laboratory of the
Galleria Nazionale d'Arte Moderna
Giuseppe Schiavinotto, Rome
Aurelio Amendola, Florence
Claudio Franzini, Venice
Luciano Pedicini, Naples
Foto Padovan, Turin
Foto Saporetti, Milan
Norihiro Ueno, Tokyo
5 X 7 Studio, Tokyo

*The works illustrated in the
volume come from*
Rome, Galleria Nazionale d'Arte
Moderna
Biella, Fondazione Pistoletto
Florence, Museo Marino Marini
Lugano, Guntis Brands
Milan, Civiche Raccolte d'Arte
Milan, Courtesy Claudia Gian
Ferrari
Milan, Collezione Rosa e Gilberto
Sandretto
Milan, COMIT - Banca
Commerciale
Milan, Pinacoteca di Brera
Milan, Courtesy Studio Guenzani
Naples, Museo di Capodimonte
Naples, Collezione Lia Rumma
Parma, Galleria Nazionale
Rome, Collezione Agata Boetti
Rome, Galleria Comunale d'Arte
Moderna e Contemporanea
Rome, Collezione Giorgio
Franchetti
Rome, Collezione Ugolini
Tokyo, Museum
of Contemporary Art
Trent, Museo di Arte Moderna
e Contemporanea di Trento
e Rovereto, Collezione Giovanardi
Turin, Giulio Paolini
Turin, RAI Radiotelevisione
Italiana
Venice, Collezione Gianni Mattioli,
Peggy Guggenheim Collection
Venice, Peggy Guggenheim
Collection, The Solomon
R. Guggenheim Foundation,
New York
Venice, Musei Civici Veneziani,
Galleria Internazionale d'Arte
Moderna di Ca' Pesaro
Zurich, Courtesy Bruno
Bischofberger

*Among the many individuals
who have in various ways made
a contribution to the organization
of the entire initiative, particular
thanks go to*
Flaminia Allvin, Sergio Angelucci,
Gabriella Belli, Bruno
Bischofberger, Agata Boetti,
Caterina Bon Valsassina,
Giovanna Bonasegale, Guntis
Brands, Paola Capata, Paola
Carnazza, Paola Castrignanò,
Barbara Cisternino, Paolo
Colombo, Giovanna Coltelli, Bruno
Corà, Angelo Cordaro, Rodolfo
Corrias, Marcella Cossu, Liliana
Costantini, Salvatore Damiani,
Laura Del Vecchio, Michela Di
Macco, Paolo Di Marzio, Umberto
Donati, Maria Teresa Fiorio, Lucia
Fornari Schianchi, Giorgio
Franchetti, Stefania Frezzotti, Daria
Fuà, Claudia Gian Ferrari, Claudio
Guenzani, Gabriele Guercio,
Jannis and Eftimia Kounellis,
Lucia La Manna, Eugenio La
Rocca, Sarah and Ruben Levi,
Roberta Maiorana, Laura Mattioli,
Alberto Merolla, Gianfranco
Micheli, Manuel Mortari,
Alessandra Mottola Molfino,
Alberto Muneghina, Giovanni
Pandini, Giulio Paolini, Gianna
Piantoni, Michelangelo Pistoletto,
Armando and Patrizia Pizzinato,
Roberto Possenti, Francesco
Rapone, Annie Ratti, Pierluigi

Riccio, Cristina Rodeschini Galati,
Giandomenico Romanelli, Lia
Rumma, Philip Rylands, Rosa
and Gilberto Sandretto, Chiara
Sarteanesi, Silvio Scafoletti,
Mario Schiano Lomoriello, Flavia
Scotton, Mario Serio, Carlo Sisi,
Nicola Spinosa, Stefano Susinno,
Valentina Tanni, Angela Tecce,
Barbara Tomassi, Luciana Tozzi,
Milena Ugolini, Clemente Valetti,
Livia Velani, Franco Veltri

*The present volume is the English edition of the
catalogue initially published for the exhibition of 20th
century Italian art held at the Tokyo Museum of
Contemporary Art from 22 September to 2 December
2001. The exhibition was largely composed of works from
the collections of the Galleria Nazionale d'Arte Moderna
in Rome, alongside some exceptional pieces from
the host museum in Tokyo and others loaned from major
public and private collections in Italy.
The exhibition opened shortly after the 11 September
attacks on the United States, thereby placing an
enormous added burden on the Japanese organisation
Nihon Keizai Shimbun. I therefore extend my thanks
both to it and its president, Takuhiko Tsuruta.
This publication is also the fruit of their generosity
and provides a more extensive reading of the historical
and critical themes followed by the exhibition.
I would like again to mention those who worked
with us towards the organisation of this demanding
event: the director of the Tokyo Museum of
Contemporary Art Hirotaro Higuchi; its chief curator
Junichi Shioda; the Italian ambassador to Japan Gabriele
Menegatti; the president of the Fondazione Italia
in Giappone 2001 Umberto Agnelli, its general manager
Umberto Donati and its deputy director Salvatore
Damiani.
I would also like to thank those sponsors who supported
the exhibition in a variety of ways. They are Epson,
the Kirin Brewery Company Ltd, Shiseido Co. Ltd, Dai
Nippon Printing Co. Ltd, Toray Industries Inc., the
Nomura Securities Co. Ltd, Yamanouchi Pharmaceutical
Co. Ltd, the Yasuda Fire & Marine Insurance Co. Ltd,
Alitalia and the East Japan Railway Company.*

Sandra Pinto
*Soprintendente della Galleria Nazionale
d'Arte Moderna, Rome*

Contents

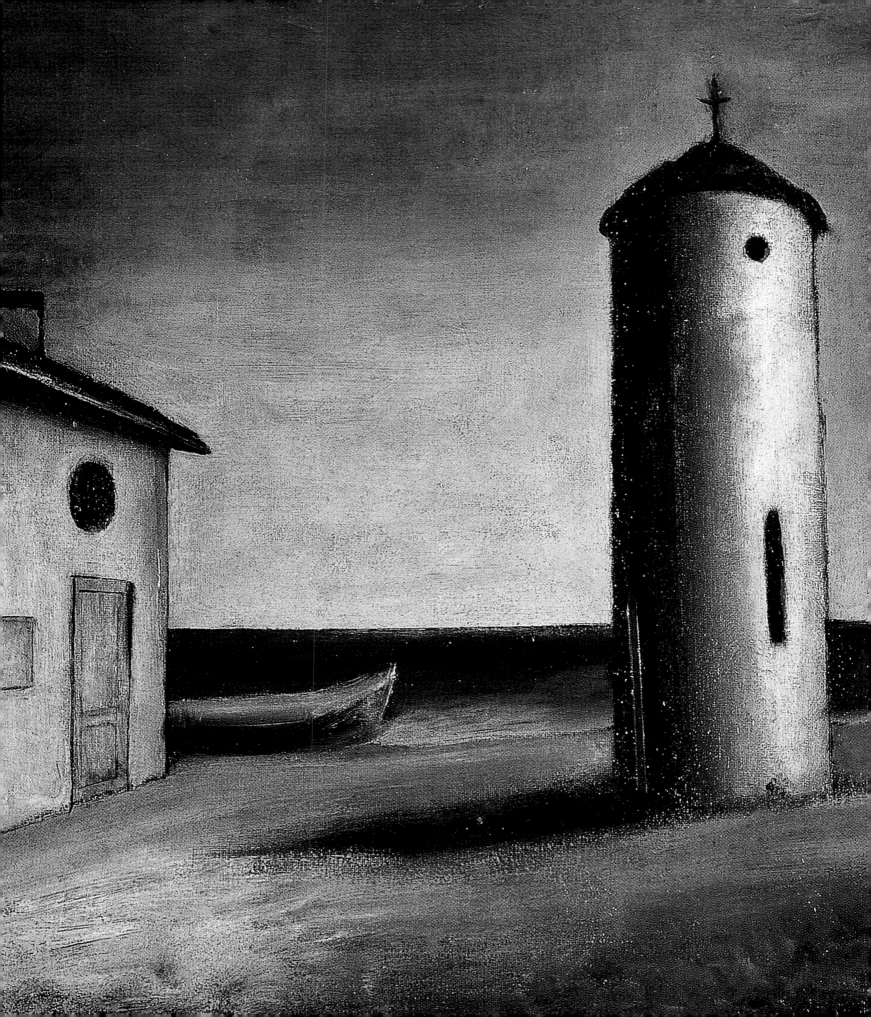

A History of Italian Art in the 20th Century

*One hundred works from the Galleria Nazionale
d'Arte Moderna and from other Italian collections*

A possible history

The history we have attempted to trace in the following pages is only one of the possible histories of Italian art in the 20th century, as implied by the title of the exhibition. More precisely it is the history that includes the series of phenomena that best embody the essence of Italian art within a world panorama of art history in the last century, looking back as if through a magnifying glass from the more 'global' perspective of today.

For this reason some seductive personalities such as Ottone Rosai have been excluded from our selection on the grounds that their relevance was on a too local plane, while others such as Maurizio Cattelan have been omitted because their 'rootless' nature does not make them relevant to Italy's panorama more than that of any other country. 'Our' history includes well-known phenomena alongside others that have yet to be broadcast, with the aim of placing them within the context of other events across the planet from 1900 to 1999. We have tried to give a cross section of Italian culture through the visual arts whilst remaining conscious of parallel historical developments in politics, literature, music, theatre, cinema and industrial progress. In a word, we have tried to give an anthropological picture of Italian art in the 20th century.

Our next challenge was to assemble this history, starting first of all from the documents kept in Italy's only museum of national standing, the Galleria Nazionale d'Arte Moderna. Immediately after followed Italy's major collections, ranging from state institutions such as the collections at Brera or Capodimonte and Parma, to the local museums of Milan, Venice and Rome. Italy's private collections now housed in museums are also featured, such as the Mattioli collection at the Guggenheim in Venice, the Jesi collection at Brera, the Jucker collection at the Galleria Nazionale d'Arte Moderna, the Giovanardi collection at Trento's MART and the Peggy Guggenheim collection. The unavailability of works from collections in Turin, with the exception of the

RAI collection, and Florence with the exception of the Marini Museum, is purely accidental and is due to the works being currently on loan elsewhere. We have intentionally not relied on loans from major museums in Europe and the United States, in themselves proof of the critical and historical recognition enjoyed by some of Italy's leading artistic currents of last century. Our choice aims in fact to highlight an aspect of Italian culture that is too often criticised: adequate institutional involvement in the promotion of contemporary Italian culture, albeit within the limits of partiality that inevitably characterise critical positions in this field. We also wished to illustrate the contribution to Italian culture brought by the lively history of collecting modern art in this country, particularly in Milan.

Story of a conflict. For and against modernity

Like many other events that have occurred throughout the globe and that only now come to be evaluated as history, the conflict between the supporters of modernity and its detractors remains without a winner to this day. Among the first examples of literature on this subject there are J. Clair's *Considérations sur l'état des beaux-arts. Critique de la modernité* (Paris 1983), A. Compagnon's *Les cinq paradoxes de la modernité* (Paris 1990), and Gao Xingjian's *Per un'altra estetica* (Milan 2001).

The first half of the century

Modernity broke onto the Italian cultural scene after unification in 1870, when Italy became a sovereign and independent state. In the visual arts Divisionism gave a poetical and metaphorical language to technical, scientific and ideological (socialism) progress, all ideas with which the new Italy hurried to come up to date. Decadentism on the contrary embodied the opposition against modernity, proposing a model for the new state based on classical ideals and on new idealist philosophies coupled with the ancient philosophies of the classical and post-classical age. The

Amedeo Modigliani,
Testa, 1912–13
Turin, private collection

Lorenzo Viani, *Autoritratto*, 1909
Florence, Galleria d'Arte
Moderna di Palazzo Pitti

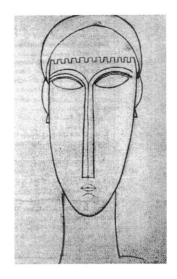

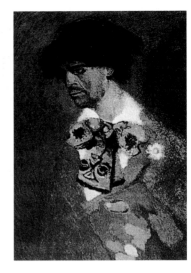

processes it used to conjure up these ideas were much akin to the methods adopted simultaneously in the discovery of the subconscious. Outside Italy Paris was the centre for militants in favour of modernity, while Munich attracted those of the opposite ideal. It is important to consider also the ambivalent background of Italian art history, tracing a conceptual line from Giorgio Vasari in the 16th century right through to post-Modernism and to which both sides are entitled to refer. On the one hand a history made up of 're-births' favoured periodical returns to a tradition still recognised as valid, while on the opposite side progress strongly advocated that the present is more perfect than the past. With the avant-garde movements later this concept was taken a step further, with the future viewed as more perfect than the present.

At the beginning of the century the two sides were still clearly entrenched in their respective positions. The progressive front took a 'futurist' direction and identified with every aspect of modern life and civilisation. This identification went beyond painting, sculpture and architecture and included music, literature, theatre as well as new paths opened up by scientific discoveries such as photography, film, electricity, cars, planes, the telephone, the telegraph and the latest generation of weaponry. The other front either turned its attention towards the inner nature of man, first with Metaphysics and later with Surrealism, or meta-historically back to the traditions with *Valori Plastici* and the Novecento movement. With the exception of the futurist incursions here and there throughout Europe as far as Moscow, Paris became the only reference point for everything modern and everything free. It was not the sole haven for one or other of the opposite artistic beliefs but functioned as the cradle for all avant-garde movements. So much so that it also hosted the nihilism of a life-suppressing art, in the name of which life and reason were to be sacrificed. With the label of *art maudit*, madness and dissipation also made their entry into the so-called avant-garde

movements. Amedeo Modigliani, with his diminutive 'Modi' pronounced as the French word for damned, *maudit*, is the emblem of this current. He was not alone, however. Soutine in Paris and, more locally in the artist's hometown of Viareggio near Leghorn, we find also Lorenzo Viani. Modigliani had two faces, however, classical and modern. His colour and sour brush were fauve, while his composition remained sophisticated and serene. While his sculptures were free of western canons, anti-classical, his drawing style on the other hand was directly inspired by the Quattrocento.

The fascist regime fostered both sides, so long as the virile element was brought to the fore. This was particularly visible in the architecture of the period, which included classical decorative techniques such as frescoes, mosaics and sculpture and grafted them onto recent European architectural currents such as the Jugendstil, Futurism and Bauhaus. Its classical elements were featured both in a revised and corrected version of traditional decorative arts techniques as well as through the rationalist, purified forms of Le Corbusier and Mies van der Rohe. Both declinations owed much to the metaphysical architecture present in the paintings of de Chirico, in turn reminiscent of the Italian Quattrocento, of the deserted ideal cities of Piero della Francesca and period architectural treatises. The fascination of the metaphysical element was to remain long in Italy's figurative repertoire, right through to the urban views of Fellini and Antonioni. With its roots in rationalist architecture, in turn descended from Bauhaus, Milan saw the birth of Italian design. Kept alive in embryonic state by Gio Ponti's magazine *Domus* until after the war, its international success exploded in the second half of the century. Abstract art imported along with architectural currents from abroad also found footing in Italy, with the Milione gallery in Milan up to date with the contemporary French experience of Abstraction-Création. Osvaldo Licini was destined to international triumph only after the war at the Venice Biennale in 1950, while Enrico

Sandra Pinto

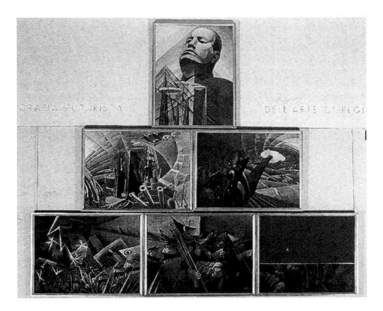

Gerardo Dottori,
Polittico fascista, 1934
Rome, Galleria Nazionale d'Arte
Moderna

Massimo Campigli, decoration
of the central hall of Padua
University, 1939–40

Prampolini was in direct contact with the movement in Paris in the early 1930s.

Meanwhile in North Africa and Argentina spread a figurative culture tinged with Fascism. Prevalently traditional, this phenomenon was particularly influential in architecture of a 'colonial' imprint that we are only now beginning to see the tip of the iceberg of. In art this was represented by a kind of 'civilising' emigration such as the Novecento exhibition organised by the regime muse Margherita Sarfatti in 1930 in Buenos Aires. Modernist and anti-fascist, the Jewish emigration instead elected Paris, the United States and Brazil. The collector Pier Maria Bardi moved to São Paulo. But following these itineraries would lead us away from the main road of European and western culture to areas that will shortly have to be recovered by historians now that a global awareness has woven together things that were once scattered.

The regime absolutely did not approve of the subversive tendencies emanating from Surrealism, particularly when they originated from Dada. Prampolini was obliged to camouflage his work first as futurist and then as multi-material abstraction. Fascism nonetheless did tolerate the lyrical intimism of some, such as Morandi, or the anguish alluded to by Pirandello, Mafai, Raphaël and Scipione. Like the poets of the time they chose an extreme form of expression, metaphorical or more often hermetic but nonetheless decipherable to those in the know. The Italian expressionists had nothing to do however with the horrors represented by Germany's expressionist grandguignol artists, banned by the Nazi regime. Italy would have to wait another fifty years until artists of the Transavanguardia could rediscover a Beckmann or a Kirchner.

Despite the moment of great lack of communication Italy's intelligentsia, segregated from the rest of the free world between 1937 and 1943, was hit by the bombshell message of *Guérnica*, thereby sparking off a resistance to the regime also in the field of art. After the war, with neo-

Giorgio de Chirico,
I piaceri del poeta, 1912
Basel, private collection

Marcello Piacentini and
Attilio Spaccatini, original sketch
for Via della Conciliazione,
1937–50

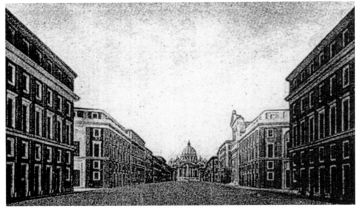

Cubism and the acclamation of Picasso at the 1948 Venice Biennale and with his solo exhibitions both in Rome and Milan in 1953, modernity sprung back more violently than ever. On the side of modernity stood the revolutionary figurativism of neo-Cubism and Abstract art. Against modernity stood realistic and popular figurativism, a good vehicle for propaganda. The entire world watched these two credos clash at the 1950 Venice Biennale. Until post-Modernism the anti-modernity party was to be associated with a totalitarian regime, Stalinism *tout court*. Abstract was supported at the time by the socialists and realism by the communists. At the centre of the political spectrum the Catholic world represented by the christian democrats disapproved of any modern thought whatsoever, along with right wing parties. With his *Comizio* Turcato provided the best symbolical end to the struggle between abstraction and realism. This concept becomes particularly obvious if one places this picture in its context. One must first consider the renewed popularity of Balla's flag paintings, featured in a retrospective on Futurism at the same edition of the Biennale. The same year Guttuso presented his neo-realist painting manifesto *Occupazione delle terre incolte in Sicilia*. Twenty years later Guttuso was to again give his answer to Turcato with the red flags in his *Funerali di Togliatti*.

The second half of the century

The predominant artistic genre in Italy at this time was film. Having broken free from the subculture imposed upon it by Fascism, where it had the function of providing the cheapest and most provincial form of evasion possible, the postwar period saw the rise of names such as Rossellini, De Sica, Visconti, Germi, Fellini, Rosi and Antonioni. This triumphant neo-realist saga was politically oriented towards the left, and therefore in favour of the opposition. Their imagery and *tableaux* were followed by some artists who had chosen to rebel against non-figurative culture. These included Guttuso first and foremost, as well as Vespignani,

Sandra Pinto

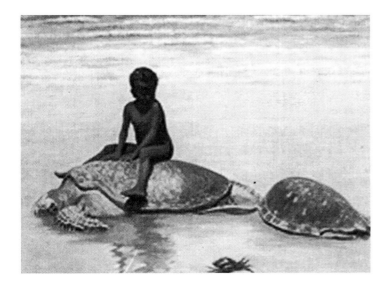

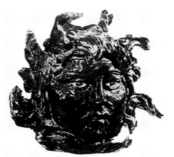

Giuseppe Rondini, *Bambino su testuggine*, 1930–35 Rome, Istituto Italiano per l'Africa e l'Oriente

Lucio Fontana, *Cabeza de Medusa*, c. 1942 Buenos Aires, private collection

Romagnoni and Cremonini. The remainder of the visual arts largely hurled themselves headlong into modernity, or neo-Avant-garde. At an ever mounting pace these generated and surpassed crises of both language and identity, a process that is still continuing to this day. As usual, philosophical thought referred towards Europe, as a vulgarisation of Parisian existentialism, the artistic version of which was *art autre*, *tâchisme* or *informel*.

But American art also left an immediate mark when Peggy Guggenheim moved into Ca' Venier and presented it at the 1948 Venice Biennale. Not exactly indigenous, this art was the product of the many European intellectuals who had fled Nazism and Fascism in the 1940s. These were surrealists and abstract expressionists such as Gorky, De Kooning and above all Pollock with his gestual provocation, or Action Painting. The artists that now broke scandalously on the scene, such as Fontana, Capogrossi and Colla, all came from a traditional but informed past, along with Burri who had made a false start in life as a surgeon. These artists were the ones who most radically and vigorously broke free of an exhausted language that seemed to have lost any relevance both to external reality and our inner perception of life and thought. They created a new artistic language that was met with scandal for its crudity but whose real intention was to impose a new concept of beauty and art. It is worth while noting that this was the last moment before today when pride of place was occupied by mature artists, whose vast acclaim by international critics and from younger generations was only matched by the scandalised reaction of the Italian public. The real value of Burri's *Sacks* for example was not understood as an elitist aesthetic expression. They were instead taken for a provocation, which had repercussions even in Parliament. Inaccessibility to the public or the masses became in fact a requisite, another return to what had happened at the time of the first works by fauve, cubist, futurist and particularly dadaist artists. This time however the newly arrived television magnified every-

thing, with its original sin of anaesthetising banalisation and culturally impoverished diet.

Other realities were also present which must not go overlooked. Until the war artists had formed a substantial part of a community made up of intellectuals, journalists, men of letters, poets, musicians, actors, historians and philosophers. Their 'sites', to use a word from today's Internet jargon that has more or less the same meaning transposed into a virtual sense, were much the same as in the 19th century: cafés, limited edition magazines often from university presses or semi-clandestine. The few private galleries were only in Rome or Milan. The market was virtually nonexistent. So long as a work of art was approved of by the regime, the state represented its most important destination after it had been subjected to the rigid disciplines that governed trade union exhibitions, competitions or the selection committees of the Venice Biennale. Private collecting was made up of exchanges of works amongst members of the artistic community and the market was only sustained by acquisitions and commissions from a handful of cultivated industrialists and professionals. In the second half of the century dozens of private galleries did appear however, mostly in Rome and Milan and with a few equally important ones in cities such as Turin, Genoa, Venice, Bologna, Florence and Naples. As the artistic world expanded legions of professionals churning out Action Painting or *informel* sprung up overnight, forcing these genres into the cliché of a traditional artistic workshop. The market was hungry for quality and therefore needed sufficiently foolproof selection procedures. The economic boom had started and the market from abroad turned its gaze towards Italy. Within this framework critics entered into a new relation with artists and art dealers. Glossy art magazines and catalogues started circulating internationally. Long standing intimate acquaintances with painter or sculptor friends lost their importance. It was now fundamental to be able to spot new talent as it emerged, identify the new element that would

provide guarantees for the future. It was now necessary to define a style, both for the artist and the critic, and keep it continuously up to date like design or fashion, incidentally two fields at which Italy's recovered productivity excelled. The goal now was akin to the struggle to win a prize. At times the 'prize' was real, but it is also true that policy at the Biennale was to award prizes to established artists rather than to new talent. More often than not the 'prize' consisted in the much valued opinions given by museums directors, art dealers and front line critics. University professors and journalists of repute still made up the large part of these, although by this stage the job was entrusted to professionals expert at marketing cultural novelties.

The modernity hurdle race coincided blatantly at the end of the 1950s with the ideologies of consumerism and mass communication. Western philosophical thought distributed a variety of antidotes, ranging form those of Benjamin to McLuhan and Marcuse, while the political scene underwent revolutionary phenomena such as the Che, Mao and Ho Chi-Minh — or all the role models of the 1968 student revolts. In Italy however it was more the anthropological line and structuralism of Lévi-Strauss that solidly prepared and accompanied the pauperist rigour of the most pondered art in the country. The popularity of mass icons such as China's *ta tse bao* and the Red Book, as well as the picturesque misdemeanours of hippies and Hare Krishnas — modified products of the beat generation — were all waves that punctually broke on Italy's shores. But the banalisation of these icons manifested itself most frequently in a sort of self-inflicted American colonisation with the odd stimulating flash. Schifano's futurisation of the Pop repertoire looking at a Coca-Cola poster through a moving car window is an example. The charisma of Kennedy and the 'I have a dream' slogan of pacifist mythology appeared in 'normalised' versions throughout Europe and Italy. A very 'personalised' version of this recovery appeared in Rome with the Tartaruga gallery, which paradoxically recovered classical imagery, ru-

Pericle Fazzini,
*Ritratto del poeta
Giuseppe Ungaretti*, 1936
Rome, Galleria Nazionale d'Arte
Moderna

Amerigo Bartoli,
Amici al caffè, 1929–30
Rome, Galleria Nazionale d'Arte
Moderna

Mario Schifano, *Coca-Cola*, 1963
Private collection

Mario Ceroli, *Cina*, 1966
Rome, property of the artist

ins, the Coliseum, Michelangelo and gave them the banalising Pop treatment. Since this was just the Italian version of something born elsewhere and not an indigenous phenomenon like the rest of what we have chosen to present, we have not included it. Before going onto the next paragraph, where we will cover Italian art's most original and fundamental contribution to the 1960s, we could just pause a moment to underline the different linguistic attitudes taken by New Dada, Pop and Conceptual art towards a phenomenon of mass communication such as the growing importance of the Far East. In 1966 Ceroli represented Maoist uniformisation in his installation *Cina* as a people's theatre, while Novelli poetically evoked an Orient reddened by the Vietnamese holocaust in 1968. The later, more elegant, multi-cultural and conceptual interpretation of this theme came from Fabro's *Shanghai* installation.

Let us instead look in greater detail at how this scale enlargement, or cultural territorial expansion, underscored the abandonment of traditional methods of communication that were no longer able to cater for the needs of the new worlds of thought and action that had been opened up. Evidence of the tragic backwardness of the southern hemisphere began to emerge. The word 'global' was beginning to supplant its predecessors such as 'earth' and 'world', assuming a significant weight in the panorama of western culture since the universe had become accessible after Gagarin's incursion into space at the beginning of the decade and man's first landing on the moon in 1969. The peculiarity we want to demonstrate here concerns the end of the 1950s and lasted throughout the 1960s. It was the complex penetration of American New Dada, which was totally different from the Italian artistic tendencies towards Pop art. Born as a provocation and as a reaction against art too influenced by European models such as Abstract Expressionism had been, New Dada re-launched the desecrating and provocative attitude of Duchamp in the US at the beginning of the century. The idea was that man should react and come to terms

Sandra Pinto

Gastone Novelli, *L'Oriente risplende di rosso*, 1968
Rome, Ivan Novelli collection

Cy Twombly, *La caduta di Iperione*, 1962
Rome, Galleria Nazionale d'Arte Moderna

with the materials surrounding him. If art was to survive after clearing away the existing misconceptions, one would find a more sincere approach to the real world. Italy too underwent a form of trial against the lofty notion of 'Culture' by taking a step back into the past. In Italy however, with the exception of Manzoni's tins this trial to culture was rarely on a provocative plane. Provocation in Italy was never for its own sake but continued to aspire a dignity of style whilst seeking pastures anew from which to start from scratch. Thanks to Cy Twombly, an American who had come to live in Italy in the mid-1950s, who never Italianised but without whom the history of Italian art in the second half of the 20th century would have been very different, New Dada in Rome assumed aristocratic and refined features. Twombly's relation with Rome could audaciously be compared to Nicolas Poussin and Claude Gellée in the 17th century. The sublimation of anonymous reality is visible in Colla's recovery of waste material, as well as in the *décollages* of Rotella. It appears in the delicate metre of the poetic and pictorial 'diaries' of Novelli, as well as in the mystery of the immaterial space made of pure light in Lo Savio. Echoes of Twombly, Capogrossi and Jasper Johns appeared even in the alphabets that the Athens-born but Italianised Kounellis outlined on the canvas in time with his singing. From the radical position of Fontana, with his cuts inflicted on the canvas, in Milan Manzoni went the furthest in developing thought on space by arriving at a Carthesian quandary on himself and on the ultimate goal of art. Castellani forced the monochrome canvas into three-dimensionality. The kinetic artists Colombo and De Vecchi managed to modify the two-dimensional nature of a wall according to mechanical rather than simply optical or tactile principles. The strong personal interest of Giulio Carlo Argan, an academic of world renown and of Palma Bucarelli, director of the Galleria Nazionale d'Arte Moderna, lent institutional prestige to kinetic and optic art. Widely represented at the museum, these works underline well the Italian peculiarity of this

movement compared with its parallel versions in France, Germany and Latin America, particularly highlighting the difference with recent research in the US.

The conceptual heritage in these years was not only used to 'reset' the tools and actions in making art, however. From the New Dada stance artists such as Paolini, Pistoletto, Fabro and Boetti were becoming increasingly familiar with a growing form of 'identity test' that encompassed the entire process of making a work of art, its maker and whoever the work is intended for. The self and the other, programme and chance, intention and destiny, historicised knowledge and creative prediction — all these represented the common conceptual heritage. Far from being the theme of this or that work, this heritage was establishing itself as a formal language in a domain where grammar and style should be, strictly speaking, banished.

So, what was the specific Italian elaboration of Conceptual art? The artists in question were highly informed and exhibited outside Italy. The borders within Europe were gradually breaking down and there was a constant awareness of developments in American art. These included Hard Edge, Post-painterly Abstraction, Minimal art, Primary Structures, Land art and Conceptual art, happening and environment, later termed performance and installation. The instruments used by Italian artists were similar to those of their American counterparts. But while American artists concentrated on pure pragmatism, Italian artists tended to develop new rules for the representation of the world much as perspective or the breaking down of the optical prism in their times. Pascali's square metres and cubic metres of earth and water recall the 'territorial' operations of Long or Smithson. Mochetti's use of artificial light and precision mechanisms recalls the luminous light constructions of Flavin or Nauman; the mirrored surfaces of Pistoletto intended to represent the obvious in an analogical form are comparable to Warhol's serialised commercial images. The universe in and around us appeared increasingly protean,

contradictory, incomprehensible in its entirety. The Italian conceptual artist was trying to find a way to represent this universe the way it is, through the formal worth of a classical vision. The so-called Arte Povera period from 1967 to 1971 was the final phase of this process of reductivist formal rigour that had started between 1958 and 1959. We believe the well deserved, world-wide success of this movement was thanks to its typically Italian transposition of thought into an art form almost as if one were putting it in fine copy. Particularly in the American sphere of Conceptual art, this aspiration to beauty did not seem as vital as the physical realisation of the thought itself, be it ugly or beautiful. It did not matter as long as the artistic action reflected a thought, a perception, an awareness of life. For the Italian Arte Povera artist on the other hand thought in the artistic sphere represented the world and existence in a totally new form of artistic meta-language.

The following decade marked the beginning of a period of 'digestion' of novelty. Two systematic studies of Italian art after 1950 were published by Giorgio De Marchis, who had been first curator and then director of the Galleria Nazionale d'Arte Moderna, preceded by the useful repertoire of Maurizio Fagiolo, a university art historian of the Argan school. De Marchis co-wrote his first study with Sandra Pinto and Livia Velani for the exhibition *Due decenni di eventi artistici 1950–1970* at Prato. The second study was written for the 20th century tome of Einaudi's 1982 history of Italian art. All other Italian writers on the subject can be classified as sources to interpret the phenomena in progress but the two essays mentioned above stand apart for their historical method and motivations. Where in his 1970 essay De Marchis presented a situation still open to judgement, in his 1982 work he bravely painted a generally negative picture. 1968 appeared to De Marchis as the end of an era, marked by series of deaths in the art world, including Pascali, Fontana, Novelli and Colla. The Venice Biennale was contested, with artists choosing either silence

Sandra Pinto

or progressive academisation. A historical analysis of events over the past thirty years would prove that 1968 was not the end of everything, however. The century abbreviated by Hobsbawm still had some surprises in store.

Because of the difficulty of living in 1970s Italy under terrorism, that culminated in the killing of the christian democrat leader Aldo Moro, and driven by their conceptual beliefs, leading artists from the previous decade developed a geo-political interest that took them beyond the Italian sphere in search of means to understand the 'small' world through the 'large' world. In this light we can appreciate the maps of Boetti. The only exception was Paolini, who continued his solitary research focused exclusively on the secrets and complicity that bound classical Italian and European culture to the moral duty for art to exist at least in concept. The global art market, of which Gian Enzo Sperone's Sperone Westwater Gallery in New York was one of the leading Italian exponents, contributed by developing the high profile status of important artists through solo exhibitions in major private galleries and public institutions. Artists therefore evolved independently and, to a degree, in competition with one another. The sensational, semi-institutional or institutional exhibitions were a work of art unto themselves and served to publicise the main body of the artist's work. The American art capitals were now joined by Asia, with Japan and Korea. And while museums the world-over were able to keep up with these developments, Italy remained behind. With the creation in 1975 of the Ministry for Cultural and Environmental Heritage the Galleria Nazionale d'Arte Moderna lost its allocation of resources for the acquisition of contemporary art that it had enjoyed when it was part of the Education Ministry. The Museum was now forced to share funding with all of Italy's other state museums, and then only buy 'historical' works at least fifty years old. Although the 19th and early 20th century collections benefited with important acquisitions this did not compensate for a prolonged absence of policy regarding

contemporary art. This shameful gap was only bridged recently, in 1998, when the Ministry for Cultural Heritage and Activities appointed a special office to deal with contemporary culture and started work on the National Centre for the Contemporary Arts. Italy's other contemporary art museums, be they private (Prato), public (Rovereto and Trento), or mixed management (Rivoli), only developed in the 1980s and 1990s.

At this point a radical change was brought on by the admission of post-modernist thought into the arts from its previous domain in architecture, helped by the philosophical backing of Umberto Eco and Gianni Vattimo.

Perhaps it was the inherently difficult logic and controversial nature of the term 'post-modern' that made its fortune as a 'password' for insubordinance and turned it into the new 'trademark of the 1980s' (Compagnon 1990) in Italy and elsewhere. The term had emigrated from the United States to Europe at the end of the 1970s, when it was considered the American equivalent of French post-Structuralism. For Umberto Eco Conceptual art, avant-garde, Modernism could not go beyond an impossible meta-language. Since the past 'can not be destroyed because destruction brings silence, it must be re-visited ironically, without innocence'. In the visual arts the answer came from Transavanguardia, with its visionary re-evaluation of recent and distant past figurative culture. This ranged from the Expressionism and Primitivism of the 20th century to the mythical realms and ages of fresco, mosaic and miniature painting. The post-modern architectural celebration was consummated at the 1980 Venice Biennale with the exhibition by Paolo Portoghesi *La presenza del passato*. It is undeniable that in Italy the idea of post-Modernism came to be understood as anti-modern, a remedy provided by history for rehabilitation from the disease of modernity, vanquished by its own need to outdo itself. But as Vattimo is renowned for saying, post-Modernism is a 'weak thought', simply suggesting 'a different way of conceiving the relation between

Arnaldo Pomodoro,
Sfera con sfera, 1979–80
Private collection, now located
at the Forte Belvedere, Florence

Alighiero Boetti, *Alternando
da 1 a 100 e viceversa*, 1993
50 kilims from various
collections

tradition and innovation, imitation and originality, a relation that does not necessarily reward innovation and originality on principle' (Compagnon 1990).

For the time being, however, the inheritance left by post-Modernism is not particularly comforting, even though it might be reasonable to hope in a recovery sometime in the near future. The modern concept of history is having to pay a very high price. Thanks to the permissiveness engendered by post-Modernism in the younger generations the abuse and appropriation of past and present civilisations is visible to all. This abuse brings to mind the raiding of a department store by aliens for a picturesque masquerade. No offence intended but one does suspect this tendency in today's artists is neither against the civilisation of yesterday nor the civilisation of others. It is against civilisation *tout court*. The homologation of the global universe and the real time communication are the sirens tempting a modern day Ulysses. They imply that the same value can be applied to all things, that what is real is virtual, that everything can be reduced to a web page where lambs graze with wolves and where pacifists co-exist with the violent. We have gone beyond Scylla and Charybdis, beyond history. But, as Ulysses continued to sail and eventually reached port, after we have overtaken post-Modernism and its leftovers what will history have in store for us in the near future?

For the moment we can only record the last decade in the 20th century, intentionally or not largely neo-conceptual in Italy (in this phase neo-Conceptualism is devoid of historical concepts, the young conceptual artist using pure historical quotation extensively) to understand the altered world after 1989, Italy's unmasking of political corruption and the crisis of the art market that severed the ties between the older and younger generations. Only when older artists assumed the role of teachers did this link remain, as in the case of Fabro and Boetti. Largely similar to what was going on elsewhere, representation of the world was above all a representation of oneself as an individual, an attraction to cultural nomadism and an urgency to mithridatise oneself from the poison of globalisation whilst toying with it at times. But the truculent provocation so prominent in other cultural *insulae* such as the United Kingdom was absent from the Italian scene. Despite everything, and perhaps subconsciously, Italian art retained what has been generally defined as its 'second half of the 20th century' identity. As De Marchis wrote, it retained 'its uniquely mental character of invention, its rigorous formal control, its measured use of expressive means and a high level of craftsmanship. An understated elegance obtained through simplification that owes nothing to instinct, spontaneity or primitivism and that is never schematic, banal or superficial'.

It is worth making one last point on how after 1968 Italy's feminist movement was by now leaving a clear mark in art. Ever since the 16th century women artists had featured, albeit in a minority, on the Italian art scene. By the 20th century a qualified and numerous female contingent of critics, historians and dealers were present: Margherita Sarfatti and Irene Brin, to name but two, in the first half of the century. Prior to the 1980s female artists were still the partners of male artists, however. But as from the mid-1980s the equality, both numerical and in terms of status, was such and so sudden that it is worth considering the phenomenon in terms of the contents and means adopted by these generations. Perhaps today's predilection for intimistic confession and at times provocative exhibitionism is better understood as related to a female mind and its need to re-mould society.

To return to the initial issue, we have traced *one* possible historical line. Some might opt for a quantitative balance but there is no literature to draw from on this approach. One would have to resort to the first hand material such as catalogues, invitations and critical pieces, from wherever these events took place. Another line could have been to trace the map of artistic 'monuments' in 20th century Italy based on absolute inherent quality, assuming that such a

Sandra Pinto

quality exists. The only 'monuments' listed here are such in that they are included in the history of the theories of modernity and 'legal tender' anti-modernity. Another issue is whether the 20th century is one single macro-period in art, or how many artistic sub-periods within the 20th century are really identifiable other than our attempt to settle more or less decade by decade the close-up alternation between modernity and anti-modernity, identity and crisis of identity? To what degree will the end of the 20th century relate to the early decades of the 21st in terms of a reasonable classification of artistic periods? And at its other end with respect to the 19th century? If one had included the regional scenarios within Italy would this have helped give a more defined image or modified it in a different way? If one were to trace an international history would these works still feature alongside their foreign counterparts? The author's personal answer to this last question would be to the affirmative.

Sandra Pinto
San Concordio di Moriano, 26 July and Rome,
26 August 2001

Postscript

I like to hope that the exhibition will be evaluated for what it presents rather than what is absent. Perhaps a guideline to the choices we have made would nonetheless be useful. We have acted on the information provided by our Japanese colleagues, who told us that Modigliani and Morandi are particularly appreciated in Japan. We have therefore included a greater number of works by these two artists in the exhibition, conscious of the fact that this would cause a degree of imbalance in the show but pleased of the honour it would give to these two Italian masters. Some will wonder why Evola, not particularly known, is featured when an artist of the fame of Anselmo has been omitted. Or why there is Pizzinato and not Zigaina or Ziveri, or even Birolli

and Sassu. Licini is present and not Melotti, Munari or Soldati. There are Turcato and Accardi but not Dorazio, Perilli or Sanfilippo. There is Capogrossi but not Afro or Scialoja. There are Kounellis and Pascali but not Schifano, Angeli, Festa, Ceroli, Fioroni, Tacchi, Mambor. The closer one gets to the present, absences outnumber presences. There is only one answer to all this. We have selected works that had an 'added' value over the artistic quality and historical importance of others, therefore making them more representative within the framework of an exhibition such as this one. It can happen that fine views are hidden from a single viewpoint and need to be appreciated from a different angle while others of equal merit gain visibility from being in the foreground.

23

Catalogue

With its scientific studies of light Divisionism is the movement that identified most with the desire for modernity that characterised Italian, and in particular Milanese, society and culture at the beginning of the 20th century. Nonetheless Divisionism was also an element of continuity from the previous century, to which it contributed a considerable forward drive.

'If modern art is to have an identity', Segantini had written already in 1887, 'it will be to research into light and colour'. Doubtless he intended a naturalistic sense, as pursuing the spiritual goal of art. With his call for grafting idealist content onto artistic expression Previati backed Segantini's thought. Along with Pellizza da Volpedo and Morbelli, Segantini and Previati spearheaded a late 19th century renewal movement in art. Although they did not generate the movement in itself they nonetheless in unison applied the 'divided colour' theories of Rood and Chevreul to their works. They are thus tied to the idealistic and symbolist interpretation of reality, be it naturalistic or social, present in Italy at the end of the 19th century. By the time Previati published his *Principi scientifici del Divisionismo* in 1906 the divisionist research into portraying light as a symbol of spiritual truth had already borne its greatest fruits in works such as *Maternità* (Motherhood, Previati), *Il quarto stato* (The Fourth Estate) and *Il sole* (The Sun, Pellizza). Of these works *Il sole* combines an epiphanic vision of light and the ultimate symbol of life with a portrayal of nature.

Notwithstanding their differing interests young artists such as Giacomo Balla and Luigi Russolo saw in Divisionism a technical means for a renewed approach to reality. In his early works Balla concentrated particularly on the theme of social alienation, which places him in a positivist stance, whereas at the beginning of the century Russolo was still strongly under the influence of Previati's symbolism. In *La pazza* (The Madwoman), which is part of the *Esclusi* (Outcasts) cycle, the shredded and vibrant pictorial texture displays the disturbing condition of renegade humanity. It thus

Cesare Bazzani (1873–1939),
the Galleria Nazionale d'Arte
Moderna, Rome
photo ICCD

combines modernity of technique with scientific research into the psyche and the subconscious.

Russolo's nocturnal cityscapes on the other hand still made ample use of the symbolism implicit in the bright vibrations of light generated by lightning, mid-way between the natural and the artificial. At the same time the artist, who had recently met Boccioni, turned his eye towards the natural features of the modern industrial city. Boccioni on the other hand had a lively interest in the modernisation of the city, an aspect the artist had moved to Milan to follow closely. This theme underpinned all of Boccioni's successive output but, again in line with the founding principles of divisionist technique, the artist also wished to convey the endless continuity of the natural cycle of light to which all of man's work is subordinated.

Divisionism with a symbolist reading was by no means the only cultural phenomenon in Italy at the time, however. European Symbolism was already oriented towards *décadentiste* themes. Although the 'murky' variant of Moreau and Beardsley found little footing in Italy, Aristide Sartorio was fully in line with the European climate. Close to Böcklin and having taught at Weimar, Sartorio was also close to other symbolist coryphaei. The allegorical element prevails in Sartorio's large decorative works whereas in his paintings that bear a closer resemblance to reality, such as his views of the malaria-infested Roman countryside, the artist spiritually becomes part of the unavoidably unhappy destiny which binds people to landscape.

With strong ties to the Academy, the early development of Central European Symbolism is present in de Chirico's paintings. De Chirico too was influenced by German late romantics such as Klinger and Böcklin, as well as by the nihilist philosophy of Nietzsche, Weininger and Schopenhauer. His early works (many of which were destroyed by the artist himself) contain visionary features combined with recovered classical elements, all in an atmosphere charged with mythological symbology. All these elements continued to feature prominently throughout his activity in later life.

Symbolism represents the logical connection between the old century and the new. It acted as a catalyst for the mutating progress of Italian culture through the use of idealistic, 'veristic' and allegorical devices. Similarly the divisionist technique was later to pave the way towards the formal renewal achieved by Futurism.

With its curvaceous and anti-classical dynamics Symbolism was one of the primary elements in European Modernism in the early years of the century at a time when the term 'Liberty' was used for a style that was to exert a growing influence on architecture and the decorative arts. According to the modernist ideology these two disciplines should no longer be considered inferior to the fine arts painting or sculpture. It is worth noting that architecture and decorative arts were both admitted to the 1903 Venice Biennale on a par with those art forms.
M.M.

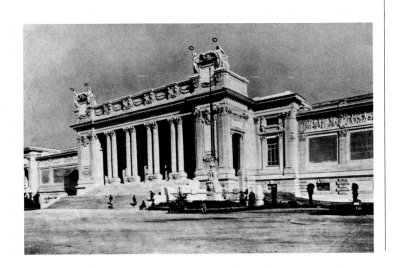

27

Giuseppe Pellizza da Volpedo
1. *Il sole* (The Sun), 1904
Oil on canvas, 150.5 x 150.5 cm
Rome, Galleria Nazionale d'Arte
Moderna, Inv. No. 1053

Initially entitled *Sole nascente* (Rising Sun), this painting was submitted by the artist to the 1905 Munich exhibition and to the 1906 National Exhibition of Fine Arts in Milan, where it was acquired by the Galleria Nazionale d'Arte Moderna. The work belongs to the divisionist movement, which emerged in the wake of French *pointillisme* in the 1880s and which was fired by the same scientific, positivist spirit expounded by Gaetano Previati in his *Principi scientifici del Divisionismo*. The movement's main exponents were Previati, Giovanni Segantini, Vittore de Grubicy, Pellizza da Volpedo and Angelo Morbelli.

A letter written by Pellizza to his friend Angelo Morbelli dates the completion of *Il sole* at 1903. With his positivist background Pellizza was at the time directing his attention towards gaining knowledge of natural phenomena. He dedicated himself to real-life studies of the way in which landscape mutates throughout the day and in particular at moments of great emotional stimulus such as sunrise and sunset. He thus went beyond the traditional landscape painting techniques of Antonio Fontanesi and the Barbizon School.

The artist wrote at the time: 'The rising sun fascinates and dazzles all nature, submitting her to its influence. This great and powerful spectacle escapes our meagre means of reproduction but I think it is time that painting should try... to obtain a gradually tighter hold in the future until a ray of its light is imprisoned in colour' (cit. in Scotti 1974, p. 134). Divisionist technique represents a scientific means for the intellectual appropriation of natural light. The sun's disc was in fact methodically depicted by Pellizza who picked out each single particle of light and combined it with the others for the final luminous effect of great technical precision and emotional power.
M.M.

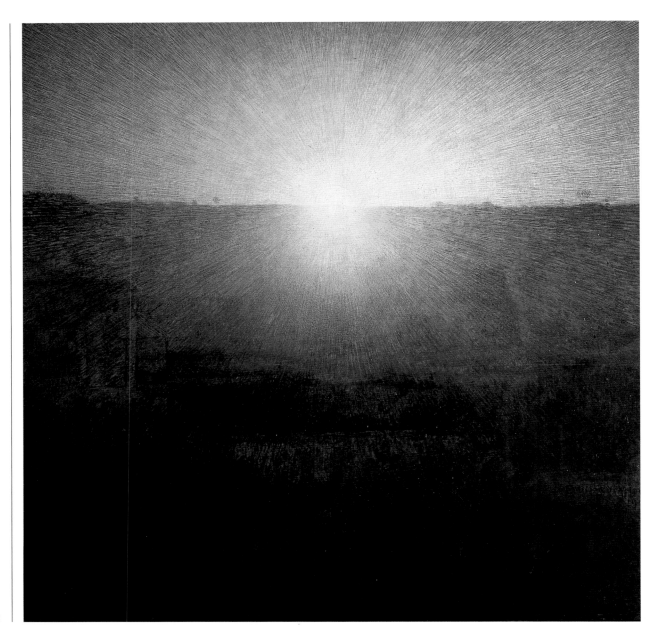

Light between Physics and Symbol

Luigi Russolo

2. *I lampi* (Lightning), 1909–10
Oil on canvas, 102 x 102 cm
Rome, Galleria Nazionale d'Arte
Moderna, Inv. No. 5025

The nocturnal subject of Milan's outskirts lit up by flashes of lightning features in another picture by the artist, of which the whereabouts are unknown, painted with a more analytically divisionist technique in 1909 and entitled *Periferia* (Suburbs), as well as in an etching of the same year, *La città addormentata* (The Town Asleep) in the Bertarelli collection in Milan. In this way Russolo aligned himself with other futurists working in Milan between 1909 and 1910, interested in depicting the city's industrial outskirts at their busiest, as was the case with Boccioni, or at their quietest, as was the case with Carrà. The factories and deserted buildings are wrapped in a disturbing, stormy light, while the painting as a whole displays considerable influences from Russolo's friends Boccioni and Carrà. The exasperated divisionism of Russolo, however, at a time when the artist was already concentrating his attention on music, still has symbolist features particularly in the expressionist use of pure colour — blue, pink, green, yellow — applied with smearing brush strokes. This 'discord' in the colours is also acoustic and reflects an inner state of mind similar to that expressed by Boccioni in *Gli stati d'animo* (States of Mind).

The painting was exhibited for the first time at Milan's Famiglia Artistica in 1910, where it was bought by the collector Francesco Penazzo di Maderno. In 1958 it was shown at the Barbaroux gallery, Milan, during the retrospective exhibition organised by M. Zanovello Russolo, where it was acquired by the Galleria Nazionale d'Arte Moderna.
In 1968 it was presented at the 34th Venice Biennale in the section entitled 'Quatto maestri del primo Futurismo italiano'.
M.M.

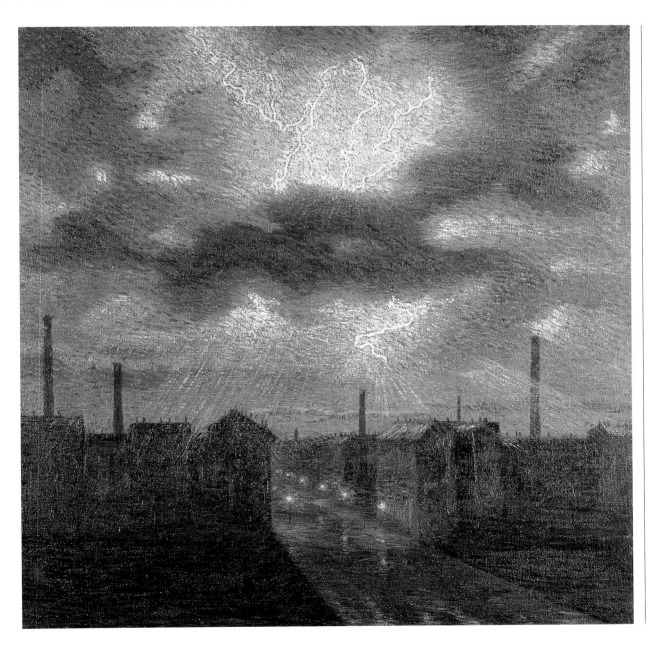

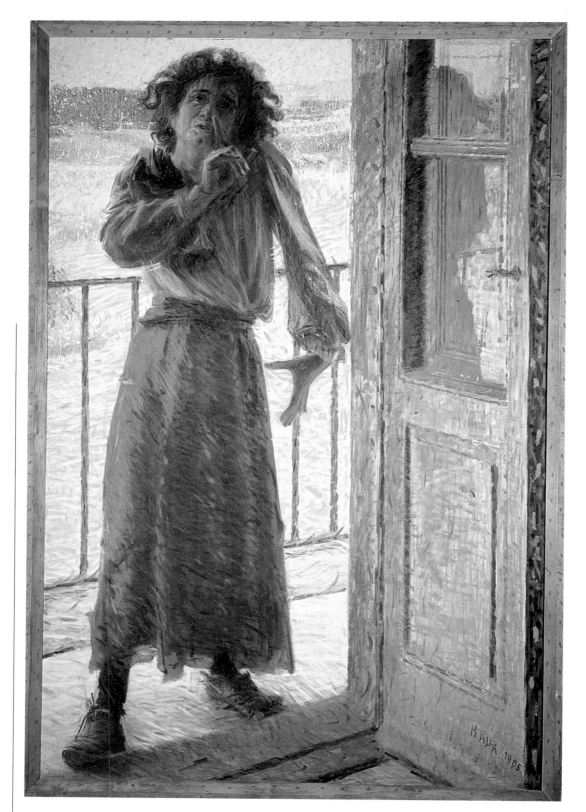

Giacomo Balla
3. *La pazza* (The Madwoman), 1905
Oil on canvas, 175 x 115 cm
Rome, Galleria Nazionale d'Arte Moderna, Inv. No. 8146/b

This painting portrays Matilde Garbini, a mentally sick woman wandering around Rome's Parioli area and whom Balla would invite into his studio to analyse her deranged behavioural traits. Balla had already approached the theme of mental illness and senility in 1902 with his painting *Il mendicante* (The Beggar), as well as in 1903 in *I malati* (The Sick Ones). This interest sprung from the artist's developing interest in positivist and sociological studies in psychiatry, expounded by Lombroso in Italy and by Charcot in France, who both published essays on hysteria and hypnosis cures. In 1895 Freud had also published his *Study of Hysteria*, in which he defined the condition as an illness of the subconscious rather than an organic disturbance.
Balla made a series of studies for the character, featuring both her physical and behavioural characteristics. Here Matilde is shown in the doorway of the artist's studio in Via Paisiello, where he had moved in 1904.
Framed against the light behind her, although the subject is in an open space she appears to be locked in a kind of glass prism. The woman's facial expression and her excited pose convey the tragedy of her existence. This is further underlined by the bright colours, applied with a lively divisionist technique, that spill over the figure and onto the frame, itself painted grey as if it was itself a part of the door and dotted with red as if picking up the last specks of coloured light from the centre of the picture.
This was part of a series of works donated by the artist's daughters to the Galleria Nazionale d'Arte Moderna in 1984.
M.M.

Umberto Boccioni
4. *Tre donne* (Three Women),
1909–10
Oil on canvas, 180 x 132 cm
Milan, Banca Commerciale
Italiana collection, Inv. No. 98

This painting was presented for the first time at the Venice Permanente exhibition in the summer of 1910. It develops some of the key elements of Boccioni's transition from the intense luminosity of Previati, achieved through the use of tenuous and vibrant filaments of colour, towards a more modern concept of light that floods the images to such an extent that they blend into their environment. All the light from the window to the left of the painting is concentrated on the three female figures of Boccioni's mother, sister and, at the centre, his girlfriend at the time Ines. According to the new painting techniques adopted by Futurism, the light is spread out into small strokes of colour-light. As specified in the *Manifesto tecnico della pittura futurista* (Technical Manifesto of Futurist Painting), 'to paint a figure you don't have to *make* it, you have to make the atmosphere… movement and light destroy the material nature of bodies'. In this way the surrounding space is devoid of descriptive elements, according to a practise also derived from Previati, and the three women are placed in an almost transcendental dimension. In line with futurist theory the three figures are in fact modern-day Vestal Virgins, their long white robes contributing to reduce any reference to their bodies and accentuating the 'musicality of lines and folds' for a strongly charged overall emotional effect.
M.M.

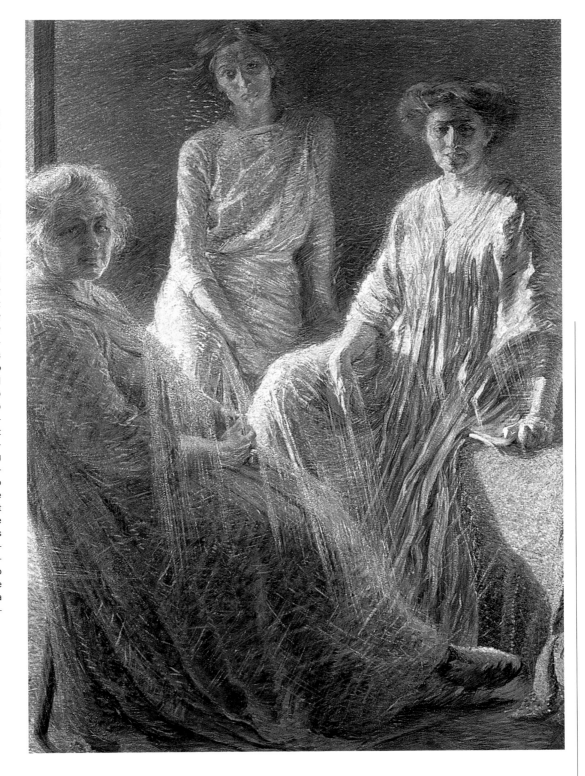

Aristide Sartorio

5. *Malaria*, c. 1913
Oil on canvas, 60 x 131 cm
Rome, Galleria Nazionale d'Arte
Moderna, Inv. No. 6667

Sartorio first presented a painting at the 1883 Rome International Exhibition with the Latin title *Dum Romae consulitur, morbus imperat*, later simplified to *Malaria*.
The iconography of that work was decidedly realist, depicting a woman weeping over the little body of her child in a marshy landscape. Several years later in 1905 the artist presented a painting entitled *Febbre* (Fever) at the Rome Amatori e Cultori exhibition. This work is believed to be a first draft or previous version of the painting here exhibited and in possession of the Galleria Nazionale d'Arte Moderna. Although the work here on show was certainly completed between 1911 and 1920 it was probably started in the first decade of the 20th century and left unfinished for many years. The symbolist motif overrides the realistic, with Sartorio best displaying his study and poetic inspiration derived from the Roman countryside and the Pontine Marshes combined with an analysis of the changing atmospheric light effects throughout the day. The landscape is evoked with simple, horizontal lines, while the solar disc lends the work an increased compositional and symbolic value as it accompanies the work's theme of existential tragedy with its unheeding light.
The painting was bought from the artist's son in 1984.
M.M.

Psyche between Morbosity and Myth

Giorgio de Chirico
6. *Lotta dei centauri* (The Fight of the Centaurs), 1909
Oil on canvas, 75 x 112 cm
Rome, Galleria Nazionale d'Arte Moderna, Inv. No. 6347

The painting depicts the rape of the Lapite women by the centaurs, subject matter which also adorned the western frieze of the temple to Zeus at Olympia and which also inspired Arnold Böcklin's 1873 *Battle of the Centaurs*. Böcklin, an exponent of German Romanticism, was 'copied' by de Chirico during his frequent visits to Munich. Giorgio de Chirico himself writes of his debt to the work of the German artist. Painted in Milan in 1909, this is an early work and displays a romantic vision of mythological painting in the classical style. This is in line with the anti-impressionist thought matured by de Chirico in Athens, when he was a student of Jacobidis, and later in Munich when he came into contact with Academy circles. The work is one of the few from this period to have survived destruction at the hands of de Chirico himself.

The painting was first shown in 1930 at an exhibition in the French capital organised by the Milano gallery on 'Italian Painters Resident in Paris'. It was probably on this occasion that the artist added the signature 'G. De Chirico' to the lower right hand side of the painting, which had previously only been marked with the initials 'G.C.' at the centre.
M.M.

The anti-positivist evolution of speculative thought sparked off at the beginning of the century by the predominance of symbolist thinking opened the way towards the birth of the avant-garde movement across Europe. The philosophical thought that coloured the entire European cultural climate at this time expressed itself through spiritualism (the surpassing of the material dimension), vitalism (anti-rationality) and relativism (the idea that knowledge can only be relative).

Consciously or not, art related to the cultural climate of the new century, pervaded by the 'negative' philosophies of Nietzsche and Schopenhauer, along with Dilthey's spiritualism and Bergson's new concepts of matter and time. Also influential were Husserl's phenomenology, the criticisms levelled at scientific, positivist thought and the advent of new anti-dogmatic scientific methods such as those used by Einstein for his Relativity Theory and Planck for his Quantum Theory.

With their revolutionary concepts of imagery and figurative languages, the avant-garde movements stood diametrically opposed to academic tradition in art. Expressionism (c. 1905), along with the Brücke group in Germany and the fauves in France broke out of static form by exasperating content and image. Cubism (1906–07) on the other hand strove to reconstruct the world through a new spatial concept and a plastic synthesis of form. Partly due to its desire to catch up and be on a par with Europe's most advanced artistic phenomena, the extreme nature of Futurism in Italy pursued modernity and progress by glorifying machinery and speed. Many young artists supported the *passatismo* (old hand) definition of traditional figurative culture used by F.T. Marinetti in his 1909 Futurist Manifesto. Within a matter of years artists like Boccioni, Carrà, Russolo and Severini had all written their own defiant manifestos in which they called for radical change, both in art and throughout Italian society. A knock-on effect stemming from the myth of progress had generated first the myth of the machine and then the myth of speed.

Boccioni's painting *Rissa in galleria* (Brawl in the Arcade) appeared shortly after the publication of the Manifesto and represents the passage from a divisionist idea of dynamics, with maximum chromatic vibrancy, towards the new currents of frantic movement associated with the convulsive rhythms of metropolitan life. In the artist's successive works presented here, *Dinamismo di un ciclista* (Dynamism of a Cyclist) and *Dinamismo di un cavallo in corsa + case* (Dynamism of a Horse in Motion + Houses), every naturalistic reference is abandoned in favour of a layered dismembering of the single parts that interlace to achieve a simultaneous view of the images and the space in which they move. Balla too renewed his figurative language by adhering to the movement, although his position differs from that of his colleagues in as much as he studied photo-dynamics and focused greatly on the research carried out by European abstract artists of the time, particularly Kandinsky. In the same way Severini by the end of his futurist period and with his light, musical touch, owed a debt to the Cubism of Picasso and its dismembering and inversion of surfaces and objects. Fired by the many manifestos and 'Futurist soirées', Futurism enjoyed an enormous success on account of its underlying non-conformist attitude and because of its experimentation in all cultural fields that in many cases preceded Dadaism and Surrealism.

Futurism invested all its creative energy in the First World War, for which it had advocated intervention and hailed as 'the only possible cleansing of the world'. This crisis was marked by the death of Boccioni on the front, as well as by the defection towards other paths on behalf of many of the movement's followers. The avant-garde was not yet finished in Italy, however. Further innovation came from Giorgio de Chirico, who had lived in Paris in the 1910s and come into contact with the poetry of Apollinaire and Cocteau. The metaphysical painting of de Chirico between 1910 and 1920, with its programmatic intellectualism, influenced many of the artists receptive to novelty such as Carrà, De Pisis and Morandi.

A strong French avant-garde component is present in the two works by de Chirico on show here, both of which are from 1914. As with the works featuring city squares and the early mannequins, their iconography marks the achievement of a figurative originality based on an utterly intellectual, meditative composure.

The highly personal still lives of Giorgio Morandi fully achieved metaphysical art, which bears no relation to natural or historical reality, and consequently to conscience, placing objects in a new and surprising relationship with one another. The unpretentious subject matter chosen by Morandi before his metaphysical period culminates in these 'boxes' of clear light, where simple objects are placed side by side as if suspended in a dimension of maximum concentration.

Altogether in a different category, and certainly more French than Italian, was Amedeo Modigliani. Despite his ingrained aversion to form, this *artiste maudit* managed to combine elements that had naturally made up his education in Italy (the Tuscan Trecento school of painters and sculptors such as Simone Martini, Duccio and Tino da Camaino) with the African sculpture he became acquainted with in Paris. Also influential was the Fauve movement, again encountered in Paris, then a haven for anything new and anarchic where all possible artistic expression was cradled and which encapsulated eccentricity and existential unease. His instinctively psychosomatic portraits and provocative, ingenuous nudes are rendered in a language that, although bound within its codes, is undeniably modern.
M.M.

ROMA GIVGNO. 1917. NUMERO DI SAGGIO

n. 1 .noï" C. 30

RACCOLTA INTERNAZIONALE D'ARTE-D'AVANGVARDIA RECVEIL INTERNATIONAL D'ARTE D'AVANT-GARDE

ROMA VIA TANARO 89

RACCOLTA N. 1, E. PRAMPOLINI, costume fono-dinamico (legno.) MARCEL JANCO, bois. V. ORAZI, una forza — festa rustica. G. SEVERINI, peinture. BINO, macolature. BUZZI, boccioni. T. TZARA, froid jaune. N. GALANTE, paese (legno). N. GALANTE, note d'arte decorativa. BINO, frescura. E. PRAMPOLINI, architettura dinamica. F. MERIANO, toussaint. E. PRAMPOLINI, picasso. H. ARP, bois n. 1. ATTIVITÀ e PASSIVITÀ in rassegna letteraria. IO.

COSTUME FONO-DINAMICO E. PRAMPOLINI

Umberto Boccioni

7. *Rissa in galleria*
(Brawl in the Arcade), 1910
Oil on canvas, 74 x 64 cm
Milan, Pinacoteca di Brera
(Jesi collection)

In its review of the annual Milan Famiglia Artistica show, on 21 December 1910 the newspaper *La Perseveranza* commented this painting thus: 'The scuffle takes place near a café in an arcade. As the crowd runs and heaves, so do the shadows under the arched lamps'.
Along with *Retata* (Round-up) (1910) and *Baruffa* (Scuffle) (1911, in sketch version) which also feature heaving crowds in line with the aesthetics of metropolitan dynamism promoted by Marinetti, *Rissa in galleria* gave Boccioni scope for a frantic composition based on converging diagonal lines in which divisionist technique accompanies a chromatic expressionism that precedes the solutions adopted for *Stati d'animo* (States of Mind) in 1911. The vibrant *pointillisme* of Seurat and the expressionist power of Toulouse-Lautrec act as reference points, resulting in an animated, feverish atmosphere crossed by a dense light that engulfs the figures hurled against the café windows. The divisionist technique adopted by Boccioni for this painting uses minute touches of colour-tone 'woven' over the entire painted surface, giving it a diffused luminous vibrancy.
Two preparatory sketches exist for the painting, which was completed in the second half of 1910 after the publication of the *Manifesto Tecnico della pittura futurista* (Technical Manifesto of Futurist Painting) on 11 April and during the difficult labour of *Città che sale* (Rising City). The painting was shown for the first time in 1910 in Milan, with the title *Baruffa*. It appeared later between 1916 and 1917 at an exhibition organised at Palazzo Cova entitled *Boccioni pittore e scultore futurista*, where it was presented under the name *La rissa*.
M.M.

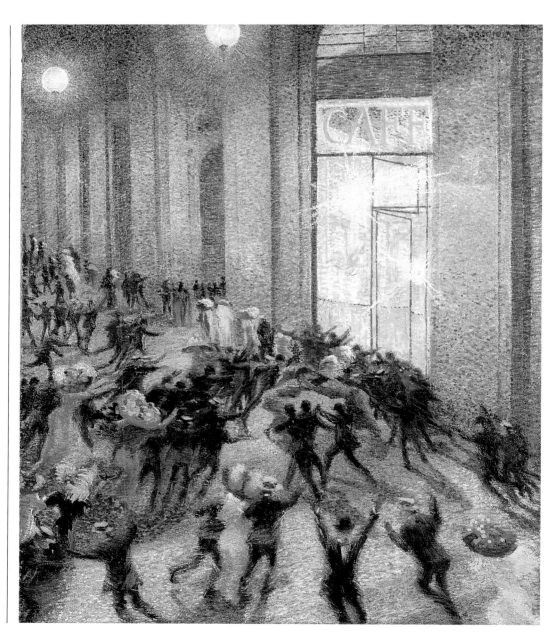

Futurism

Umberto Boccioni
8. *Dinamismo di un ciclista*
(Dynamism of a Cyclist), 1913
Oil on canvas, 70 x 95 cm
Venice, Peggy Guggenheim
collection (Mattioli collection)

This painting was preceded by a series of preparatory studies (Milan, Raccolta Bertarelli; London, Estorick collection), in which the artist progressively eliminated any naturalistic reference from the subject, ultimately breaking down the single parts into diagonal segments that cut through the surrounding space. Although lines of strength within the work give it a centrifugal movement that tends to project the image outside the canvas, the plastic quality of the painting's central area coupled with its architectural construction stabilise the image and highlight its lively chromaticism.

The painting was first shown in 1913 at the *Lacerba* exhibition in Florence at the Gonnelli gallery, and in 1914 in Rome. That same year the work was published on Boccioni's own *Pittura, scultura futuriste* essay. As Boccioni wrote the previous year, '...we want to show the object "achieve dynamism", in other words give a synthesis of the transformation undergone by the object in its two motions: relative and absolute... This suggests the use of lines of force that characterise the potentiality of the object and which bring us to a new unity that is the essential interpretation of the object. More specifically: to the intuitive perception of life'. By 'absolute motion' the artist meant the motion that is intrinsic to the object's essence, whereas by 'relative motion' he meant the motion set off by the object's relation with the surrounding environment. This subject matter also symbolises the speed achieved through modern technology. The bicycle allows the man to move through space and time, while the acceleration rate determines a plastic and dynamic synthesis of the two elements.
M.M.

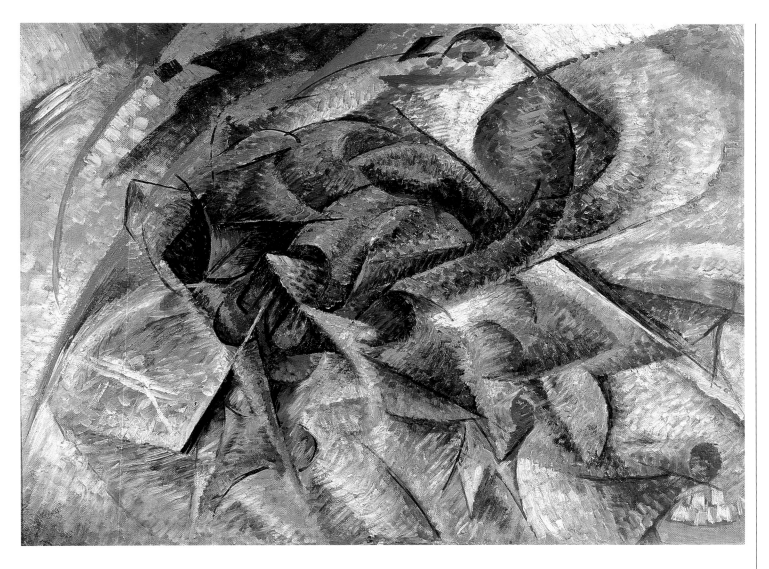

Umberto Boccioni

9. *Dinamismo di un cavallo in corsa + case* (Dynamism of a Horse in Motion + Houses), 1914–15
Gouache, oil, wood, cardboard, copper and painted iron, 112.9 x 115 cm
Venice, Peggy Guggenheim collection

Also entitled *Costruzione dinamica di un galoppo* (Dynamic Construction of a Gallop) the work aims to convey the relation between a galloping horse and the houses between which it is dashing. There is a strong thematic and compositional link between this work and *Dinamismo plastico: cavallo + caseg-giato* (Plastic Dynamism: Horse + Block of Houses) at Milan's Galleria d'Arte Moderna, which also dates from 1914. A number of preparatory studies on paper exist for this latter work, including one currently in the Bertarelli collection in Milan which is the closest to the final work. In both works speed dissolves all perception of the hooves of the animal and appears to suspend the image in mid air. The multi-material object created by Boccioni solves in an original way the 'inter-penetration' of planes idea, that stems from the movement of the galloping horse within an urban landscape. Boccioni takes commonly used materials to build the composition with large, slender surfaces that lend an aerodynamic feel to the form. Boccioni had already expounded on the combination of different materials to create a work in the 1912 *Manifesto tecnico della scultura futurista* (Technical Manifesto of Futurist Sculpture). Here wood, cardboard and metal, in places underlined by strokes of colour give birth to form and redefine the single objects in terms of their essence within time and space. Although in 1913 Boccioni was dedicated mainly to painting it is likely (Calvesi 2001) that as from 1915, when Balla and Depero were researching into the use of different materials, he felt the need to reinvent himself in a field that had been his own aesthetic idea. If this theory is correct, the sculpture could thus be dated at between 1915 and 1916. 'Rediscovered' in the 1950s, Benedetta Marinetti dated the work at 1911. After the parts were reassembled in 1957 it was exhibited at Rome's La Bussola gallery. The work has undergone restoration on more than one occasion and has recently been returned to its original state, as shown by period photographs.
M.M.

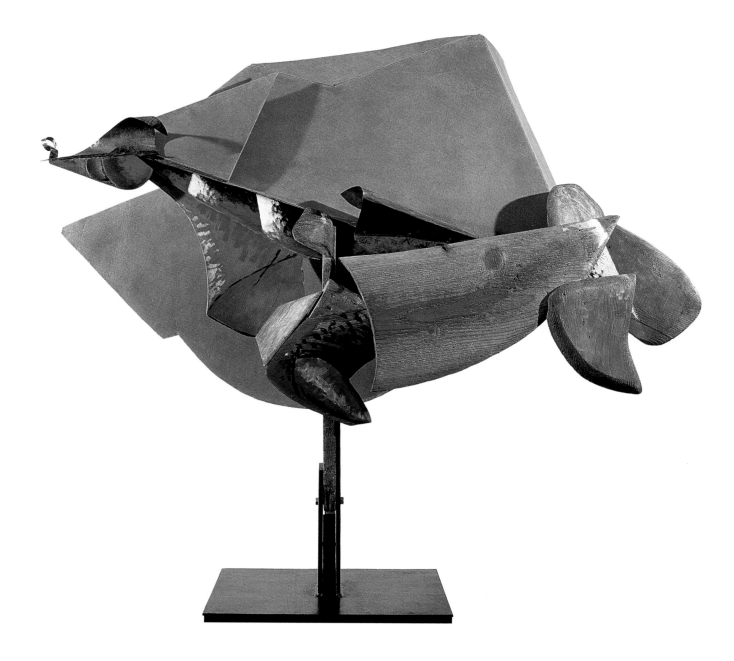

Giacomo Balla

10. *Espansione dinamica + velocità* (Dynamic Expansion + Speed), 1913
Varnish on canvassed paper,
65.5 x 108.5 cm
Rome, Galleria Nazionale d'Arte Moderna, Inv. No. 8149

Analysis of speed was the central theme of a series of works started by Balla at the end of 1913 and which continued throughout the following year. With respect to works such as *Guinzaglio in moto* (Leash in Motion), *Bambina moltiplicato balcone* (Girl x Balcony), *Lampada ad arco* (Arched Lamp) and others exhibited at Rome's Teatro Costanzi in February 1913, in which movement was also at the base of composition, in *Espansione dinamica + velocità* the artist abandoned the naturalistic element in favour of the mechanical object (a car). This brought Balla to an abstract vision in which there is no outline of the car itself but rather waves of movement generated in space by the continuous dynamism of the wheels. This is conveyed through a succession of curves whose beginnings and endings blend into one another.

The kinetic tension generated by this technique negates any connotation of colour; with perpendicular and oblique lines facing one another at the top of the work and curved forms enfolding themselves on different layers in a vortex. In their two-dimensionality the triangles of light indicate the lines of perspective leading into space. The triangular forms fathom both space and time, which also gathers speed. The idea is to unleash a variety of sensations in the viewer, ranging from sound and noise to air movement. The tendency towards a monochromatic range stems both from Balla's studies of artificial light at the beginning of the century and from his experience with photo-dynamics with his photographer friend Anton Giulio Bragaglia, inspired by the photo-dynamism and the chrono-photography of Muybridge and Marey. This chromatic choice best conveys the 'pure dynamic sensation' interpreted by Boccioni in his *Stati d'animo* (*Gli addii, Quelli che vanno, Quelli che restano*, 1911–12) (States of Mind: Farewell, Those Going, Those Staying) and on which he subsequently expounded in 1914.

The work is part of a donation made by Giacomo Balla's heirs to the Galleria Nazionale d'Arte Moderna in 1984.

M.M.

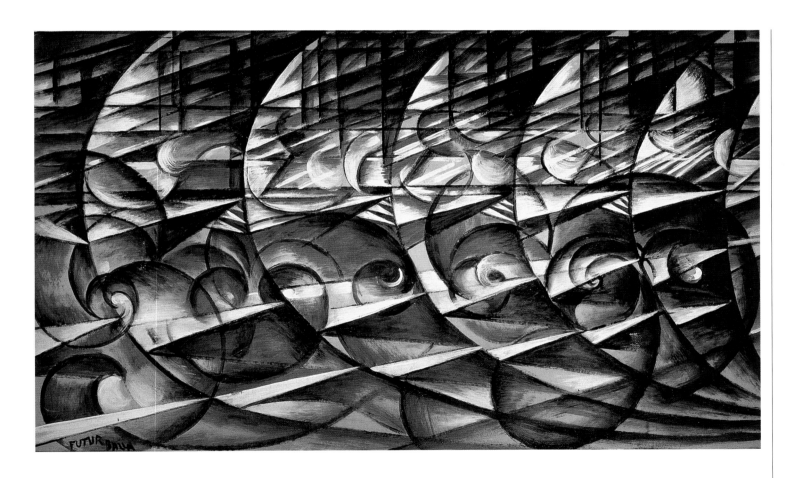

The Avant-garde and the War

Giacomo Balla

11. *Insidie di guerra*
(War Snares), 1915
Oil on canvas, 115 x 175 cm
Original frame painted in white,
red, black and green
Rome, Galleria Nazionale d'Arte
Moderna, Inv. No. 8154

Exhibited for the first time in 1918 at the artist's solo exhibition at the Bragaglia gallery in Rome, the work was originally entitled *Insidie del 9 maggio* (9 May Snares). It is one of a series of paintings that come under the heading *Dimostrazioni interventiste* (Interventionist Demonstrations) most of which had already been shown in 1915 at the Sala d'Arte Angelelli in Rome and which are all in line with Marinetti's futurist idea of war as the 'world's only cleanser'.

Balla defined these works in the *Cronache d'attualità* (1919, p. 4) as bearing the 'architectural expressionism of the masses and of volumes of voices'. The original title links the work with the 9 May demonstration at Rome's Termini railway station against Prime Minister Giolitti, who advocated neutrality in the imminent conflict. In this light the painting could be displaying the dangers of an insidious neutral approach to war as opposed to a more interventionist stance. Balla symbolises this through the plastic construction of geometric and ribbon shaped elements that evoke complex emotions and mental states.

The work is part of the donation made to the Galleria Nazionale d'Arte Moderna by Giacomo Balla's heirs in 1984.
M.M.

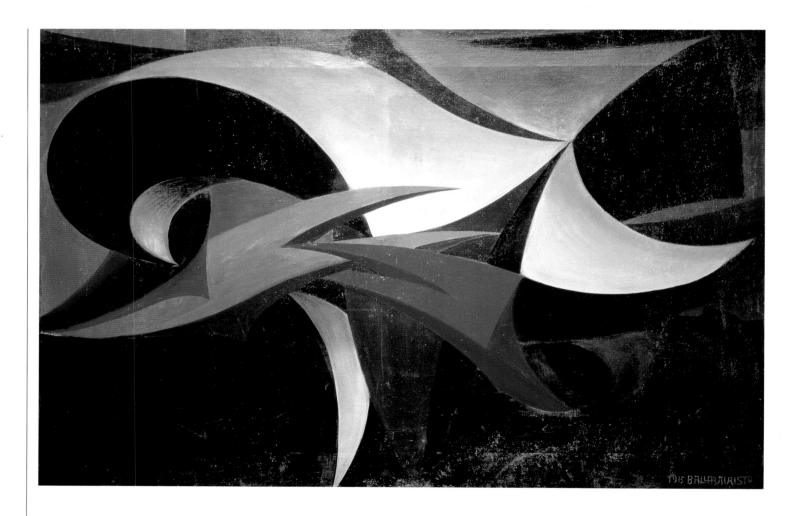

Gino Severini

12. *Grande natura morta con zucca* (Large Still Life with Pumpkin), 1917
Oil on paper on board, 92 x 65 cm
Milan, Pinacoteca di Brera
(Jesi collection, reg. cron. 5466)

This painting was donated to the Pinacoteca di Brera by Maria Jesi in 1984, after most of the Jesi collection had already been donated in 1976. The work is dated December 1917 on the rear, a period during which the artist experimented with a synthesised form of Cubism. At the same time Severini published his theories on the subject in a series of important articles that appeared in *Mercure de France* between 1916 and 1917 entitled 'Symbolisme plastique et symbolisme littéraire' and 'La peinture d'avant-garde', in which he extended the modernist idea of breaking down matter to every-day objects. In this respect the still life offered ample scope both for expressive potential and for the synthesis of collage. Initially, as with the still lives painted between 1916 and 1917, a super-position of chromatic levels prevailed, but as is clear in this picture by the end of 1917 the compositions became increasingly complex. This was not only through the inversion of the surface, along the lines of Picasso, but also through an increased number of object profiles and with the inclusion of painted sections.

The work probably remained the property of the artist for some time before appearing on show for the first time in 1926 at the Salon des Indépendants group show in Paris. It was also featured later at Severini's major solo exhibition in Amsterdam in 1931. Severini chose the picture for the second edition of the Rome Quadriennale to document the synthetic-classical phase of his work and won first prize for painting. In 1950 the work was exhibited at a retrospective show in the Venice Biennale, where it was listed as being part of the Puratich collection. The first time it was documented as being part of the Jesi collection was in 1961, when it was featured in a monographic exhibition at Rome's Palazzo Venezia.
M.M.

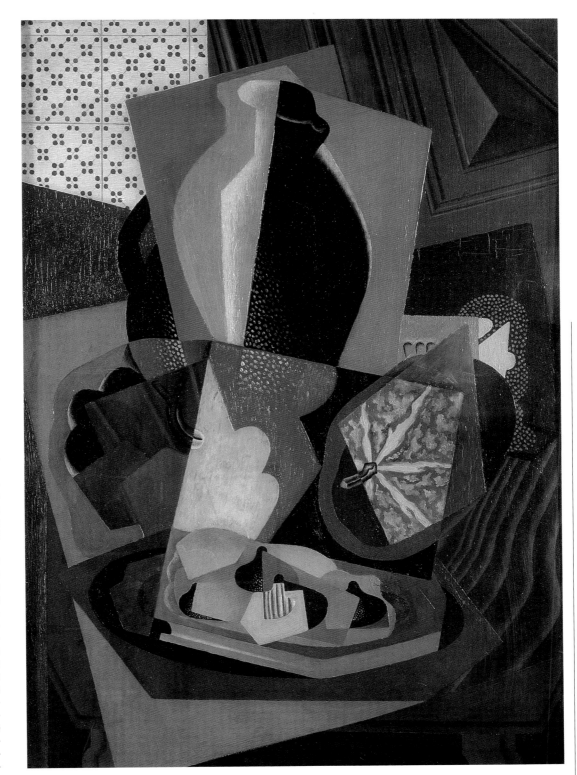

Giorgio de Chirico

13. *La primavera dell'ingegnere*
(The Spring of the Engineer),
1914
Oil on canvas, 52 x 43 cm
Milan, Pinacoteca di Brera

Although the work is signed and dated 1913 on its lower right side, the artist could have left it unsigned in France in 1915 until his return in 1924, thereby offering a plausible explanation for why the date is a year too early. The canvas also bears the title *Le printemps de l'ingénieur*, written by the dealer Paul Guillaume, with whom the painting was stored until 1924. Despite this the work was shown in Paris in 1920, 1922 and 1926. It was sold at the Drouot auction in Paris in 1927, where it must have entered the collection of René Baer.

The fairly hermetic nature of the subject features a framed picture showing a classical female figure against a wooded landscape hanging on one of the walls that form the metaphysical space of the work. The unfinished female figure, the limbs only partly coloured, is clearly drawn from the romantic imagery of Böcklin with which de Chirico had become acquainted during his early Milanese sojourn. The artist successively deepened his study of German Romanticism in Munich, where he attended the Academy and studied the philosophy of Nietzsche, Schopenhauer and Weininger. After a brief but significant interval in Florence and Turin, de Chirico moved to Paris in 1911 with a well-developed metaphysical imprinting which he cultivated further upon encountering the avant-garde poetry of Apollinaire, Cocteau and Jacob. *La primavera dell'ingegnere* is part of this new, already metaphysical dimension of de Chirico's painting, conveyed by uninhabitable buildings and by a concept of space frozen between the wings and backdrop of a stage, in which the 'fictitious' character of the painting itself acquires a disturbing symbolical power.
M.M.

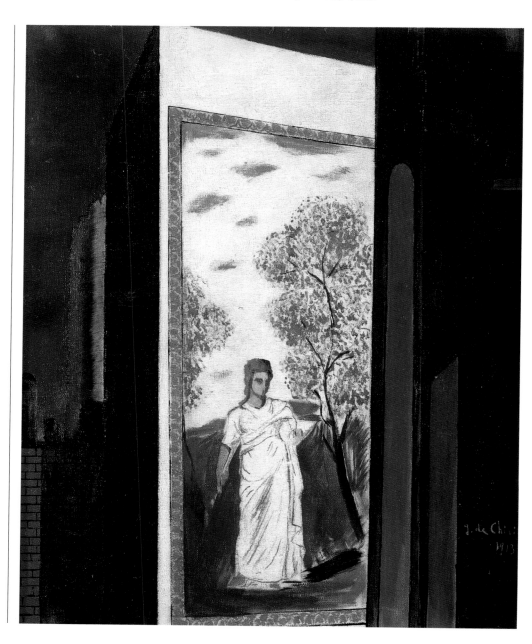

Giorgio de Chirico
14. *La nostalgia del poeta*
(The Poet's Nostalgia), 1914
Oil and charcoal on canvas,
89.7 x 40.7 cm
Venice, Peggy Guggenheim
collection

De Chirico painted this picture between 1915 and 1916 before leaving Paris for his first sojourn in Ferrara. Based on a previous and better-known portrait of his poet friend Guillaume Apollinaire, *Ritratto* (Musée d'Art Moderne de la Ville, Paris), dating from the spring of that same year, this work was inspired by the poem Apollinaire was composing at the time, *Le poète assassiné* and marks the beginning of a new transformation in the work of de Chirico. The artist's friendship with Apollinaire combined with his studies of Nietzsche and Schopenhauer brought him to conceive unreal visionary and symbolically charged spaces.

The space depicted in this painting is dreamlike and lacks any adherence to perspective. Objects are placed in psychological suspension, as if conjured up by the mind through hermetic mechanisms of association. For de Chirico this marked the beginning of a new metaphysical phase after the *Piazze d'Italia* period between 1910 and 1913. In this period architectural composition based on perspective, coupled with a deeply melancholic atmosphere, suggested disquieting visions and places in memory far removed from reality. During this time, which preceded the artist's period in Ferrara from 1917 to 1918, de Chirico and Carlo Carrà had outlined Metaphysics as an art movement in its own right.

In 1914 de Chirico simplified his compositions into works where symbols represented by lifeless, vaguely human forms relate to one another in a mute language of associations. The bust on the left is a reference to the classical age that has been reinterpreted with the dark glasses. The fish drawn in relief on an ancient stele and the cryptogram engraved beneath take on a mysteriously religious symbolical value, while the mannequin draped in a black robe is allusive of a simplified and inanimate human body. The strong influence these works must have exerted on Surrealism a few years later is clear.
M.M.

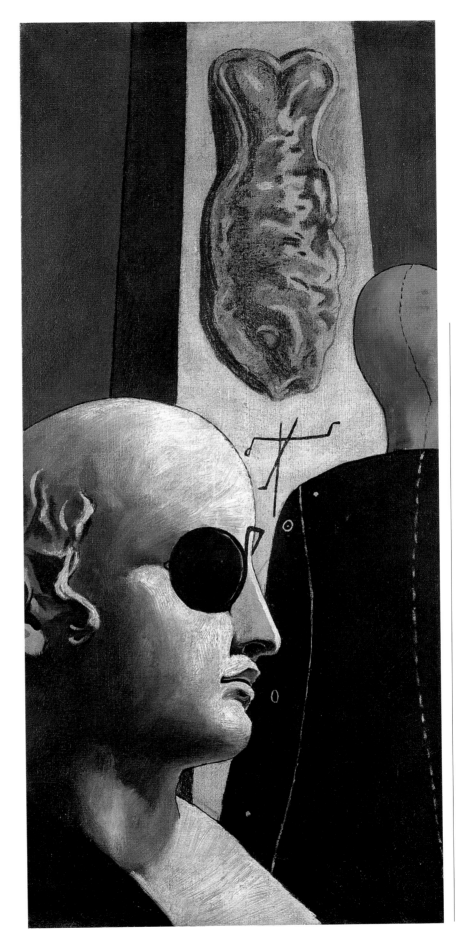

Giorgio Morandi

15. *Natura morta* (Still Life), 1918
Oil on canvas, 68.5 x 72 cm
Milan, Pinacoteca di Brera
(Jesi collection, reg. cron. 5082)

This work was completed at the end of 1918, after the two still lives in the Jucker (see cat. no. 16) and Magnani collections, and prior to the 1919 picture in the Jesi collection. The painting was first owned by the painter, writer and founder of the Rome magazine *Valori Plastici* Mario Broglio. It then passed into Valdameri collection in Milan until it was acquired in 1942 by the gallery of Stefano Cairola in Genoa. Successively the work formed part of the collection of Alberto Della Ragione until it entered the Jesi collection late in 1948. This collec-

tion was donated to the Italian state in 1976.
As for the other still lives mentioned above, this work falls under Morandi's 'metaphysical box' period, where forms are framed in a clearly calculated space displaying the artist's habitual subject matter: regularly placed mannequins, bottles and cylindrical sticks depicted in a still, golden light.
In 1916–17 some of Morandi's works had already embraced Metaphysics. But the artist's involvement was chiefly due to the close friendship that sprung up in 1918 with Giuseppe Raimondi, a young Bolognese intellectual and editor of the magazine *La Raccolta* that played a vital role in the spread of Metaphysics. Morandi already had his own clear and totally original

position with regards to Metaphysics, however, far removed from the enigmatic poetry of de Chirico and somewhat closer to Carrà's mythology of every-day objects. Essentially Morandi stuck to his own particular contemplative and meditative ability to research into the plastic and formal construction of objects. By placing them in atemporal space, Morandi analysed and photographed their archetypal nature.
M.M.

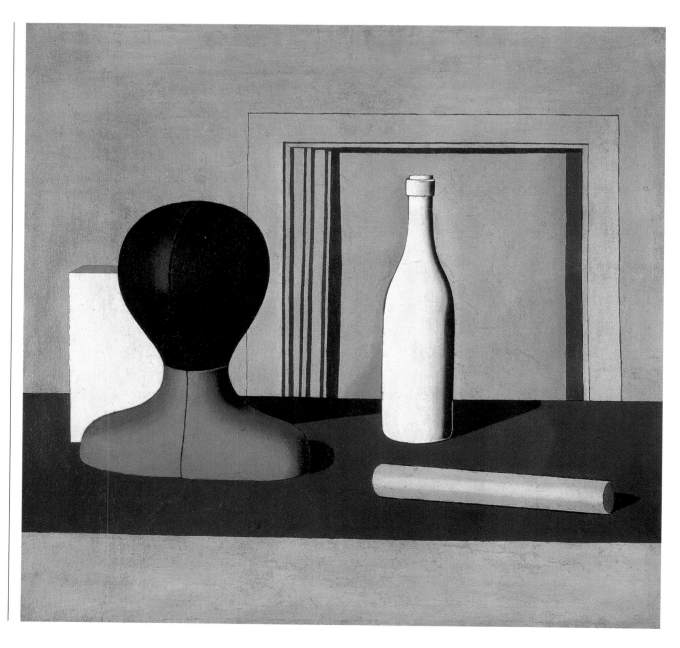

Giorgio Morandi

16. *Natura morta con scatola*
(Still Life with Box), 1918
Oil on canvas, 80 x 65 cm
Rome, Galleria Nazionale d'Arte
Moderna, Inv. No. 853

In 1917 Morandi met the writer and art critic Giuseppe Raimondi in Bologna. A year later Raimondi founded the magazine *La Raccolta*, thereby acting as the main vehicle for the artist's acquaintance with the Metaphysics elaborated at Ferrara in 1917 by Carrà, De Pisis, de Chirico and Savinio. At this time Morandi was abandoning the chromaticism of Cézanne in favour of a clearer *chiaroscuro* image construction, as well as a greater plasticity. Already visible in works dating from 1917, this transformation combined with the new poetic language of de Chirico to create a more mature pictorial expression in which objects such as mannequins, bottles and frames gave life to what has been termed Morandi's own 'Metaphysics of every-day life'.

Natura morta con scatola was painted in 1918 in Bologna and is part of a group of works all featuring the box element containing objects such as a small ball, a doorstop and a ruler. These elements are simply themselves and do not have any hidden meanings. They remain suspended within the rigorous geometry of the box containing them, assuming more a meta-historical than a metaphysical value, thereby drawing attention to their eternal form or 'mental evidence'.

When it was shown for the first time in Rome in 1942 at the 51st exhibition of the Galleria di Roma featuring works from the Valdameri collection, the work was entitled *Cassetta con birillo* (Box with Skittle). It was later acquired by the Jucker collection, which was in turn bought up partly by the Italian state and partly by the Commune of Milan.
M.M.

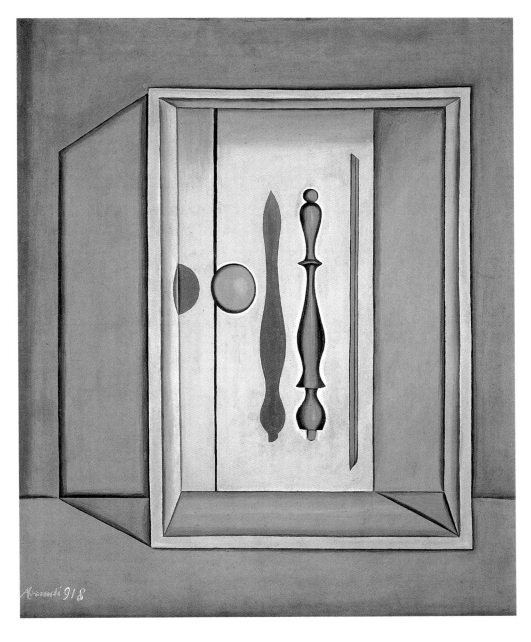

The Avant-garde and the War

Amedeo Modigliani
17. *Ritratto del pittore Moise Kisling* (Portrait of the painter Moise Kisling), 1915
Oil on canvas, 37 x 29 cm
Milan, Pinacoteca di Brera
(Jesi collection, reg. cron. 5037)

Modigliani and Kisling, a Polish Jew who had arrived in Paris in 1910, were among the restricted group of artists featured by Paul Guillaume at his Parisian gallery on Rue Miromesnil. The two artists soon became close friends, with Kisling helping Modigliani financially and Modigliani producing a series of portraits of the Polish painter. This picture, completed in 1915, is the first of this series and comes from a phase when Modigliani had returned to painting after ending his period as a sculptor in 1914. It precedes what was to be his mature figurative expression and clearly displays the artist's new formal research. Modigliani had gradually left behind the primitivism of previous years characterised by African and Cambodian art in particular, as well as by the sharp angles of Cubism in favour of shapes with greater volume obtained with layers of colour in the manner of Cézanne. Cézanne's influence is also visible in the asymmetrical placing of the eyes, while vestiges of Cubism can be seen in the name of the person that has been written in the top right section of the painting. The proximity of the sitter almost completely blocks out any background in the painting, which therefore lacks a setting. As well as depicting Kisling's psychological nature, Modigliani intended to convey the atmosphere of Parisian avant-garde circles at the time, according to a partly expressionist custom still in use. The same year Modigliani also painted a number of other friends and colleagues such as Picasso, Laurens, Gris and Soutine, for whom he employed a similarly frontal viewpoint. The work belonged to Paul Guillaume and was shown for the first time in a posthumous exhibition organised by the Bing gallery in Paris. At the beginning of the 1930s it passed into the collection of the Milanese Milione gallery, from which it entered the Collezione della Lanterna — the cover name for the collection of Emilio and Maria Jesi.
M.M.

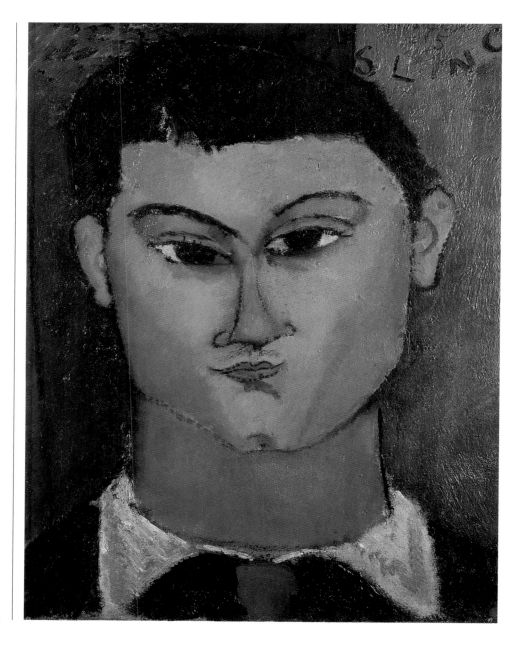

The 'Maudit' Artist

Amedeo Modigliani
18. *Ritratto di Paul Guillaume*
(Portrait of Paul Guillaume), 1916
Oil on canvas, 80.5 x 54.5 cm
Milan, Museo Civico d'Arte
Contemporanea, Inv. No. 7431

Modigliani met Paul Guillaume in 1914 through Max Jacob. A young man, Guillaume had just opened a gallery in Paris, in Rue Miromesnil, where his chief trade was in African art. Along with de Chirico, Kisling, Picasso and Matisse, Modigliani was one of the first contemporary artists Guillaume presented to the public. As from 1915 Modigliani made four portraits of Guillaume, all of which are accompanied by a profusion of drawings. In his first portrait Modigliani inserted the inscription *Novo pilota* (New pilot) alongside the image of Guillaume, thereby labelling him a patron of the avant-garde and a new spiritual guide for his art. Modigliani's friendship with his first patron Paul Alexandre had ended violently in 1914 but he was never to attain the same degree of intimacy with Guillaume. This seated portrait, completed in 1916 and considered one of the masterpieces of the artist's consolidated stylistic autonomy, portrays Guillaume in one of his habitually casual, elegant and detached poses. The image is built around a strong line that in fact passes through a series of superimposed layers. The two-dimensional effect subtends the simultaneous development of all the dimensions in a process that elongates the figure in the manner of primitive Tuscan Trecento art, an ever-present cultural sediment in the art of Modigliani.
The painting initially belonged to Guillaume and successively passed into the Pallini collection in Milan.
M.M.

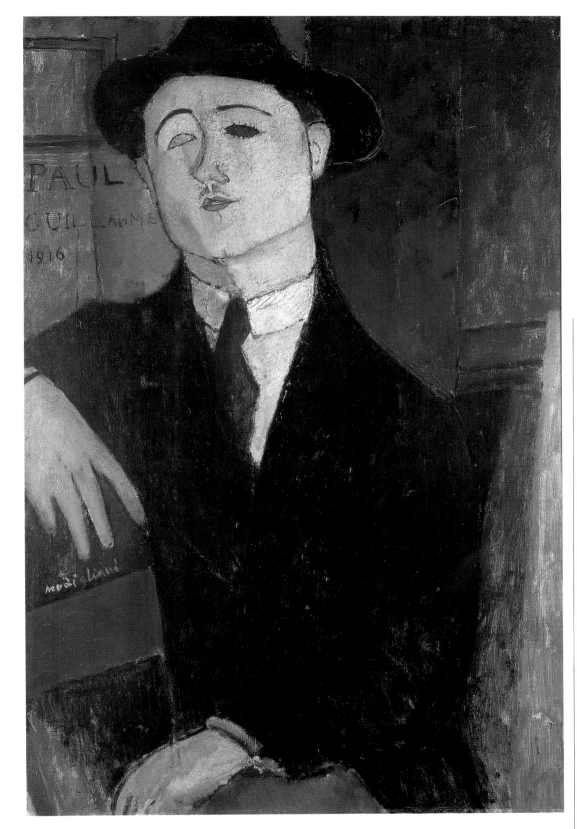

Amedeo Modigliani

19. *Testa di giovane donna*
(Head of Young Woman), 1915
Oil on canvas, 46 x 38 cm
Milan, Pinacoteca di Brera
(Jesi collection, reg. cron. 5081)

Although lacking a date, the stylistic affinity with other portraits from the period indicates 1915 as the probable year of completion. These include the series of Beatrice Hastings, Modigliani's lover at the time, as well as the Mazzotta collection's *Testa di ragazza* (Girl's Head) and various portraits of Modigliani's painter friends all from the same period. The identity of the woman in the portrait is unknown but the painting has the expressionist connotations present in Modigliani's work between 1915 and 1916. This

happened after Modigliani had turned back to the angular harshness of Cubism visible in paintings like *Gli sposi* (The Married Couple) and *Madame Pompadour*. Here the language of the artist evolves and the image gains a structural firmness through the use of a more uniform and fluid matter. Originally the work may have been owned by Paul Guillaume, who subsequently passed it to the G.F. Keller collection in Paris. In the 1930s it was listed in the inventory of the Milanese gallery Il Milione. Before 1946, however, along with *Ritratto di Kisling* (Kisling's Portrait) and *Ritratto d'uomo* (Man's Portrait) it entered the Collezione della Lanterna, the name used to cover up the collection of Emilio and Maria Jesi during the period of

racial persecution. Thus inscribed, the painting was shown at the exhibition on Modigliani organised in Milan in 1946 by the Associazione Amatori e Cultori delle Arti Contemporanee. In 1976 the work was part of the considerable donation made by the Jesi collection to the Pinacoteca di Brera, along with the two other canvases named above.
M.M.

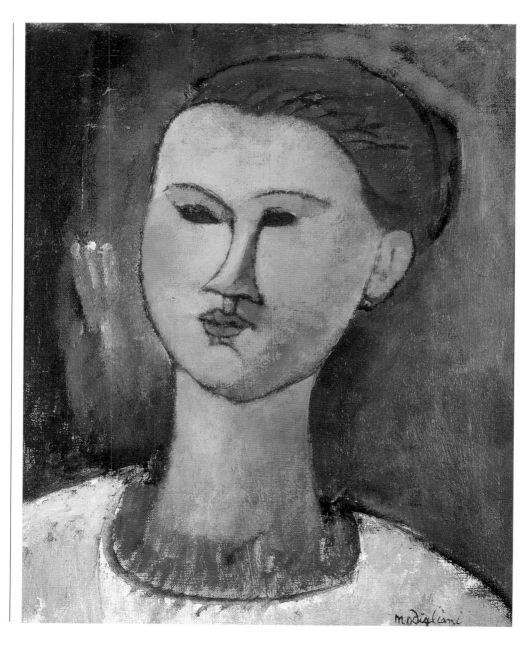

The 'Maudit' Artist

Amedeo Modigliani
20. *Nudo sul cuscino*
(Nude on a Cushion), 1917–18
Oil on canvas, 60 x 92 cm
Private collection

On account of its being part of a strictly academic repertoire, the nude had been banned or transformed by avant-garde artists. Between 1911 and 1914, however, Modigliani came to terms with this theme through his use of the caryatid inspired by the culture of Africa and Asia, in particular Cambodia. Very few examples of his work in stone remain in this genre but there are a number of paintings, some of which on paper. It is no coincidence that the artist recovered the naturalistic sense of the nude in this period between 1916 and 1917,

a time when he achieved full stylistic autonomy after digesting his experiences with expressionist and cubist avant-garde movements, along with the influence of Cézanne and black art. Modigliani's painting opened up in this phase, displaying a bolder and more penetrating formalism, towards an unconditioned array of psychological interpretations of those around him. All his portraits in fact are nothing but a formal, and at times virtuosic, elaboration of different characters and states of mind that reflect, as if in a mirror, those of the artist. The nudes are thus extremely personal, conveying 'in a figure certain characteristics of the human spirit and temperament through the artist's states of mind. These could be sensuality, tenderness, irony or

melancholy. A subtler definition, however, would be that they are not sensual, tender, ironical or melancholic but emblems of these emotions. Modigliani's distilled formality and his transfiguring, stylistic filter are the driving force' (Russoli 1958). Also known as *Nudo sdraiato* (Reclining Nude) or *Nudo rosso* (Red Nude), *Nudo sul cuscino* is one of Modigliani's 'great' nudes, in which there is a greater incisiveness of definition, outline and features. The pictorial technique makes the most of background tonality, heightening the living physical presence of the sitter. As Bucarelli wrote in 1959, 'Modigliani's nudes are detached from everything; alone, absolute, as if suspended in a void'.
Presumably this painting was part

of the series of works exhibited late in 1917 at the artist's first one-man show at the Berthe Weil Gallery organised by Modigliani's new patron Leopold Zborowsky. The nudes caused scandal with the public and police intervened on grounds of indecency. The work was shown for the first time in Italy at the 1926 Venice Biennale. Prior to 1944 it was bought by the Feroldi collection in Brescia, and from here it passed into the Milanese collection of Gianni Mattioli.
M.M.

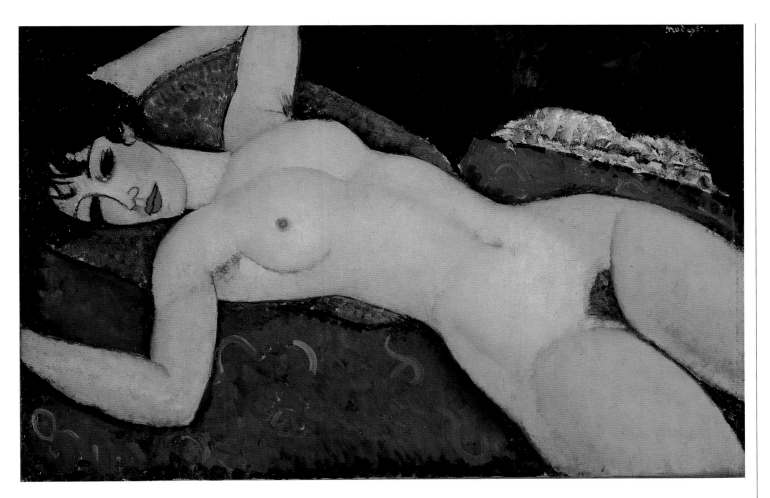

The first post-war period in Italy was marked by a return to traditional figurative art. This was not simply in reaction to the avant-garde movements but stemmed rather from the influence of contemporary European experiences that gave life to artistic expressions in turn labelled 'realistic', 'objective' and 'classical'. All these experiences strove towards an objective view of reality after the confusion of the war by forging a link particularly with the traditions of late Medieval and Renaissance art. Tangibly compact shapes and adherence to the technical laws of painting and sculpture generated, even in artists such as Matisse and Picasso, a volumetrically constructed form inspired by the stateliness of classical art. A 'heretical' element developed even in the most reactionary cubist circles with the purism of Ozenfant and Jeanneret. Cleansed of the dismembering composition of Cubism and sustained by a more architectural construction, shapes reached the expressive purity of geometry.

Julius Evola embraced this poetic language, shifting from his initially futurist stance towards a spiritually-influenced form of abstract synthesis expressed through clear, concrete, almost mechanical shapes. The inner intellect excludes any emotional involvement with the image on the picture and begins to resemble the language of contemporary Dada. A Kandinsky-inspired abstraction is instead visible in the work *Scienza contro oscurantismo* (Science versus Obscurantism) by Balla, demonstrating the deep-rooted evolution that had overtaken the artist since his adherence to Futurism. Balla was fascinated by Hildebrandt's concept of form as an original visual creation, as well as by Worringer's theories on abstraction. Both these ideas were at the base of the European Abstract movement, and in particular the work of Kandinsky. For Balla they represented the only means to escape the involution of futurist expression.

The metaphysicism of de Chirico, whose imagery had already been forged around 1915 in Paris and which was steeped in the negativist philosophy introduced to him by his friend Apollinaire, already contained the seeds of Surrealism. So much so that when de Chirico returned to Paris in 1924 he joined the group of surrealists headed by Breton. Classical and literary elements began to feature in his work at this time, including mannequin-characters, warped perspectives and surprising associations. Disagreements soon sprung up with his comrades however, due to the clear vision of de Chirico who did not accept the surrealists' faith in the subconscious and their representation of the world of dreams. Andrea Savinio on the other hand continued to remain in contact with the group. Composer, writer and 'amateur' painter, only having taken it up in 1926, Savinio bent surrealist expression to his own ironical taste and to a visionary tendency that was more than just imaginative construction and recalling images from the memory. Savinio was also receptive to modern techniques in photography and film making, which he livened up with his surrealist experience.

Another Italian artist to live in Paris in the 1920s and breathe its intellectual novelties was Filippo De Pisis, who had also been close to de Chirico and Savinio during their metaphysical period in Ferrara. Although the influence of Impressionism prompted De Pisis to change his pictorial technique, the 'stenographic' style of his painting aimed at fixing objects before their disappearance from memory shows a spiritual affinity with Surrealism. And it was this affinity that prompted De Pisis to paint still lives in which objects lost any proportional relation to one another, suggestive of a vision from the sphere of dreams.

No artist more than Enrico Prampolini managed to carry Futurism to the extreme of its renewal through integration with Europe's most anti-formalist avant-garde movement: Dada. In *L'automa quotidiano* (Daily Automaton) Prampolini exemplifies his transition from 'mechanical' art to cosmic idealism. The work is also proof of his real estrangement from Futurism that he used as a screen to cover his inclinations towards Surrealism and Dada, two movements considered degenerative at the time in Italy. Man's estrangement from modern technological progress, sym-

bolised by the automaton, is a clear influence of Surrealism, just as the many materials used by the artist in this period are both a legacy from Futurism and an adherence to the dadaist use of matter.

As in the rest of Europe, the aftermath of the war in Italy was a moment of great uncertainty and dissatisfaction. This climate of confusion created a burning need to take refuge in the richness of past traditions, a need that in many cases engendered the nationalism to oppose foreign ideas. The Rome-based magazine *Valori Plastici*, published from 1918 to 1922, was the literary embodiment of this historical period. Some of the finest artists of the time such as de Chirico, Carrà, Martini and Morandi gathered round this publication, which sought to rediscover a lost art and advocated a return to traditional stylistic values, as well as compositional balance and an appreciation of great artists of the past. But the magazine also functioned as an update on contemporary movements in Europe such as Abstract art, and particularly neo-Plasticism. The work of Morandi and Martini came to be known through its illustrations. The artist most aligned with the magazine's theories was Carlo Carrà, who terminated his metaphysical period in its pages and opened a totally new phase with his 1921 painting *Il pino sul mare* (The Pine Tree by the Sea). This was based on depicting a sombre, contained form of reality inspired by the 'primitives' and in particular Giotto. Carrà's writings on the Florentine Trecento artist's painting published in *Valori Plastici* remain in fact some of his most acute. *Dopo il tramonto* (After Sunset) is the work that has been chosen to best represent the artist's new style. The composition is made up of simple forms 'bathed in natural light', in an atmosphere that still retains something of the Metaphysics but which has echoes of the style of Piero della Francesca.

In the 1920s in Turin Felice Casorati matured a style based on extreme linear concision made up of rapt, motionless figures lit by an intense cold light. The Renaissance style was the artist's main reference point, and in particular Piero della Francesca, from whom he drew the sense of metaphysical suspension of figures and objects in perspectively ordered spaces. Casorati's clear renditions of reality immersed in an enchanted atmosphere bring him close to the 'magical realism' coined in Germany by Franz Roh in 1925 and brought to Italy by Massimo Bontempelli.

While *Valori Plastici* was promoting its archaic ideals Mario Sironi in Milan was researching into the classical dimension, following his experiences with Futurism and Metaphysics. By the early 1920s the artist had already attained a consciously independent expressive language. Sironi was able to capture and interpret modernity in a simple and obvious language at least into the mid-1920s. The artist personified a need to recover lost tradition, not by imitating the ancient masters, however, but rather by creating a new form of classicism free from verism and descriptivism. The first theme to receive 'treatment' according to this new viewpoint was the modern cityscape, which was placed in a space reminiscent of something metaphysical but which was even more solidly constructed. Sironi's work featuring city outskirts was to become a new iconography for the modern city. The human figure was another theme dear to the artist, who with his severe outlines and dark colours imbued it with a renewed majesty. Sironi used the past to create a new image of humanity that had acquired dignity and credibility from following the examples of the ancient world.

This cultural climate, so attentive to tradition, also left its mark in sculpture where the archaism of Marino Marini drew inspiration from ancient Greek, Etruscan and eventually Romanesque statues. For Marini this was a means of reacting to the hedonistic ornamentation rampant at the turn of the century. Classical themes and iconography remained present in the work of Arturo Martini throughout his lifetime to recreate ancient myths in the modern world. His reckless freedom of spirit allowed him to free sculpture from its academic bonds without resorting to experimentalism.
M.M.

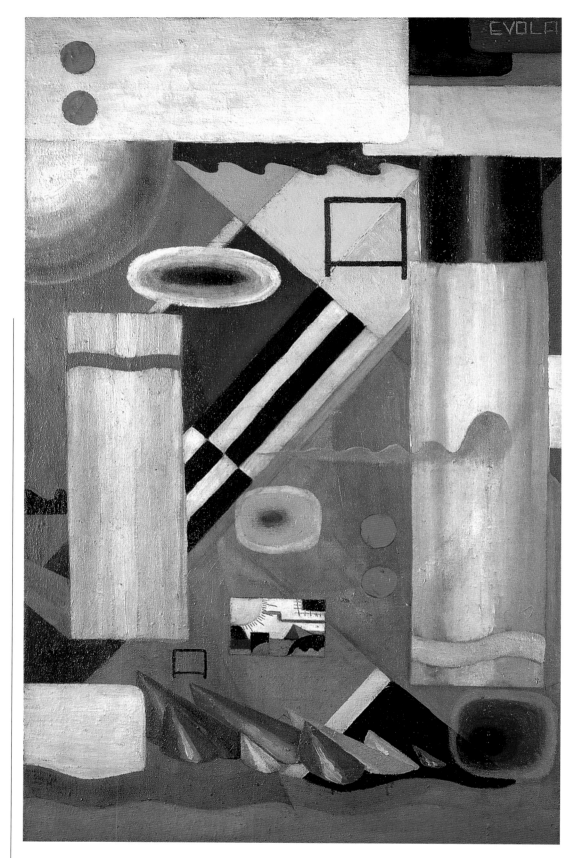

Julius Evola
21. *Paesaggio interiore, ore 10.30*
(Interior Landscape, Time: 10.30),
1919–20
Oil on canvas, 100 x 63 cm
Rome, Galleria Nazionale d'Arte
Moderna, Inv. No. 5183

Exhibited for the first time at the Bragaglia gallery in Rome in 1920, the painting is part of a series of works with the same title completed between 1919 and 1921 and mostly exhibited by Bragaglia. They differ from each other in that they 'record' the artist's ideas at the moment in which they were painted. Evola himself had divided his works into two sections: the period of 'sensorial idealism' from 1915 to 1918 and the period of 'mystical abstraction' from 1919 to 1921. Synthetic and futurist, the first period was characterised by the dynamic transfiguration of objective information, as well as by the search for emotions provoked by colour and sound. In the second period shapes acquired a greater solidity and clarity, to an extent that they often had volumetric, almost 'mechanistic' connotations, while colour was spiritualised into a brightly chromatic Kandinskyan vision. Symbolist elements are also present, however, such as the secessionist-style 'A' repeated twice in different sizes, or the rounded shapes painted in different concentrically arranged colours. Evola's research at this time focused on maximum objectivity in the painted image, conjured up to express an exclusively intellectual interior far from any emotional involvement. As Enrico Crispolti pointed out (1998, pp. 19–31), with his 'absolute spiritualism' Evola opposed the prevailing abstract tendencies in the Roman cultural environment of the time. He reacted both against Balla's 'formal fantastic creativity' and Prampolini's 'formal physicism' with a capillary analysis of his own self. He thus followed the path of central European imaginative syncretism, made of secessionist, futurist and cubist reminiscences and of purist aspirations, all elements that combine to create the complex language of Dada.
M.M.

Giacomo Balla

22. *Scienza contro oscurantismo*
(Science versus Obscurantism),
1920
Tempera with oil layers on wood,
24 x 35.5 cm
Original frame painted grey
with triangular applications
on four sides
Rome, Galleria Nazionale d'Arte
Moderna, Inv. No. 8161

Also entitled *Oscurantismo e progresso* (Obscurantism and Progress) or *Scienza che spacca* (Splitting Science), this painting was shown in 1925 at the III Rome Biennale and features the theme of progress victorious, symbolised by the light of science illuminating past ignorance. The frame is 'part' of the subject, underlining the dynamic expansion of the clashing forces within the painting through the juxtaposition of the triangular shapes along its edge. Although Balla's interest in science is alluded to in the title, this work uses elementary shapes to represent the abstract concept of positive force, symbolised by the wedge shape. A series of luminous triangles and multi-coloured ribbons emerge from a black background and penetrate a triangular element placed on the opposite side of the painting. This wedge shape had already been used by Marinetti, Carrà, Boccioni, Russolo and Piatti in their 1914 *Sintesi futurista della guerra* (Futurist Synthesis of War), where the image symbolised Futurism breaking up the culture of *passatismo*, or excessive relish for the past. The same iconography crops up again in the 1919 manifesto of the Russian constructivist El Lissitsky entitled *S'insinua nei bianchi il cuneo rosso* (Red Wedge Breaks up the Whites), in reference to the advance of the Bolshevik army.

By now far from Futurism, around 1920 Balla became increasingly concerned with the symbolic content of his painting. His contacts with young artists such as Pannaggi, Paladini and Marchi fired an interest in European abstract-constructivist culture, which he applied in an abstract manner thereby overcoming the provinciality of Italian Futurism. The abstract nature of *Scienza contro oscurantismo* was clearly inspired by Kandinsky and by his theories on the symbolical value of shapes and colour. In turn Kandinsky had just returned to Russia, where he had been influenced by Constructivism and was giving more order to his geometrical shapes according to an increased symbolical rigour.

The work was part of the donation made by the heirs of Giacomo Balla in 1984.

M.M.

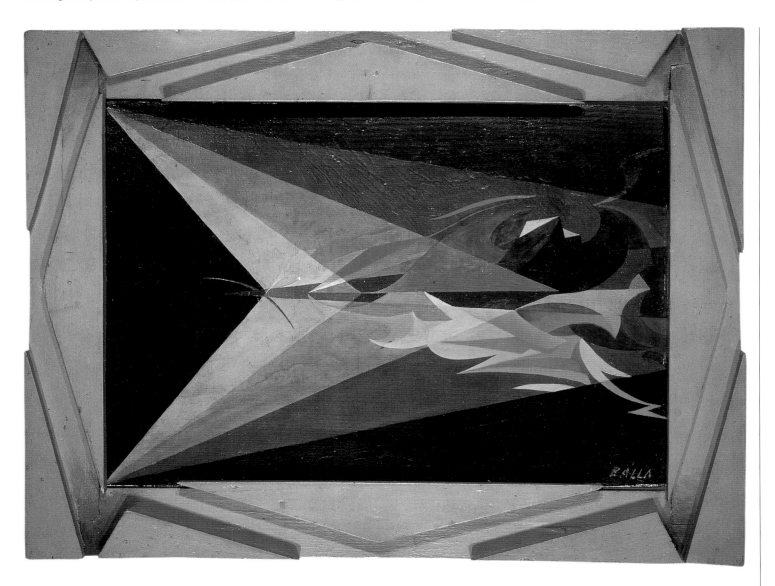

Giorgio de Chirico

23. *Ettore e Andromaca*
(Hector and Andromache), 1924
Oil on canvas, 98 x 75.5 cm
Rome, Galleria Nazionale d'Arte
Moderna, Inv. No. 5739

The painting is one of a series of works, each in two versions, completed by de Chirico between 1922 and 1924. These are *Il Trovatore* (The Troubadour), *Ettore e Andromaca* and *Il ritorno del figliol prodigo* (The Return of the Prodigal Son), and still display elements of the metaphysical research carried out by the artist some years previously. By the end of 1924, however, de Chirico joined the surrealist movement. As well as absorbing the the-

ories of Breton, who published some of his paintings on *Litérature* and had presented an exhibition of his work at the gallery of Paul Guillaume, de Chirico also became friends with Ernst and Eluard.
The painter had already treated the subject of Hector and Andromache before the 1920s, in 1916, during his period in Ferrara. From this time there is a drawing published on *La Brigata* in 1917 and an identical subject reproduced in 1919 on *Valori Plastici* in a feature dedicated exclusively to him.
In the 1920s de Chirico returned to this subject, along with that of the prodigal son. Both works feature an almost human figure next to a mannequin with some human attribut-

es and postures. This gradual humanisation anticipates the iconography de Chirico was to develop after 1925 in Paris. From then onwards even horses, which appear in the far background of this work, would assume the status of protagonists. The character of this painting, which may have been subsequently altered by the artist, is one of transition from the Metaphysics towards Surrealism. The usual iconography is placed alongside elements from Classicism and literature. The metaphor takes the place of symbol and the range of colour grows denser and softer.
Compared with the other versions of the same subject the setting in this painting, made up of towers,

horses and a warrior, contributes to the title and to the recognition of the two characters drawn from Homer.
M.M.

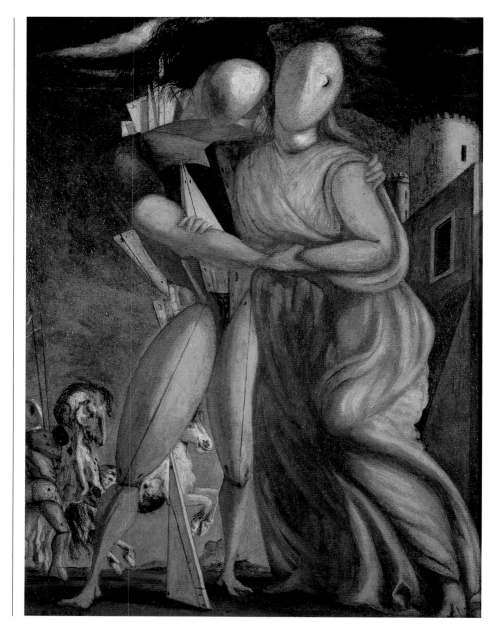

Surrealism

Alberto Savinio
24. *Annunciazione*
(Annunciation), 1932
Oil on canvas, 99 x 75 cm
Milan, Museo Civico d'Arte
Contemporanea (Boschi
collection, Inv. No. 1086)

Savinio completed this painting in 1932 while he was staying with his brother in Paris. Although the rear bears the inscription 'Apparition', the work has always borne the title *Annunciazione* from the moment it was shown in Turin that same year, presumably for the first time, and later in 1935 when it was published in a Polish magazine. The same title appeared in a monograph curated by Savinio

himself in 1949. A second version of the painting from the same period also exists in a private collection. In tempera and smaller in size, measuring 55 by 46 cm, it differs slightly in the perspective of the window that leans to the left instead of to the right, while the angel's head is closer.

Savinio had already treated the Annunciation theme in works from 1929 onwards, such as *L'Annonciation* (The Annunciation, 1929), *L'Annunciateur* (The Announcer, 1930) and *L'annonce faite à la Vierge* (The Annunciation Made to the Virgin, 1930). In these paintings he distorted the biblical episode by imbuing it with a universally eschatological and terrifying mean-

ing. Figures and objects uniformed with the same pictorial matter take part in the event, almost always set in the open.

In this 1932 *Annunciazione* Savinio returned to tradition by placing the episode within a room with warped perspective. True to surrealist style the artist has conceived the human figures metamorphosed into animal form. The Virgin, with the face of a pelican, is seated asleep while at the open window looms the vision of the gigantic, disturbing figure of the angel bringing the holy message. The drastic meaning of the message is implied by the abnormality of the angel's face, this last inspired both by Picasso and, like many of Savinio's images of

the period, from one of the etchings by François Perrier, collected in a volume of which Savinio owned a copy. The manner in which the scene has been cut, with the angel's face close up, as well as the insertion of the large head of the angel, bear witness to the influence surrealist experimentation with film at the time had on Savinio. This fantasy interpretation of the biblical tale allowed Savinio to place sacred and mythological themes side by side, thereby offering a lay interpretation of the Annunciation as a radical change in reality.
M.M.

Filippo De Pisis
25. La grande conchiglia
(The Large Seashell), 1927
Oil on canvas, 53 x 41 cm
Turin, private collection

De Pisis had already been using the seashell motif in his still lives since 1926. In one of these, *Natura morta marina* (Marine Still Life), the very same shell as here was painted lying on the beach amidst other objects. This theme recurred again in later works, with again the same shell in *Natura morta marina con grande conchiglia* (Marine Still Life with Large Shell), painted in 1930, with the shell lying on the beach amidst crustaceans.

De Pisis lived in Paris from 1925 until 1939, where he went on featuring abandoned objects in landscapes with turbulent skies. The lively colours he used to paint his subject matter came to be known as his 'Metaphysics of things'.

In his 1933 essay *Un pittore allo specchio*, De Pisis wrote: '...maybe only I know the research and work I have had to go through to achieve what to a superficial observer seems "elementary", as some critics have condemned my work. And yet it is very easy to see that my onions, my motley assortment of very humble objects, my flowers, all breathe with a life of their own that is not alien to poetry...'

Thus the still lives of De Pisis are full of life and poetry. In this *Grande conchiglia* of 1927 the towering height of the object is indicative of the influence exerted over the artist by the surrealist environment in Paris at the time. De Pisis had conceived a 'vision' in which the marine element acquired a dreamlike quality, surpassing the height of the wing of the house on the right, the compositional anchor of the picture illuminating it with its strong pink colour that reflects the brightness of the shell's interior. The equal importance of the two elements is stressed by the shell's dark shadow, as well as by the outsized apple and lettuce leaf.

With his 'out-of-scale' use of objects, as well as through the fluid and frayed nature of the paint, De Pisis brings about a kind of epiphany of silent and surprising revelation in things.
M.M.

Surrealism

Enrico Prampolini
26. *L'automa quotidiano*
(Daily Automaton), 1930
Oil and collage on board,
100 x 80 cm
Rome, Galleria Nazionale d'Arte
Moderna, Inv. No. 5726

The painting was completed during the artist's Parisian sojourn and shown for the first time at the 1931 Rome Quadriennale, where it won first prize for painting. With the title *L'automatisme quotidien* it appeared in 1935 at the exhibition *L'art italien des XIX^e et XX^e siècles* at the Jeu de Paume in Paris. The work stands mid-way between Prampolini's futurist derived 'mechanical art' of the 1920s and the surrealist influenced 'cosmic idealism' that characterised his production in the 1930s. The futurist label protected Prampolini from being associated with Surrealism and Dada, considered degenerative movements by the regime. Prampolini had been an active member of the dadaist community from 1916 onwards, however, and contributed substantially to the spread of European avant-garde movements in Italy through magazines such as *Avanscoperta* and *Noi*. During his stay in Paris Prampolini also exhibited alongside surrealists such as Miró, Arp, Man Ray and Ernst, with whom he shared choices of rhythm, curved lines and evocative colours, as well as their ironical and every-day subject matter. Inspired by Chaplin's Charlot character, *L'automa quotidiano* is clearly surrealist in its use of the symbolism concerning the alienation of the ordinary man with regards to scientific and technological progress of the time. Throughout his career Prampolini worked with a variety of materials, combining colour with extra-pictorial elements, beginning with his futurist and cubist *papiers collés* in the 1910s and ending with his dadaist and surrealist collages in the 1950s. The 'emotional and evocative value of the matter within the spatial dynamics' is obtained here through the use of elements gathered from reality, such as the cardboard with numbers, as well as from substances used in their own physical consistency such as the sand that coats the foot of the automaton. In this case Prampolini applied the distinction he had written about in 1944 on *Arte Polimaterica*, in which he theoreticised on the difference between object-matter (fragments of reality) and organism-matter (biological or inorganic elements).
M.M.

Mario Sironi

27. *Nudo con lo specchio*
(Nude with Mirror), 1923
Oil on canvas, 96.2 x 72.5 cm
Bergamo, private collection

This female nude was painted during the artist's classical period. Its isolated, archetypal, plastic and solemn features anticipate the expressionist evolution of Sironi's style. Identified by Benzi in 1987 as one of four works presented by Sironi at the 1921 Venice Biennale, on that occasion the painting was entitled *Figura*. Along with *L'Allieva* (The Pupil), *L'Architetto* (The Architect) and *Venere* (Venus) it hung in the room featuring six twentieth century painters, a section curated by Margherita Sarfatti.
The subject epitomises the new classical majesty with which Sironi opposed the slavish imitation of the past indulged in by artists connected to the magazine *Valori Plastici*. Although backed by Sarfatti this movement certainly owed much to Sironi as well. It promoted the idea of a modern Classicism, along the lines of Picasso but with a totally independent poetical content and an innovative figurative language.
When painting the figure, in fact, Sironi avoided any reference to tradition. To avoid surrendering to verism he simplified the volumes, while by outlining the mass heavily and using dark brown colour he dodged returning to the hedonism of neo-classical sculpture. The composition is placed in a closed environment whose boundaries are marked by vertical and diagonal levels to avoid the risk of descriptive narrative.
Two preparatory drawings entitled *Studio per figura* (Study for Figure) dating from around 1923 feature the full figure set in a Renaissance-inspired environment. These drawings mark the transition from a still partly classical vision to a majestic new image whose only remnants of tradition are the mirror and drape.
M.M.

Between Primitivism and Classicism

Felice Casorati

28. *Concerto* (Concert), 1924
Oil on canvas, 152 x 151 cm
Turin, Rai Radiotelevisione
Italiana collection

Casorati presented this painting along with fourteen works including *La madre* (Mother) and *Duplice ritratto* (Double Portrait) at the 1924 Venice Biennale, where an entire room was given over to his work. This painting was part of a series of six completed between 1923 and 1924 that heralded Casorati's new style, spotted only in part by Lionello Venturi in his preface to the catalogue.

The recovery of Renaissance tradition embarked upon by the artist in 1918 fits within the widespread return to traditional values that spread across the whole of Europe in the post-war period. Casorati's personal return to tradition consisted mainly in finding a rational order for things according to the humanist principle that man can only understand the world by comparing it to himself. This way of thinking brought Casorati to create a very literally metaphysical form in which he goes beyond the actual 'physical' nature of the image. Form is the absolute protagonist of his work, while the colours are filtered and controlled by the intellectual construction of the image. As Casorati himself explained, 'I adore static shapes. Since my painting stems from within and not from fleeting "impressions" it is only natural that my figures are static as opposed to the shifting images of passion...' In the early 1920s Casorati's severe views softened somewhat, giving way to lighter tonalities livened up by a warmer light that coloured even shadows. Figures that had previously been motionless began to breathe. In *Concerto* they become, in the artist's own words 'hedonistic instruments of gaiety'. As Luigi Carluccio underlined in 1958, the real concert here is hinted at by the rhythm and collective harmony of the weightless bodies wreathed in a transparent atmosphere. '*Concerto* is a choral imagination of the female nude, a chance to define in a musically structured sequence the various positions of the object within space and, almost, within time'. More recently M. Lamberti (2000) has labelled 'too complex' the mechanism of female nudes in the gynaeceum of *Concerto*.

The painting was bought at the Biennale by Vittorio Lodigiani along with other works in the same series. It then passed into the Crippa collection of Bergamo and in 1965 to Turin's Galleria Gissi, from where two years later it entered the Rai collection in Turin.
M.M.

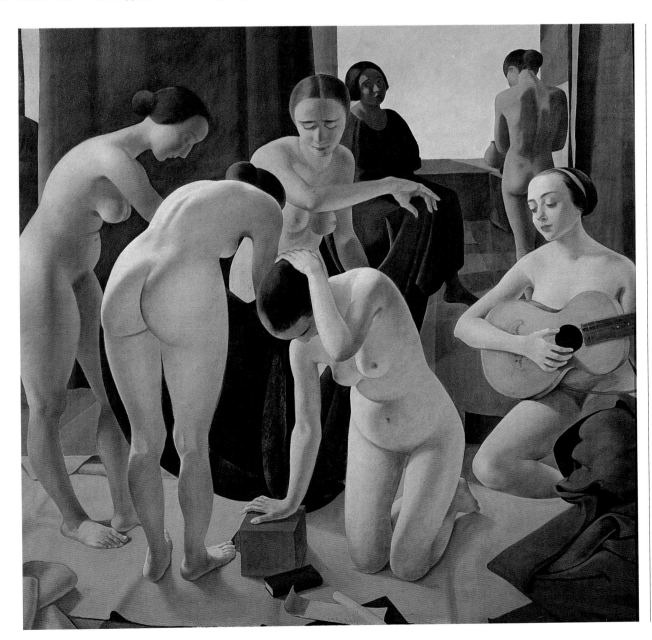

The Post-war Period and the 1920s

Arturo Martini
29. *Centometrista*
(100 Metre Runner), 1935
Bronze, 35 x 37 x 36 cm
Venice, Galleria Internazionale
d'Arte Moderna di Ca' Pesaro

This work is the bronze version of a slightly larger chalk sculpture currently the property of the Banca Popolare Vicentina in Vicenza. It is part of a group of sculptures completed during the summer of 1935 while Martini was staying with the director of the Galleria Milano, Peroni, in Blevio on lake Como. In contrast with his large-scale commissions of the period, Martini here created a series of smaller works: *Salomone* (Solomon), *Maternità della montagna* (Motherhood of the Mountain), *Ulisse* (Ulysses), *Lao-coonte* (Laocoön), *Il ratto delle Sabine* (The Rape of the Sabine Women). The subjects are all taken from the ancient world and, according to Martini, inspired by a visit to the Museo Nazionale in Naples where he came into direct contact with Greek sculpture. In this so-called 'Blevio Cycle', described by Martini himself in *Colloqui*, published posthumously in 1997 as 'a moment of grace... [the sculptures] came into themselves like blown glass', the artist explores a more intimate sphere of sculpture, rediscovering a more spontaneous movement in the human figure and experimenting with techniques that are different from those of his large decorative works.

Centometrista is therefore part of a return to classical subjects for Mar-tini, which provided him with inspiration for a new stylistic and formal phase. The athlete is portrayed during the moment of maximum concentration before the sprint forwards at the start of the race. The physical and psychological tension is rendered with great elegance, placing the figure in a kind of geometric three-dimensionality. It is the expression of the mental and physical energy of the ancient and modern worlds as well as alluding to the great importance attached to sport by the fascist regime of the time.
M.M.

Between Primitivism and Classicism

Marino Marini
30. *Donna seduta*
(Seated Woman), 1938
Bronze, 100 x 47 x 64 cm
Florence, Museo Marino Marini

Completed in 1938, this is the bronze version of a 1934 sculpture in Viterbese stone entitled *Bagnante* (Bathing Woman) that was shown at the 1934 Rome Quadriennale. Marini's female figures embody themes such as fertility, with his numerous versions of *Pomona*; relaxation, with *Dormienti* (Sleeping Women), and meditation with *Bagnanti* (Bathing Women). The figures are rendered with large, plastic curvaceous bodies evocative of the archetypal Mediterranean woman with her rounded features and archaic significance. Right from his studies Marini's self-imposed contemplation of traditional sculpture ranging from Etruscan art to ancient Greece, Egypt and even Tang terracotta finally brought him to reflect on the Romanesque. The artist was deeply impressed by his visit to Bamberg cathedral in 1934, where he saw its equestrian statues that were to provide the inspiration for one of his most important themes as from 1936.

Initially a painter and drawer, Marini took up sculpture in the 1920s with which made a significant contribution to the art of the period. A pupil of Domenico Trentacoste, Marini closely followed the European avant-garde movements of his time but preferred to distance himself from the anti-academic feelings rampant at that moment. His art in fact sought neither to establish ties with Futurism and Cubism nor did it take any definite stance in the conflict between figurative and abstraction. In his work Marini seeks a human, earthly and at the same time spiritual and emotional form of expression. This particular perception of life resulted in a limited range of subjects with isolated, decontextualised figures. Lonely and meditative as well as mysterious and saturated with inner certainties, these figures are often ennobled by mythological titles.

The *Donna seduta* bronze is part of the second donation made by the widow of the artist to Florence. It entered the collection of the Marino Marini museum in 1988.
M.M.

Mario Sironi

31. *Paesaggio urbano*
(Urban Landscape), 1920
Oil on canvas, 44 x 60 cm
Milan, Pinacoteca di Brera
(Jesi collection, reg. cron. 5102)

With the publication early in 1920 of the *Manifesto contro tutte le rivisitazioni nella pittura* (Manifesto against All Revisitations in Painting) Sironi felt the need to detach himself from futurist research and from neo-metaphysical formalism in favour of a new period which marked a return to Classicism and composed structure. He began painting urban landscapes chiefly inspired by the industrial suburbs of Milan, featuring the iconography that was to remain with Sironi for over twenty years. These include skyscrapers, bridges, cranes, building sites, cement and concrete. Humans feature only sporadically, along with slow moving lorries, trams and cars.

The artist displayed the first results of this new research at Milan's Galleria degli Ipogei in a group exhibition organised by Margherita Sarfatti. The three landscapes presented on this occasion have been certified as being *Periferia* (Suburbs, private collection, Venice), *Paesaggio urbano con camion* (Urban Landscape with Lorry, private collection, Milan) and *Paesaggio urbano* which appears to have been finished between the end of 1919 and the first few months of 1920.

In his review of the Ipogei exhibition for the magazine *Il Primato Artistico degli Italiani*, Enrico Somarè described the works so accurately that they can be identified. He wrote 'Apartment blocks, factories, industrial buildings, workers houses, scattered around or towering over the city suburbs at its fringes with countryside rattled by shrill whistles at twilight and whose sky is blackened by smoke'. Sironi certainly drew reference from the 1910 landscapes by Boccioni, such as *Officine a Porta Romana* (Industrial Sheds at Porta Romana), *Mattino* (Morning) and *Fabbrica Foltzer* (Foltzer Factory) which featured the contrast between modern industrial dynamism and the still rural appearance of the landscape. For Sironi in the 1920s modernity identifies with and is ennobled by a new classical monumentality that still resorts to some neo-metaphysical solutions. These are visible in the rarefied, almost suspended atmospheres, as well as in the vertiginous perspective at street level and in the broad areas of dense colour. Part of the Jesi collection in Milan, the painting was donated to Brera in 1976.
M.M.

Between Primitivism and Classicism

Carlo Carrà

32. *Dopo il tramonto*
(After Sunset), 1927
Oil on canvas, 49.5 x 70 cm
Rome, private collection

Dated 1927, this work was shown for the first time at the 1928 Venice Biennale and comes from a period during which Carrà was deepening his studies on the early Italian Renaissance, particularly Piero della Francesca and Paolo Uccello. According to Roberto Longhi these artists were at the base of Carrà's stylistic rigour. On 5 September 1927 Carrà published a well-known essay on Piero della Francesca in *L'Ambrosiano*, where he analysed Piero's metaphysical characteristics, attributing an ascendancy to Paolo Uccello. According to Carrà, Paolo Uccello 'had found the sublime metre of bodies within space, the perfect superimposition of volume on the invisible junctures of the planes. This harmonious research into poetry and perspective needed only to be immersed in natural light, as already done by Domenico Veneziano'. At a moment of his activity characterised by so-called 'magical realism', the example of Paolo Uccello and Piero brought Carrà back to the structuring metaphysical elements of ten years before. The painting's closest references in fact seem to be the city squares and flavour of de Chirico, although in this work the iconography is different and closer to reality. According to D. Guzzi in 1994, 'Carrà is immediate because his compositions are not inspired by dreams, or visions from memory, but by the real world. The space of the painting is broad, the simple perspective enters the canvas directly. The stark architecture is built from light and shadow while the chromatic range, running cleverly down the painting in horizontal bands, plays on a swift but natural passage from dark to light. The low, monochrome tonality used for the houses, silos and the beach in fact gives way to the lively tintas of the sky and sea, which with its intense emerald green colour marks the boundary between the two dimensions of existence, natural and supernatural'.
M.M.

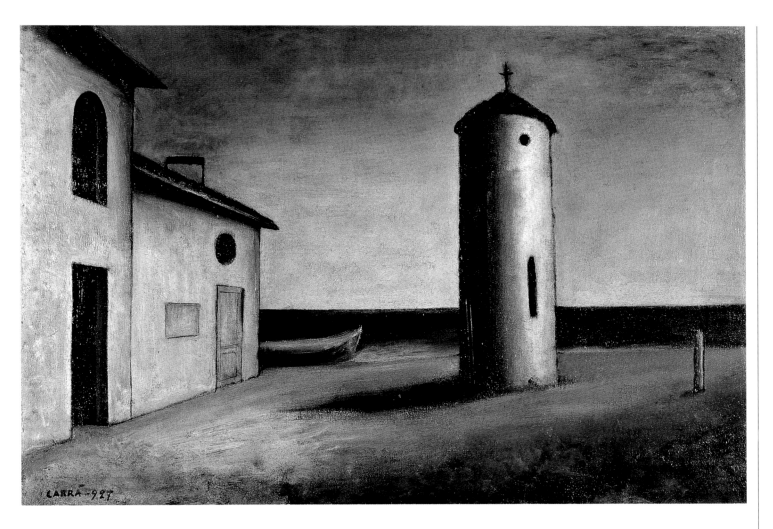

IV. From the Affirmation of the Fascist Regime to the Second World War: a Return to Order and Resistance

Throughout the 1920s and 1930s the return to figurative expression based on traditional values was the winning formula of Italian art of the period. Proof of this is the attempt to institutionalise the phenomenon in Milan in 1923 undertaken by the Novecento group of artists that included Sironi, Funi, Dudreville, Marussig, Oppi, Malerba and Bucci but which was to spread to include all other major artists of the moment.

Clearly the large number of adherents to this movement make it difficult to trace a common line, although the general trend was to depict subjects taken from nature or everyday life in a style that monumentalised the figures. Margherita Sarfatti supported the movement which, as its name implies, considered itself the most significant expression of the age. Sarfatti defined its objectives thus: 'Clarity of form and restraint in concept; nothing complicated or eccentric, with an ever increasing exclusion of the arbitrary and the obscure'. The growing fortunes of the Novecento movement are exemplified in the many exhibitions organised by Sarfatti both in Italy and abroad, starting in 1926. In 1930 an exhibition in Buenos Aires featured 46 artists, including Morandi and de Chirico.

Throughout the 1920s a more or less latent tendency to find continuity with past artistic culture, particularly that of the Trecento and Giotto, prevailed in the movement. This opposed the archaism of the 1910s, from Picasso to Modigliani, who had drawn their inspiration from classical and black art as a means to rebel against intellectualism and tradition.

Artists such as Carrà, Campigli and Casorati, however, adhered to the movement in their own original manner and, despite taking part in all its exhibitions, faced the problem of their inspirational sources differently. For Carrà contemplation of the work of Giotto was a vehicle for building a universe of images within a primitivism steeped in hope and solitude. Human figures in his paintings were to appear ever more rarely, eventually vanishing completely in favour of essential landscapes awash with an atmosphere of suspension.

Fresh from Paris where he had been one of the 'Seven Italians in Paris' (along with De Pisis, Paresce, Savinio, Severini, Tozzi and de Chirico) Massimo Campigli adopted an archaism primarily derived from contemporary French and German figurative sources such as Picasso, Léger and Schlemmer. Back in Italy the artist rediscovered Egyptian, Etruscan and Pompeian models, creating a repertoire of chiefly female figures depicted schematically according to a strict formula that resulted in austere, almost hieratic shapes. Gino Severini was also part of the Italian group in Paris but his experience in the decorative arts started in the 1920s prompted him to fathom the decorative repertoire of the ancient world, particularly Greece and Rome. He then combined the elements he had found in groups, creating paradoxical still lives made up of objects, monuments and plants.

Crisis hit the Novecento group early in the 1930s when the political regime withdrew its consensus on account of the movement's alleged xenophile tendencies. But although the linguistic connotations of the movement continued, its demise was brought on chiefly by the disputes that sprung up between the too many artists comprised within it, as well as by the broad variety of poetical languages that had composed it.

Already by the end of the 1920s disapproval against Novecento was mounting, with artists grouping together bound by the common need to escape the movement's widespread and rigid compositional formulae and open up towards experiences from abroad. It is worth noting that the reaction against Novecento was not on a politically declared anti-fascist plane. Turin for example, with its very lively cultural life in the 1920s populated by artists such as Piero Gobetti, Lionello Venturi, Edoardo Persico, Felice Casorati, as well as by the enlightened collector Riccardo Gualino, opened up to France. Artists in the Piedmontese capital followed the line between Manet and Cézanne through to the expressionism of the fauves. The 'Turin Six', composed of Chessa, Galante, Boswell, Menzio, Levi and Paulucci, were

in fact the first group to ignore the Novecento directives. But the strongest opposition against the flagging Novecento was represented by what Roberto Longhi in 1929 defined the 'Scuola Romana di Via Cavour', founded by Scipione, Mario Mafai and Antonietta Raphaël. These artists opposed the naturalism of Novecento with the strongly dramatic subject of their work, presented through a figurative language of stark expressionistic contrasts. The group leader, Scipione was able to draw on a vast knowledge of art history ranging from Raphael to the 17th century Rome School. His compositions could be termed baroque in imagery and composition, his favourite subjects being views of Rome, while his *Cardinal decano* is a magnificent example of his clerical symbology. Scipione opted for unexpected solutions, with an expressive violence akin to that of the *maudit* Parisian painters such as Soutine amidst demoniac, disquieting and allusive atmospheres.

By comparison the formal and chromatic contrasts of Mafai are less strong. A lyrical, elegiac painter, Mafai preferred to 'visit' reality with his interior views of figures and still lives in a subtly melancholic key of every-day intimacy. The highly evocative work of Antonietta Raphaël on the other hand is more openly surrealist, after her Parisian development alongside Pascin, Chagall and Soutine. The artist displayed her exceptional talent particularly in her sculptures, based on vaguely archaic formulae expressive of an intensely *chiaroscuro* vigour.

The Scuola di Via Cavour were to exert a strong influence on art in Rome in the 1930s, when political dissent against the regime was mounting. This is visible from the work of Fausto Pirandello, with his programmatically 'anti-gracious' and hallucinogenic style, to the early output of Guttuso who in his paintings from the late 1930s was already clearly inspired by Picasso's participation and denunciation of tragic events in Spain. In *Fucilazione in campagna*, inspired by the killing of the Spanish poet García Lorca, Guttuso's language had already acquired a visibly bitter tone. The artist's

political activism was channelled into the Milanese magazine *Corrente*, which included intellectuals such as Sereni, Lattuada, Cattaneo and Persico, and artists such as Giacomo Manzù. One of the most significant sculptors of the period, by this time Manzù was already creating his series of 'cardinals', 'depositions' and 'crucifixions', symbolic of a religious involvement in the degeneration of humanity. Manzù lived this as a kind of mourning, expressing it through his use of worn materials bathed in dwindling twilight.

The same existential anxiety is also visible in Giorgio Morandi, who had always lived in total solitude and whose painting had, until the early 1930s, still been anchored to a metaphysical vision of things characterised by concentration and slow work. Mid-way through the 1930s Morandi arrived at a decisive turning point, however, upsetting his highly measured compositions with violent gashes of light and a pictorial matter that barely remained anchored to form. For the artist this was a moment of transition towards a newly recovered lucidity and balance between consciousness and reality.
M.M.

Carlo Carrà

33. *Donna con cane*
(Woman with Dog), 1938
Oil on canvas, 80 x 65 cm
Rome, Galleria Nazionale d'Arte
Moderna, Inv. No. 3918

This painting was shown at the III
Rome Quadriennale in 1939 and the
Venice Biennale the following year
where it was acquired by the state
for the Galleria Nazionale d'Arte
Moderna.
The work is part of Carrà's singu-
lar 1930s artistic production, during
which he developed a more archa-
ic poetical language that aimed to
simplify and monumentalise im-
ages by placing them within a stark
context in unnaturally rigid posi-
tions. In his many essays on art his-
tory written at the time Carrà de-
clared that his cultural reference
points were 14th and 15th century
painting, and in particular Giotto.
The central position and enigmat-
ic demeanour of the woman is a re-
current theme in the artist's work,
most notably in the various ver-
sions of *La casa dell'amore* (The
House of Love), while the dog is
used frequently to symbolise the in-
timacy of the hearth.
According to Domenico Guzzi's
critical piece written for the Carlo
Carrà exhibition at Rome's Galleria
Nazionale d'Arte Moderna (1994),
the artist may have modified the
work some months after its com-
pletion. Guzzi sustains that Carrà
painted out a second figure on the
right side of the frame. The figure
is in fact clearly visible and seems
to be leaning out of a kind of win-
dow. According to Guzzi Carrà al-
so refined the general colouring of
the painting, giving it greater body.
The current version of the work was
published on the magazine *Le Arti*
in 1939, in an article on Carrà by
Giulio Carlo Argan.
M.M.

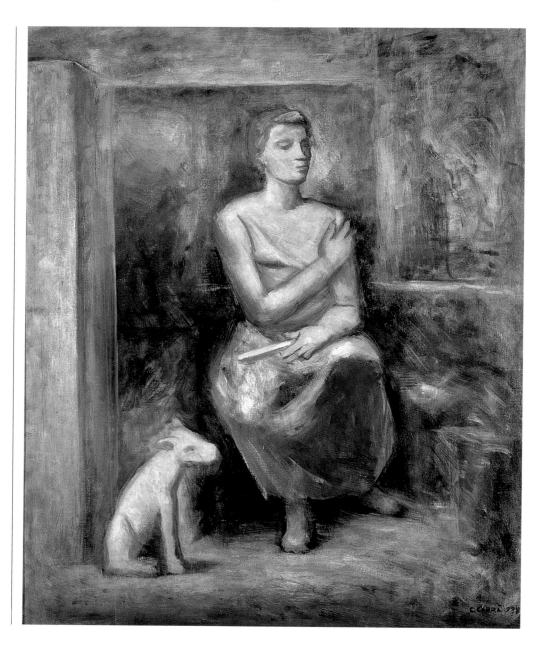

Novecento Sources: Giotto

Massimo Campigli

34. *Madre e figlia*
(Mother and Daughter), 1940
Oil on canvas, 84 x 58 cm
Rome, Galleria Nazionale d'Arte
Moderna, Inv. No. 3976

Completed in 1940 this painting was entered for the second edition of the Premio Bergamo and acquired the following year by the Galleria Nazionale d'Arte Moderna. Campigli painted the picture immediately after finishing in 1939 his decoration of the Liviano in Padua, the seat of the local university, on the idealistic theme of the builder. Campigli had in fact followed the 'muralism' of Sironi, with its primitivist cultural inheritance. Although influenced by Léger and Picasso during his Parisian sojourn, Campigli was chiefly inspired by ancient Greek, Egyptian and particularly Etruscan art, having visited Rome's Etruscan museum at Villa Giulia in 1928. The repertoire of images that derive from these re-visitations features a world of recurring women: mothers, workers, fixed and interchangeable geometric stereotypes who inhabit 'archaeological' spaces where surface and depth blend together.

The two female figures in *Madre e figlia* are placed against a background that simulates the consistency of a plastered wall through a chromatic range based on dusty grey and delicate shades. The two figures gain consistency from their strongly symbolical quality that isolates them in their archaically reminiscent frontal attitude, transforming them into archetypal, hieratic, timeless images. Of the female figures in his paintings Campigli himself wrote: 'I continue to paint my women compressed in their corsets. I make them more schematic than descriptive. Rather than be described they want to be "written", to become cyphers, marks, signs. I strive towards an impossible "definitive" form, which could signify rather than represent a woman. I have therefore sacrificed certain pleasurable details to those gestures reminiscent of the Etruscans. I limit myself to rigorous symmetry. I feel that only what is symmetrical can be definitive'.
M.M.

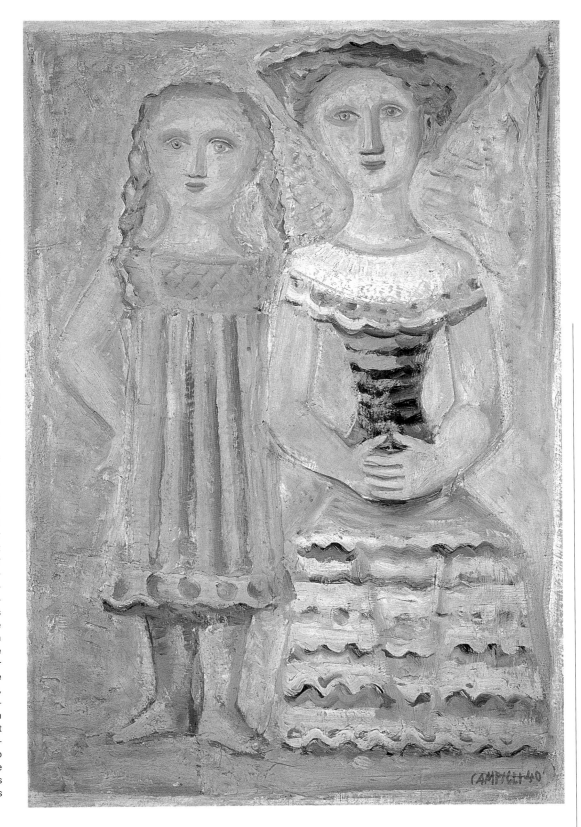

Gino Severini

35. *Gruppo di cose*
(Group of Things), 1930
Oil on cardboard, 63 x 90 cm
Rome, Galleria Nazionale d'Arte
Moderna, Inv. No. 3090

The work first appeared at the first edition of the Rome Quadriennale in 1931 under the title *Gruppo di cose vicine e lontane* (Group of Things Close and Far). Later it was published in a monograph by Pierre Courthion in 1946 with the title *Cose presenti e lontane*. From 1973 onwards it was always published and exhibited under the abbreviated title *Gruppo di cose*. Part of a series of still lives completed by the artist after his stay in Rome in 1929, the painting presents in the foreground an assemblage of objects typically from the still life 'genre': a lute, a tragic mask, a fruit basket, a shell. These are the 'near' or 'present' things, while in the background Roman monuments reduced to simple architectural elements constitute the 'distant' things. The tight composition nonetheless underlines a kind of dreamlike re-evocation of the subject matter. Severini's long stay in Paris had brought him close to the Cubism of Braque and Juan Gris first and later to the purism of Ozenfant, from whom he derived the rational order and essential nature of his compositions. As from the end of the 1920s the artist found further inspiration in the decorative repertoire of antiquity.

The painting's iconography is also common to a number of works in which Severini assembled objects in a decorative scheme he would later use in his large mural paintings. Since the 1920s in fact the artist had taken up mural decoration both in Switzerland and in Italy. This was accompanied by a series of critical reflections on the absolute need to re-establish a union between arts and crafts, with both relating to their architectural context. In the 1930s Severini actively took part in Sironi's mural painting movement. Sironi himself called him to carry out a large mosaic for the main room of the V Milan Triennale in 1933, with 'The Arts' as its theme.
M.M.

Novecento Sources: Classicism

Arturo Martini

36. *Atena* (Athena), 1934
Bronze, 125 x 56 x 38 cm
Rome, Galleria Nazionale d'Arte
Moderna, Inv. No. 5664

This is the only cast bronze bozzetto of the 5 metre-high statue of Athena placed in the rector's square of the University of Rome in 1935. The work was commissioned by Marcello Piacentini, who designed the entire university campus, and who was its first owner. The sculpture represents Athena Promachos, from the Greek meaning 'favourable in battle', custodian and protector of the city. The goddess is shown holding a spear and equipped with a shield, scaled aegis and a snake coiled around her arm. Unlike the definitive sculpture, cast at the beginning of 1935, the study has a fan-shaped head dress instead of the winged and open mouthed dragon helmet that appears on the final version. The work is obviously inspired by the ancient *Charioter* statue in Delphi, while its fine artistic quality makes it a good example of a celebratory fascist regime sculpture. Despite this, contemporary critics were sharply divided into lively enthusiasts, such as Piacentini and Oppo, and vigorous detractors such as Pacini.

Of the sculpture Martini himself said: 'With her helmet, shield and spear my Athena has a triple symbolical value'. Referring to the unusual raised arms position, Martini said 'Athena is beautiful but accursed. With the passion in the pose of the *Charioter* in Delphi I have raised her arms in defence. She is our Athena at arms, and the war has begun' (Scarpa 1968, pp. 162, 232). This could be a historical reference to Italy's involvement in the Spanish Civil War.

There is also another 50 cm high preparatory version of the work in plaster (Perocco 1966, Fig. 266).
M.M.

Renato Di Bosso
37. *Milite della Rivoluzione fascista* (Soldier of the Fascist Revolution), 1934–35
Coated plaster imitating wood and bronze, 179 x 90 cm
Rome, Galleria Nazionale d'Arte Moderna, Inv. No. 3356

Presented at the 1935 Rome Quadriennale, the work was probably completed between 1934 and 1935. It is part of Di Bosso's experience in futurist 'aero-sculpture', started around 1930. Given the celebratory nature of the subject matter the monumental aspiration is sustained by a will for synthesis that concentrates the volume on the central axis while thickly spreading the polished plates in a compact formation. Di Bosso provides a synthesis of the soldier's marching movement towards the right, with just a hint of the head and arm holding his rifle.
In the 1930s it was common practise to experiment with unconventional materials in sculpture, such as spray-on bronze effect patina over plaster, as declared in the *Manifesto della plastica murale futurista*, to which Di Bosso subscribed.
There is also a preparatory version of the work in wood, measuring 39 by 13 cm and entitled *Balilla* (*Di Bosso Futurista*, 1988, No. 71).
M.M.

Enrico Prampolini
38. *Dinamica dell'azione*
(Action Dynamic), 1939
Tempera on wood, 156 x 225 cm
Rome, Galleria Nazionale d'Arte
Moderna, Inv. No. 3756

The work featured in the Prampolini room of the III Rome Quadriennale in 1939, within the exhibition entitled *Mostra futurista di aeropittori e aeroscultori* organised by Filippo Tommaso Marinetti. On that occasion it appears the work was bought by the Italian Prime Minister Benito Mussolini, who subsequently donated it to the Galleria Nazionale d'Arte Moderna. For reasons of political decency the painting was not exhibited until after the reorganisation of the gallery in 1998. The catalogue of the Quadri-

ennale (1939, p. 89, No. 4) lists the work in the subsection entitled *Myths of Action*. Along with other works featured it is representative of the artist's special place in the so-called 'second' Futurism. Prampolini at the time was going through his 'cosmic idealism' phase, fired by his need to open up to the suggestions of fantasy that had much in common with Surrealism in Europe. The artist felt the need to create a new range of images to convey the creative and imaginative conquest of cosmic space. The result is a kind of fantastical painting that combines desire for adventure, fascination with the unknown, as well as an aspiration towards a metaphysical and meta-psychical dimension.
Prampolini summed up his new po-

sition in *L'Impero* (Rome, 8 July 1932) thus: 'Plastic dynamism has developed into physical transcendentalism from this vision of a work of art conceived as the centripetal and centrifugal result of the forces of the universe, as well as from the plastic synthesis of values of unique shapes within the continuity of space. (This was epitomised by Boccioni in one of his typical and important sculptures). Thus futurist plastic abstraction is focused on a new phase of spiritual orientation'. In a monograph on the artist by F. Menna (1967, p. 243, No. 166, Fig. 229), the painting appears under the title *Miti dell'azione, Mussolini a cavallo* (Myths of Action, Mussolini on Horseback) and is highlighted as combining three of the principles that would later be in-

cluded in the 1929 *Manifesto dell'aeropittura futurista*. These were 'expansion of form and strength' within space, 'simultaneity of time and space' and 'perspective poli-dimensionality '.
M.M.

Giorgio Morandi
39. *Natura morta* (Still Life), 1936
Oil on canvas, 51 x 62.5 cm
Trent, Museo d'Arte Moderna
(Giovanardi collection)

In the 1930s the work of Morandi underwent a moment of strong tension highlighted by an expressive upheaval of form. The paint was applied in flakes, with rapid brush strokes, while the tonality became often brighter and outlines more vague. Although the artist managed to keep compositional control over the objects in the painting, he carried out what Brandi has termed 'a dissolving attack on the object', through a lateral illumination that sweeps over the subject so violently that it renders everything apparently precarious. Actually this effect has an obvious significance that goes beyond form itself.

Over ten objects ranging from bottles to boxes, jugs and vases populate the composition of this work. Light, which enters the painting from the left, collides strongly into a vase and jug placed on a raised level. These act as the 'front line' defence for the entire order of the painting, be it mental, the need for balance and the borderline with anxiety. Some of these objects such as the jug and the narrow-necked vase with a flared opening also feature in other still lives from the early 1930s. Although a contained atmosphere still pervades these works, the extended shapes are prelude to a form of turmoil.

In 1990 M. Pasquali stressed how the painting of Morandi in those years seemed undergo a kind of 'alchemical treatment' imposed by the artist on the texture with the idea of bringing the very essence of things to the fore. From 1937 onwards the tension from the previous years loosened and Morandi attained the compositional harmony and chromatic clarity, a sort of positive vitality, that would distinguish his later works.
M.M.

Expressionist Resistance to the Regime

Giorgio Morandi

40. *Paese* (Village), 1936
Oil on canvas, 53.5 x 63 cm
Rome, Galleria Nazionale d'Arte
Moderna, Inv. No. 3713

Morandi undoubtedly painted this picture in 1936 since it appears with this date both in the catalogue of the III Rome Quadriennale, where it was exhibited in 1939 (and acquired by the Galleria Nazionale d'Arte Moderna), and in the general catalogue of the artist's paintings drawn up by L. Vitali. After a period of formal and chromatic tension that had brought the artist towards a deformation of the image, in 1935 Morandi embarked on a phase of prolific activity in which he resumed landscape painting.

The solid nature of this composition coupled with a rigorous balance between form and colour are indicative of the artist's desire to transcend the natural effects of the image itself and achieve an intellectually pure vision of memory.
Landscape had featured in the artist's production from the start in 1910. After the appearance of the still life genre in 1913 and which was to be Morandi's prime lifetime subject, the landscape periodically came to the fore. In fact the artist dedicated himself mainly to landscape in the 1930s and during the war between 1940 and 1945. He chiefly painted the village of Grizzana, near Bologna, where his family had their summer house and where they took refuge during the war. It is worth noting how the vision of nature as a human experience of time recurs frequently in the artist's last period.
M.M.

From the Affirmation of the Fascist Regime to the Second World War

Scipione (Gino Bonichi)

41. *Il cardinal decano*
(The Cardinal Dean), 1930
Oil on wood, 133.7 x 117.3 cm
Rome, Galleria Comunale d'Arte
Moderna

The work represents Cardinal Vannutelli, an acquaintance of the artist and dean of Rome's cardinals and bishops. After a number of many preparatory drawings and two sketches Scipione completed the portrait between 1929 and 1930, a period in which his productivity was at its height. By 1931 the artist had contracted a serious illness that effectively brought his painting career to a close. Head of the Via Cavour School, which he founded along with his friends Mario Mafai and Antonietta Ra-

phaël, Scipione was one of the most significant personalities on the Italian art scene between the two wars. He developed his style from extensive study of art in the museums of Rome and never tired of searching for new inspiration, particularly in the mannerist and baroque traditions from Tintoretto to Rembrandt, as well as the romanticism of Goya and the visionary spirit of El Greco.

Scipione left an indelible mark on Rome's artistic and cultural scene thanks to his ability to combine visionary or surreal elements with an original form of lyrical expressionism made up of dream-like interpretations of his own fantasies, often obsessive and premonitory of an imminent end. The paint acquires a liquid, reddish and pitch-

like flavour, giving the image a great fascination.

Scipione certainly had illustrious predecessors in mind when he decided to paint Cardinal Vannutelli, known for his diplomacy and lively nature. Titian's *Paul III* and Velázquez's *Innocent X* are two examples that spring to mind, along with 17th- and 18th-century Spanish painting in general, which considerably influenced the artist in this last period.

The painting was exhibited posthumously at the 1935 Rome Quadriennale, which featured a retrospective show dedicated to Scipione.
M.M.

Expressionist Resistance to the Regime

Antonietta Raphaël

42. Le tre sorelle
(The Three Sisters), 1936
Painted cement mortar imitating
terracotta, 95 x 60 x 55 cm
Rome, Galleria Nazionale
d'Arte Moderna, Inv. No. 6318

Midway through the 1930s Raphaël
dedicated herself to sculpture, of
which this work is her debut. It was
presented in 1937 at the VII Mostra
Sindacale Romana.
Although clearly influenced by the
French expressionism of Soutine,
whom she encountered early in her
career in Paris, and strongly at-
tracted by the plasticity of Lipchitz,
the artist displays an obvious align-
ment with the expressionist realism
of the Rome School led by Scipione.
Although the artistic result is styl-
istically close to the work of other
sculptors of the same circle such as
Pericle Fazzini and Mirko Basaldel-
la, Raphaël's sculpture surpasses
both theirs and her own painting
production.
The three girls represented are the
daughters of Raphaël and Mario
Mafai. The figures are joined to-
gether almost in a single, large
body, only visible in its three-quar-
ter length. This joining of the bod-
ies suggests that the artist wished
to combine the optical and emo-
tional vision of the image. The tech-
nique is one of the most common-
ly used by artists in the 1930s, who
tended to experiment with alterna-
tive materials given the absence or
high cost of traditional ones such as
marble and stone. This material al-
lowed the artist to create a piece
with movement, vibrancy and a
pasty quality. The earth finish in im-
itation of terracotta highlights these
qualities and was very popular
with artists of the period on account
of its Etruscan allusions.
M.M.

From the Affirmation of the Fascist Regime to the Second World War

Mario Mafai

43. *Nudo sdraiato*
(Reclining Nude), 1933
Oil on plywood, 95.5 x 144.5 cm
Rome, Galleria Nazionale d'Arte
Moderna, Inv. No. 4410

Mafai was the most lyrical exponent of the Scuola Romana di Via Cavour, as Longhi in 1929 termed the most powerfully expressive anti-Novecento movement. He was in fact removed from the intellectual deformation practised by Scipione and closer to 'reality', to the inner nature of things.

Along with *Donne che stendono i panni* (Women Hanging out the Washing) of which it features the same human typology, the painting was completed while Mafai was staying alone at the Roman hotel Salus. It was first exhibited at the second edition of the Rome Quadriennale in 1935, under the title *Nudo in riposo* (Resting Nude), where it at last earned the artist the attention of the critics. They praised the artistic maturity of the work, along with its luminosity that tends to destroy form and contours, as well as the pictorial substance that imprisons the light to then 'release' it as volume and atmosphere.

Mafai had already been twice to Paris with Antonietta Raphaël in 1930 and 1931, where he had been able to admire French 19th-century painting from Corot to Renoir, Cézanne, Utrillo and Ensor. This experience had allowed him to overcome the strong influence exerted by the expressive power of Scipione's chromatic range, in favour of a softer contrast between the colours on his palette. Mafai's language grew more melancholic while his composition, always rigorously inspired by every-day life, acquired a new intimate quality. Both in his still lives and in the figures he captured in simple positions, Mafai underlined a sense of inevitable decay and wear. Contrary to Scipione, this did not symbolise death but rather an acknowledgement of the calm unravelling of existence, both on an animate and inanimate level.
M.M.

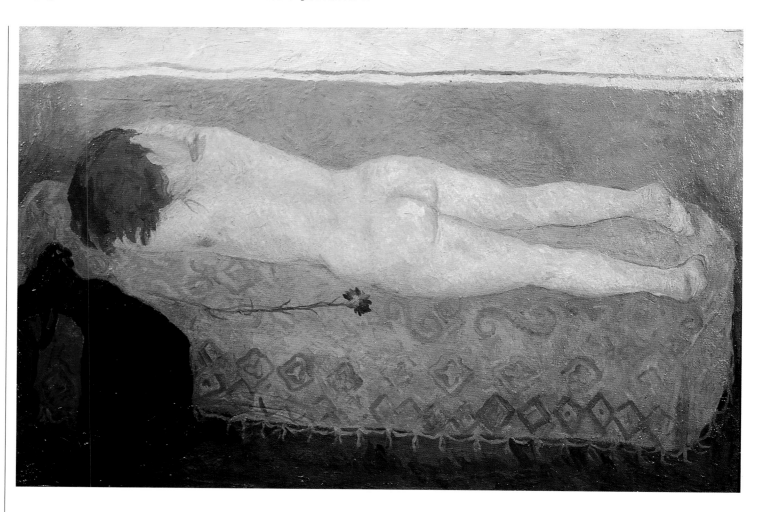

Expressionist Resistance to the Regime

Fausto Pirandello
44. *Pioggia d'oro*
(The Shower of Gold), 1933
Oil on plywood, 100.5 x 130 cm
Rome, Galleria Nazionale d'Arte
Moderna, Inv. No. 9017

Although a variety of sources date this painting either at 1934 or 1935, it was in fact exhibited for the first time in 1933 at the Galleria Milano. Along with sixteen other works it hung in Pirandello's own room at the II Rome Quadriennale in 1935, where it won third prize for painting. *Pioggia d'oro* was therefore completed in the period after Pirandello's return from Paris in 1931, where he had come into direct contact with the work of Cézanne, Picasso, Derain and Matisse. According to Appella and Giuffrè (1990, p.

24), the work could have been inspired by *Danae*, painted by the German artist Max Slevogt in 1895 and exhibited in Italy in 1923, since Pirandello's work uses many of the same iconography. His other work of the same period features large and complex compositions of a disturbing expressiveness, such as *La scala* (The Stair), *Testa di bambola* (Doll's Head), and *Il bagno* (The Bath). An ambiguous and illogical atmosphere underlies all these paintings, which display a kind of time lag between the real and the psychological dimension. In fact, although the figures go about their daily routine they are caught in moments of alienation from reality. The ambiguous nature of the painting is highlighted foremost by its title, a favourite Renaissance subject de-

picting the fertilisation of Danae by Jupiter.
The mythological episode, used to underline beauty and prosperity, finds its modern parallel in a humble interior populated by objects clumsily piled on a table. A naked woman lies with the same carelessness to the left of the painting within a foreshortened perspective intended to underline her abandonment in sleep. The thick, pasty paint used seems caked in places and gives the objects a formally concrete nature, although the spatial integrity of the painting does tend to disintegrate.
M.M.

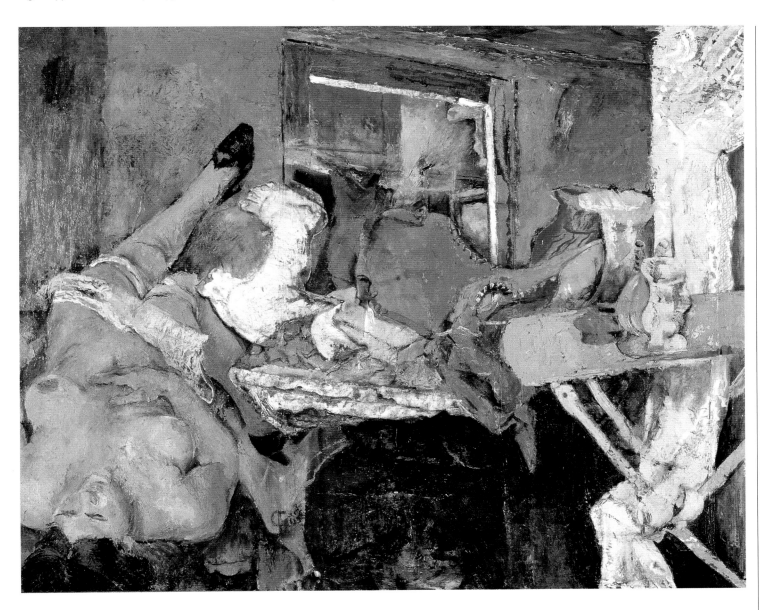

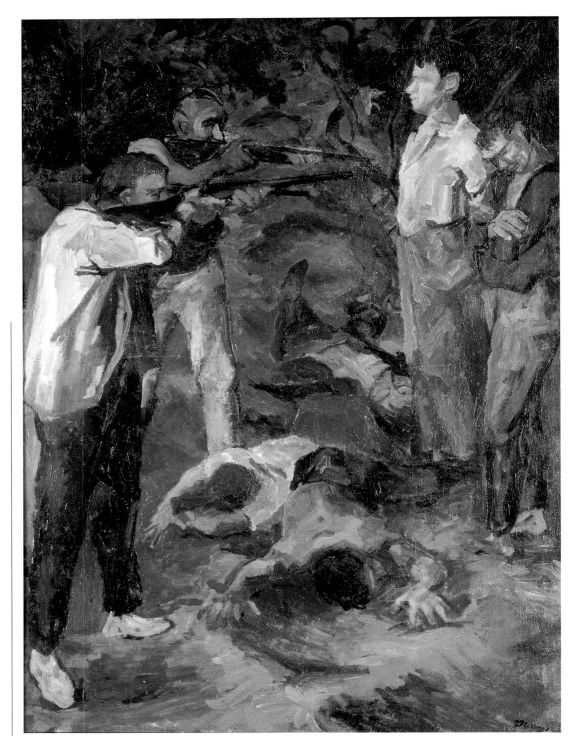

Renato Guttuso
45. *Fucilazione in campagna*
(Firing Squad in the Country),
1939
Oil on canvas, 108 x 84.5 cm
Rome, Galleria Nazionale
d'Arte Moderna, Inv. No. 3741

Dated 1939, the painting was
shown at the Galleria di Roma in
1940 where it was presented as a
'study', possibly because the artist
intended to develop the historical
and cultural aspects of the subject
further. Guttuso depicts the execu-
tion of the Spanish poet Federico
García Lorca during the Spanish
Civil War, and at the same time us-
ing the imagery of the Spanish
painter Francisco Goya's *Los Fusil-
amientos del Tres de Majo* (1808).
In a climate of war the artist man-
ages to condense human and po-
litical tension into a highly dramatic
scene that is also anti-rhetorical. He
evokes the story and depicts it nat-
urally but with an undeniable lyri-
cism.
In an article entitled 'Necessità del-
la naturalezza' published on *L'Ap-
pello* (Palermo 1937), Guttuso
wrote openly in defiance of those
who called for artists to adopt a
kind of 'peaceful, reactionary living'.
'Luckily', declared Guttuso 'not all
of us have arrived at our moral
death and there are still people who
believe in the need to do battle on
all fronts, firm in their beliefs of
modern humanity and convinced of
the truth which they uphold'.
Guttuso conveys the powerful emo-
tional tension of his message
through a restricted chromatic
range of browns and reds, that
combine with the colours of earth
and blood in a single, powerfully
expressive charge.
The work was bought by the Gal-
leria Nazionale d'Arte Moderna in
1940 after it was first exhibited to
the public.
M.M.

Expressionist Resistance to the Regime

Giacomo Manzù
46. *La grande Pietà*
(The Large Pietà), 1943
Bronze, 76 x 115.5 x 59 cm
Rome, Galleria Nazionale
d'Arte Moderna, Inv. No. 5018

In representing contemporary drama through a religious theme, a means adopted by many artists during the Second World War to denounce its horrors, Manzù was the artist who best managed to capture and retain the pathos of the subject.

The work presented here is one of two preparatory versions for the tomb of the Ratti Pope Pius XI (1922–39) commissioned between 1942 and 1943 by Pope Pius XII but which was never completed. Consequently the two bronzes,

which differ from one another in that the figures of the praying deans are inverted, are part of the artist's prolific series of religious sculptures and reliefs that represented his artistic output from the end of the war onwards. Both works entered the collection of the industrialist Riccardo Gualino, who in 1958 donated the version presented here to the Galleria Nazionale d'Arte Moderna. *La grande Pietà* was in fact presented for the first time in 1947 at the exhibition featuring the latest works of Manzù introduced by Lionello Venturi at Milan's Palazzo Reale.

As the theme is tied to the various 'cardinal' and 'crucifixion' series of sculptures and drawings, so the imagery is comparable to that of the 'deposition' bas-reliefs.

A previous *Pietà* from 1933 in silver covered copper does exist, while Manzù made a subsequent version of the same subject in 1953.

A series of drawings and etchings document the various stages of study for the subject: *Jesu dulcis memoria I* and *II*, *Te lucis ante terminum*, *Cardinale orante* (Praying Cardinal) and *Cardinale* (Cardinal).
M.M.

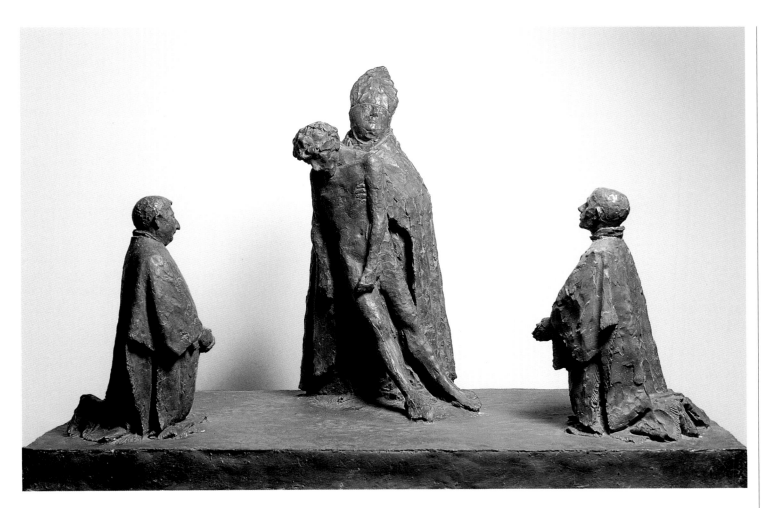

From the Affirmation of the Fascist Regime to the Second World War

V. The Second Post-war Period.
Italy Re-opens its Frontiers

Immediately after the war Italian art heightened its experience with political activism and interest already embarked upon by intellectuals, painters and sculptors during the conflict. A heated debate sprung up among new magazines, new galleries and newly formed groups centred primarily on the question of 'Realism', as this new movement was labelled in the *Manifesto del Realismo. Oltre Guérnica* (Realist Manifesto. Beyond Guérnica), published in the magazine *Numero*. With its total lack of experimentation, Realism was considered by many to be the artistic language most capable of clearly denouncing dramatic contemporary events and inducing thought on the problems afflicting society. The need to develop a modern figurative approach found voice within the movement, which referred constantly to the Picassian language of *Guérnica* in particular, as well as combining the experiences of Cubism, Expressionism, neo-Impressionism, the Roman School and the magazine *Corrente*.

With the publication in 1946 by Birolli of the manifesto *Fronte nuovo delle Arti* (New Arts Front), an effort was made to group these new progressive tendencies together under a common banner, the combative nature of which was implied by the use of the word *fronte*. A number of artists took part, including Guttuso, Morlotti, Turcato, Santomaso, Vedova, Pizzinato, Cassinari, Levi, Leoncillo and Viani. All these exhibited for the first time in 1947 in Milan and a year later on the international scene at the Venice Biennale, where they had the backing of Giuseppe Marchiori.

The group was not compact, however, particularly after the defeat of the Left in 1948, which resulted in ideological incompatibilities and different stylistic positions, all fired by the need to break with any form of conditioning from the past.

Realism was opposed from the start by Formalism, which sought to continue the experiences of the artistic avant-garde in the first half of the century, particularly those of Abstraction that had distanced itself from reality more than ever.

In 1947 the Roman Forma 1 group was born within the so-called 'Abstract art' movement. It included Perilli, Consagra, Dorazio and Accardi. The following year in Milan saw the founding of the Movimento Arte Concreta (MAC), which was influenced by Russian Constructivism and included artists such as Soldati, Dorfles, Munari and Monnet. Both these movements indicate clearly that Italy was re-opening its cultural boundaries towards contemporary artistic research from abroad, both in Europe and in the United States.

The first national exhibition of contemporary art in 1948 in Bologna featured works strictly in realist style. Notwithstanding this, the show was bitterly condemned by the Italian Communist Party, that deemed the style too inaccessible to the masses and wished to limit the creative freedom of artists in Italy by instilling in them a defined sense of social responsibility. Some artists tried to remain faithful to the party line, such as Renato Guttuso, with his enormous communicative strength, denouncement and political awareness. The realism of *La spiaggia* (The Beach), shown at the 1956 Venice Biennale may be of a less politically active nature but on the other hand is formally more sophisticated.

Deeming the situation unacceptable, other artists chose different paths. This was the case with Giulio Turcato, who from his cubo-expressionist stance directed himself towards Formalism nonetheless maintaining his social themes and continued political activism. *Comizio* (Rally) was one of the three works he exhibited at the 1950 Venice Biennale.

The 25th Venice Biennale presented a large number of dossiers on the avant-garde movements in the first half of the century, ranging from the fauves to the cubists, *Blaureiter* and Kandinsky. Realism also featured prominently, including the Mexican realists Siqueiros, Rivera and Orozco, with works that highlighted this period as being creatively very fertile. Armando Pizzinato's *Un fantasma percorre l'Europa* (A Ghost Travels Europe) was both a tribute to the Communist Party manifesto and to the manifesto of the realist

movement, with its references to Picasso, its modern figurativism that bore in mind the language of Cubism and was totally alien to any form of return to verism.

The same Biennale featured Guttuso's *Occupazione delle terre incolte in Sicilia* (Occupation of the Unfarmed Lands in Sicily), three canvases by Giuseppe Zigaina all depicting Friuli labourers, and Gabriele Mucchi with a work that depicted workers resisting police in front of a factory. The strong political message in all these works provoked widespread critical debate.

Mid-way through the century, Italy's artistic environment was still increasingly preoccupied with the struggle between abstract and figurative, notwithstanding the declaration made by Lionello Venturi at the 1952 Venice Biennale when he presented the Gruppo degli Otto (Group of Eight) artists: Birolli, Corpora, Turcato, Vedova, Afro, Moreni, Santomaso and Morlotti. Venturi claimed the only option was to 'surpass form', since in abstraction 'creative spontaneity' is abolished while in the figurative there is a risk of a 'renewed mannerism'.

One of the main players on the Italian art scene of the 1950s was Osvaldo Licini, an exponent of Italian Abstraction who received widespread acclaim at the 1950 Venice Biennale and was later to win the international critics prize at the 1958 Biennale. Although his painting is clearly inspired by Surrealism and follows Abstraction, it stands impartially above both. In the same way, Alberto Magnelli remained outside contemporary debate on figurativism, immersed in isolated meditation on the expressive possibilities of pure painting throughout the 1950s.
M.M.

Osvaldo Licini

47. *Amalassunta n. 2*, 1950
Oil on canvas, 81 x 105 cm
Rome, Galleria Nazionale
d'Arte Moderna, Inv. No. 4606

By the time Licini painted this picture he had already absorbed the surrealist theories of Breton which he had encountered soon after the war. The work was shown at the 1950 Venice Biennale, along with a further eight paintings of the same title. The critical acclaim enjoyed by Licini on this occasion was due to the general pro-abstract feeling in direct antagonism with neo-Realism at this edition of the Biennale, at which the Italian state bought the work for the Galleria Nazionale d'Arte Moderna.

Licini completed his first *Amalas-sunta* paintings in the 1940s: *Amalassunta con aureola rossa* (Amalassunta with Red Halo) and *Amalassunta luna* (Amalassunta Moon), one canvas and one panel that can be considered the prototypes of the series.

In a letter to his friend and critic Giorgio Marchiori written in April 1950, the artist explains the meaning of the subject thus: 'If I weren't around and someone curious were to ask you about her... as to who this Amalassunta that no one has really heard much of is. You must answer without hesitation in my name, smiling, that Amalassunta is our beautiful silver moon, guaranteed for eternity. Personified in a few words, she is the friend of every tired heart'. Amalassunta is therefore a lunar symbol.

On a red background the artist has arranged three dream-like forms, half hand and half foot, symbolising the duality of earth and sky. The sky is expressed through an infinite space, red here but blue or yellow in other versions. The earth is conveyed with barely traced undulating lines in the background. At the centre of the first hand there is a heart, an image that also appears in *Racconti di Bruto* written by Licini in 1913, while an eye is inside the second. This image from fantasy sums up the union between what is 'high' and what is 'low' — between the purity of emotion and the impurity of the reality the eye perceives.

A drawing also exists entitled *Amalassunta n. 2* in pencil on both sides of the paper (*Osvaldo Licini*, 1988, p. 190, no. 94). In it the hand and foot elements are enriched by profiles, one bearing the number 2 and the other 66. The second drawing is in fact entitled *Amalassunta 66* (no. 95 of the mentioned catalogue).

M.M.

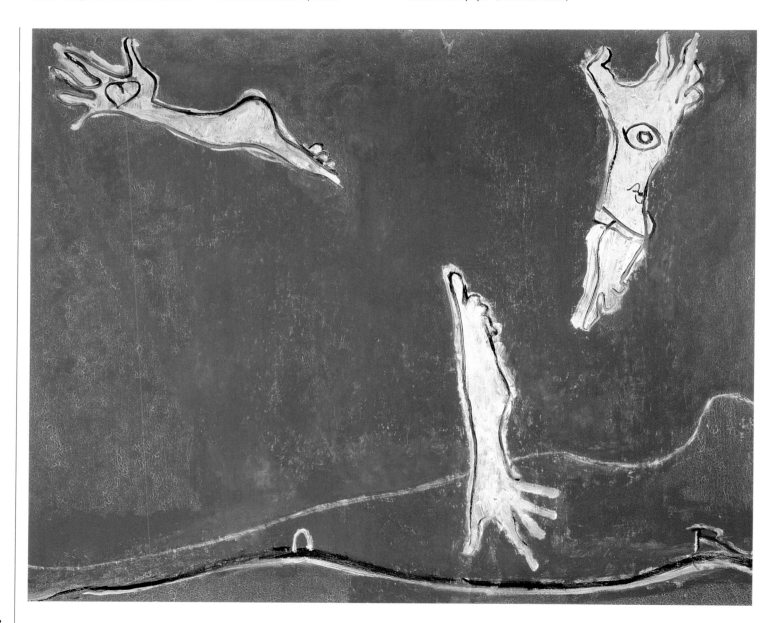

The Debate between Figurativism and Abstraction

Alberto Magnelli

48. *Conversazione a due n. 1*
(Two Way Conversation No. 1),
1956
Oil on canvas, 130 x 62 cm
Rome, Galleria Nazionale
d'Arte Moderna, Inv. No. 5213

Probably completed during Magnelli's stay at La Ferrage, le Plan de Grasse, the work was awarded the Guggenheim National Section Award for Italy in 1958 and was exhibited for one year at the Solomon Guggenheim Museum in New York. The same year Magnelli's most important critic Murilo Mendes held a conference at the Galleria Nazionale d'Arte Moderna in Rome, invited by Palma Bucarelli. *Conversazione a due n. 1* was featured in 1963 at Magnelli's impor-

tant anthology exhibition held at Palazzo Strozzi in Florence, which can be considered the artist's first public acknowledgement in Italy. In 1968 the work was exhibited at the Galleria Martano Due in Turin. That same year it was bought directly from Magnelli and became part of the collection of the Galleria Nazionale d'Arte Moderna.
The painting is made up of arched, white and flat shapes inserted with blue, arranged on a black and grey background and clearly outlined by a ochre coloured band.
Similar images appear in other works of the same period, such as *Tentazione misurata* (Measured Temptation, 1956), *Répercussions* (Consequences, 1957) and *Masse pesante* (Heavy Mass, 1958). Here too the arched shapes face one an-

other in a measured equilibrium of opposite, overlapping and mutually neutralising forces.
In his 1964 *Salvezza e caduta dell'arte moderna* Giulio Carlo Argan described Magnelli's style thus: 'The compositional order stems from an asymmetrical pendular compensation in the size and outline of the coloured areas, as well as from the excursions of graphic rhythm, the luminous quantity of opaque tonalities. Although pure in itself, each tone is the proportional medium between two opposites'.
M.M.

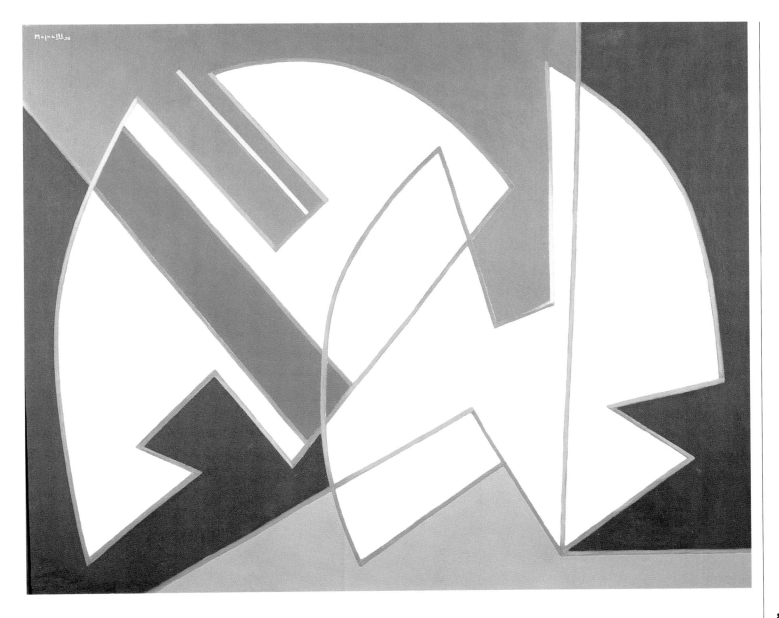

The Second Post-war Period

Armando Pizzinato

49. *Un fantasma percorre l'Europa* (A Ghost Travels Europe), 1949–50
Tempera and oil on canvas,
260 x 300 cm
Venice, Galleria Internazionale d'Arte Moderna di Ca' Pesaro

Pizzinato exhibited this painting, inspired by a poem by Rafael Alberti (in turn taken from the opening phrase of the Communist Party manifesto), at the 1950 Venice Biennale along with two paintings half its size: *I difensori delle fabbriche* (The Defenders of Factories) and *Terra non guerra* (Land, not War). Together they form a sort of triptych on the theme of labour and political activism. Immediately after the war the social conscience of

Pizzinato in support of the struggle of peasants and workers in post-war Italy was at first strictly derived from Picasso and then turned towards Realism. In 1947 he actively took part in the Fronte nuovo delle Arti, which embraced all the main exponents of post-war Italian art from realists to abstractionists. Although the Fronte had presented itself successfully at the 1948 Venice Biennale it split immediately afterwards, resulting in a clear dichotomy between abstract and realistic parties. The 1950 Biennale marked a moment of great importance for realism, with the participation of artists such as Guttuso, Zigaina, Mucchi and Mafai, and provoked fierce political and critical debate. Pizzinato commented his choices of the period thus: 'In 1950 I thought

I was being realist by accentuating the social content with a degree of aggression and an epic sense for great actions. I concentrated more on man in general, removing him figuratively from what remained in me of a futurist, cubist and expressionist nature. My aim was to break free from dated historical formulae such as Impressionism, Cubism, Futurism, Expressionism, Abstraction, to abandon the myths of European culture I deemed no longer necessary...'
Fantasma, which has something even of the lyrical invention of Chagall and La Fresnaye, still contains influences from Picasso's *Guernica*. The reality of workers is analytically described with a strongly cubist framework, well thought out in the horizontal lines of the mule to the

left, in the scaffolding to the right and in the vertical lines of the flags and peasants hoes at the centre. Crossing the picture diagonally from the left the 'ghost' raises a clenched fist, pulling the large communist banner.
M.M.

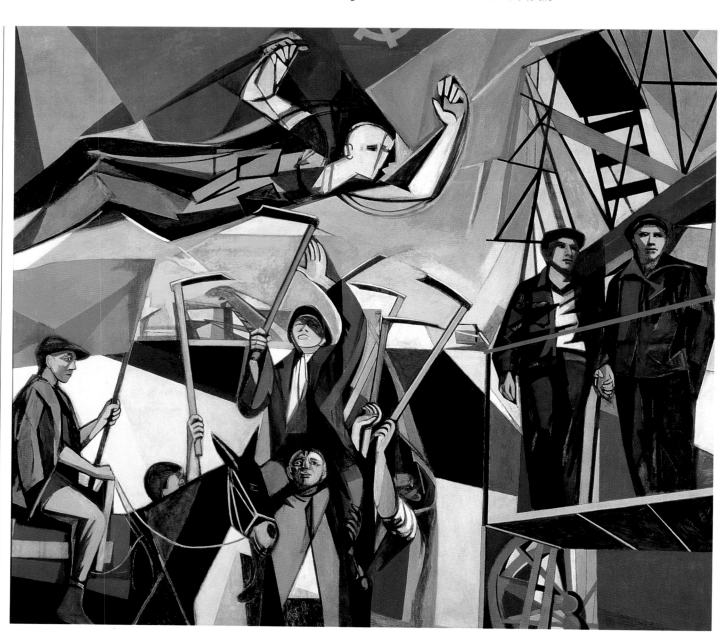

The Debate between Figurativism and Abstraction

Renato Guttuso

50. *La spiaggia* (The Beach), 1956
Oil on canvas, 301 x 452 cm
Parma, Palazzo della Pilotta

Guttuso began this painting in 1954 and continued to work on it throughout 1955. In over twenty drawings, preparatory oils and tempera sketches on paper he either worked on details or on the general views to study both the compositional equilibrium and the desired effect of a large period fresco. Here the artist has supplanted his habitually populist realism with a style aimed at conveying the condition of collective living. The crowd is bound together by scanty clothing, the summer heat and a generalised desire to enjoy the sea and the sun. In his preface to Guttuso's New York catalogue, where the painting was shown in 1958, Roberto Longhi identified Seurat's *Grande Jatte* as the illustrious forerunner of this work. Having shown his political commitment in large, historically inspired paintings such as *Fuga dall'Etna* (Flight from Etna, 1939), *Occupazione delle terre incolte in Sicilia* (Occupation of the Unfarmed Lands in Sicily, 1947–48), *La battaglia al Ponte dell'Ammiraglio* (The Battle at the Ponte dell'Ammiraglio, 1950–51) and *La zolfara* (The Sulphur Deposit, 1953), Guttuso turned to subjects from life. He was inspired by the life of the lower middle classes, particularly in moments of mass enjoyment representative of the recovering social climate after the heavy atmosphere of post-war Italy. The first of these large-scale paintings was *Boogie-woogie*, exhibited at the 1954 Venice Biennale. Apparent enjoyment is symbolised here by the syncopated dance rhythm associated with the melancholy exemplified by the thoughtful woman in the foreground. It is therefore a meditation on the existential void in that moment of collective joy.

The bird's eye perspective in *La spiaggia*, completed in 1956, catches a motley array of bodies either sunbathing or rushing around playing games and racing. The series of preparatory sketches for the work resulted in a descriptive precision with obviously realist characteristics. Rather than convey a sense of joy for living, however, these traits provoke further thought on a prevailing sense of inertia and immobility, a feeling of timeless abandonment on the beach, a place familiar to the collective imagination. The work was presented in a totally alien climate at the 1956 Venice Biennale, dominated by abstraction.

M.M.

The Second Post-war Period

Giulio Turcato
51. *Rally* (Comizio), 1950
Oil on canvas, 145 x 200 cm
Rome, Galleria Comunale
d'Arte Moderna

In 1947 Turcato had been among the founding members of Forma 1, a group of artists who professed Marxism whilst convinced that modern art should be 'formalist' or abstract. Turcato took part in the 1948 Venice Biennale that split the movement into two factions. From then onwards the artist's formal research brought him towards abstract, although not geometric, compositions in which shapes were arranged chromatically in a manner derived from the avant-garde prototypes of Picasso and Balla.

Presented with the Group of Eight by Lionello Venturi at the 1950 Venice Biennale, Turcato exhibited *Comizio* and two other works with an equally prominent social theme: *Scenderia* (The Mine Shaft) and *Miniera* (Mine). *Comizio* is the best-known work in a series of canvases started in 1948 featuring political rallies and meetings. The theme is summarised in the dynamic fluttering of the red flags highlighting the heaving crowd that fills the entire picture in a view from above. Turcato himself sustained that 'in a political meeting the flags are what counts, they are its symbol'.
Although influenced by the futurist abstraction of Balla the raised viewpoint is nonetheless developed in a manner that recalls a figurative

approach. The vertical lines of the varnished red flags punctuate the horizontal, concentric and undulating lines of the crowd.
M.M.

From *Clash* to Synthesis

VI. The 1950s: Finding One's Bearings between Paris and New York, Art Autre and Action Painting. The 1960s: Developments of and beyond Informal Art

From Federico Fellini's film
La dolce vita, 1960

The early 1950s were swept by swift change in artistic language, consequently putting an end to the post-war struggle between abstract and figurative art. Traditional techniques and materials were abandoned in favour of new techniques, new materials and new procedures. The artistic experience broadened and changed the very concept of art. Although there still remained room for painting and sculpture, traditional ideas of form and making art were uprooted. The aim of the artist was no longer the creation of a finished 'form' but rather the direct expression of an existential state, achieved through movement, automatism, journal-like phrasing of signs and the randomness of matter. The need to break free from the antithesis of content and form in search of something 'beyond' form generated a new movement and concept termed *Informel*, which spread throughout Europe and the United States. In 1952 in Paris Tapié presented the exhibition *Les signifiants de l'Informel*, while in New York Rosenberg coined the term 'Action Painting'. In Italy the term *art autre* was used for the first time by Tapié during the 1954 Venice Biennale to define the work of Capogrossi.

In Italy renewal in the visual arts was seen as a starting point for any evolution in world art. In 1951 Burri, Capogrossi and Colla formed the group Origine in Rome. Its features were an obvious 'detachment from history, art history included, and from political activism, through a desire to return to the creative artistic gesture stemming from a profound, primeval need' (De Marchis 1982). In 1950 Capogrossi held his first exhibition of Abstract art at Rome's Galleria del Secolo with works that seemed to have nothing to do either with traditional painting techniques or with the normal content of a picture. In 1952 Burri's first 'sacks' did away with the canvas and replaced it with old rags. That same year Fontana exhibited his first 'holes' on paper at a group show in Milan's Naviglio gallery. In this case the modification of the traditional work of art is even clearer since the canvas is totally empty and has been modified by an action different from that of painting.

As a reaction to Abstract Expressionism New Dada spread through Italy and the United States in the mid-1950s. This movement tended to use unconventional materials in a variety of assemblages and combinations. *Décollage*, which used images obtained from torn pieces of paper glued onto one another, was complementary to the procedure of *assemblage*. There is no longer any trace of sculpture in the *assemblages* of Colla, made up of *objets trouvés*, while Rotella's first *décollages* totally relinquish any resemblance with painting. In France Restany coined the term 'Nouveau Réalisme' to include all artists connected with this form of experience and with his manifesto in 1960 declared that painting on the traditional easel was dead.

The 1960s opened under the aegis of great artists from the 1950s such as Burri, Fontana, Capogrossi, Colla and Rotella, who were still able to produce highly innovative works that deeply inspired the younger generations. At the same time the fathers of the *Informel* revolution drew on the experiences of the younger generations for their latest developments such as the monochrome and the exasperated reductivist rigour.
R.C.

Lucio Fontana
52. *Concetto spaziale*
(Spatial Concept), 1949
Tempera on canvas, 28 x 65 cm
Signature and date with brush
on front lower right side:
'L. Fontana 49'
Rome, Galleria Nazionale
d'Arte Moderna, Inv. No. 9318

One of Fontana's first works featuring holes, this painting remained in the artist's studio until it was donated to the Galleria Nazionale d'Arte Moderna. A further two works also featuring holes and dated 1949 were displayed for the first time at the Naviglio gallery in Milan in 1952. This work is therefore connected to Fontana's 'spatial concept' canvases punctured with holes, the fruit of a sign and an action, that first exemplified the artist's overcoming the categories of painting, relief and sculpture. They are the concrete manifestation of the theories expounded in the Argentinean *Manifesto Blanco* of 1946 and of the first *Manifesto dello spazialismo* published in Italy in 1947.

'By puncturing the physical space of a pure surface Fontana goes a step further. The space is no longer earthly, prospectical or purely physical imminence. It becomes a cosmic allusion. The surface no longer opens and closes the space… it is the opening in that surface that opens up a new and infinite dimension. As with the cuts and gashes in the 1960s, the hole is the physical presence of a new concept of space on the traditional surface of a picture' (Crispolti 1986).
R.C.

Informal to Post-Informal: Gesture and Materials

Alberto Burri
53. *Grande sacco*
(Large Sack), 1952
Sackcloth and acrylic
on canvas, 150 x 250 cm
Signature on lower
back left: 'B.A.'
Rome, Galleria Nazionale
d'Arte Moderna, Inv. No. 5382

This work is part of the series of large compositions using sackcloth completed by Burri immediately after his fist experimentation with this material in a painting. This series appeared scandalous at the time. *Grande sacco* was catapulted at the centre of a number of heated debates in the press and the object of violent criticism, even in Parliament, and Burri was probably perfectly aware of the repulsive effect of the 'sack' series. Their appearance in fact was so controversial that their impact lasted well into the next decade. Despite this, front line critics immediately recognised their high formal standard. 'Burri needs to be understood spontaneously, instinctively. His material, both terrible and dazzling, rich and poor, is an alchemy of glue, white lead, varnish and mystery. It needs to be felt almost physically, particularly now that it has reached us as such an unexpected novelty' (Trucchi 1952). After his first 'sacks' in 1950, Burri began to 'alternate areas of rough sacks and painting in the picture, without however superimposing these two distinct and dialectically concordant elements. The substance of the threadbare cloth, more sack than ever after having been stretched onto the frame, is never destroyed, covered or confused with other materials. It is instead emphasised by accentuating its intrinsic beauty' (Calvesi 1959).
R.C.

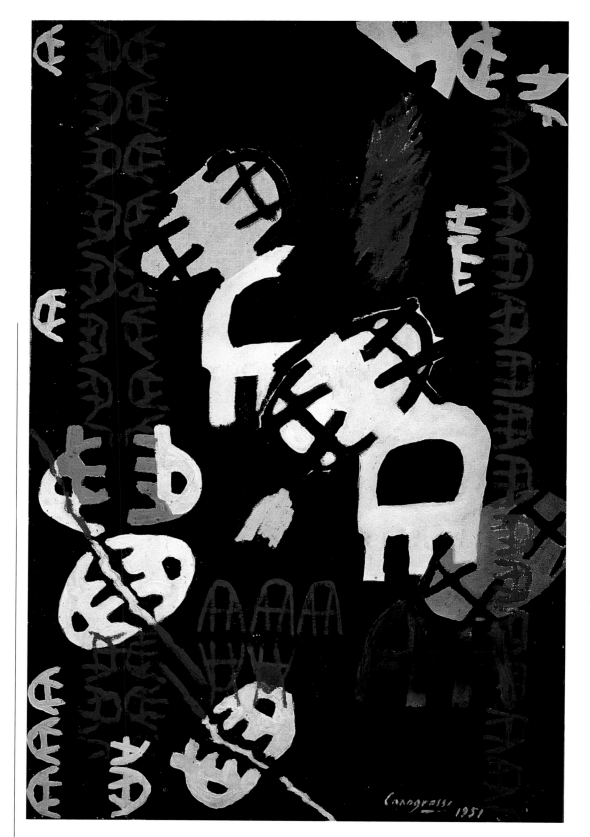

Giuseppe Capogrossi
54. *Numero 18 (Superficie 603)*
(Number 18 [Surface 603]), 1951
Oil on canvas, 90 x 60 cm
Signature on lower right:
'Capogrossi 1951'
Rome, Galleria Nazionale
d'Arte Moderna, Inv. No. 4681

Around 1949 Capogrossi began to rethink his work after a long figurative period in line with the tonalism of the Roman School. He moved towards a conception of painting as an articulate language of 'signs'. This work documents well this development and features a stencilled cipher that was to become Capogrossi's unique motif, described as a trident, fork or comb. The sign is displayed neither as an object in space nor as drawing on paper. 'Capogrossi does not substitute a repertoire of "figurative" images with a repertoire of "non-figurative" images, he just does away with the image altogether. He strips painting of any added technical value, reducing it to an elementary operation of writing' (Pinto 1970).

Capogrossi's abstract works completed after 1950 bear the title *Superficie*, followed by a progressive number, while the present work was at first simply called *Numero 18*. Entitled thus it was included in the catalogue of the 26th Venice Biennale in 1952, when it was acquired by the Galleria Nazionale d'Arte Moderna. Only later did the artist identify the painting as *Superficie 603*, and listed as number 64 in the general catalogue (1967) of Capogrossi's abstract works by Argan and Fagiolo.
R.C.

Informal to Post-Informal: from Sign to Narration

Carla Accardi

55. *Integrazione lunga*
(Long Integration), 1958
Casein tempera on canvas,
64.5 x 232 cm
Signature with brush in capitals
on the reverse, lower right
Rome, Galleria Nazionale
d'Arte Moderna

This work was shown for the first time at Accardi's solo exhibition in 1959, held at Turin's Galleria Notizie. Since 1953 the artist had begun developing a sign painting primarily through the use of black and white. Accardi herself wrote: 'It had been a year of crisis [...] isolated, I had started to draw directly on the floor [...] but I used white on black because black on white was too obvious to be able to stim-ulate me...' *Integrations* is a particular group of mostly large sized works on which Accardi worked between 1956 and 1958 and in which the signs are bound together by continuous, interweaving and entangled lines. The artist states: 'starting from the sign, isolated at first, dispersed and then structured, to then be divided again, allowed me to deepen such a schematic start and develop it into a position of interest for a structural method [...] I named the large structures of those years "integrations"'.
R.C.

91

Cy Twombly

56. *Senza titolo* (Untitled), c. 1957
Mixed media on paper glued
to canvas, 70 x 100 cm
Rome, Galleria Nazionale
d'Arte Moderna, Inv. No. 10156

The work was part of the collection of Palma Bucarelli, director of the Galleria Nazionale d'Arte Moderna from 1940 to 1975. It could have been completed before the end of the 1950s, immediately after the artist moved to Rome and probably donated to Palma Bucarelli on the occasion of the artist's exhibition in Rome presented by her in 1958. Since it is not listed in the official catalogue of Twombly (1948–95) edited by Heiner Bastian in Munich between 1992 and 1995, there is no literature on the work. The square-shaped grill placed in the lower centre of the canvas coupled with the lightly coloured, pasty nature of the painting are typical features of Twombly's work in those years. From 1960 onwards the signs became more rounded and lively, including streaks of colour and even real words. In this painting the markings unfold like writing, diagonally from left to right. The artist has used the canvas like a wall on which he has recorded his existence with any means available, from words to ideograms and indecipherable signs. As Bucarelli wrote in her presentation to the artist's exhibition at the Tartaruga gallery in Rome in 1958, 'who hasn't left a sign on the wall, that irresistible impulse to trace a sign, make a gesture, a pure gesture on pure white wall? Here the surface is mere surface to begin with but the signs build up over one another creating a time and a space. The wall now has depth'.
R.C.

Informal to Post-Informal: from Sign to Narration

Gastone Novelli

57. *Il grande linguaggio*
(The Great Language), 1963
Oil, ink and pencil on canvas,
200 x 300 cm
Rome, Galleria Nazionale
d'Arte Moderna, Inv. No. 5427

This work was presented at the 1964 Venice Biennale. Between 1961 and 1963 Novelli made a series of trips to Greece, where he came into contact with a world of myth and language that would overshadow his entire subsequent activity. As Calvesi wrote in 1963, 'The idea of the wall-surface [...] developed into the idea of the page-surface'. The painting thus became the page onto which Novelli reported his own autobiographical tale. In this sense *Il grande linguaggio* is a summary of the artist's experiences during his trip. The two narrative moments are clearly separated on the surface of the work. On the left the significant moments are illustrated with signs and graphic elements, such as the chessboard and letters of the alphabet. On the other side a landscape surrounds an empty space, probably the sea, on which appears the caption *Omero*. Novelli wrote 'there is a fairly large mountainous land unknown to anyone and unmarked on any map. The base on which this land rests is made from materials capable of curving surrounding space, so that the entire area on which it rests remains sealed in an emptiness through which space does not pass, and is therefore invisible to travellers and totally neutral'.
R.C.

Ettore Colla

58. *Carro solare*
(The Chariot of the Sun), 1967
Assemblage of welded scrap
metal, 80 (h.) x 81 (Ø) x 178
(axis length) cm
Rome, Galleria Nazionale
d'Arte Moderna, Inv. No. 5563

After his experience with the Origine group, between 1954 and 1955 Colla began to work on his first assemblages using scrap metal. Contrary to assemblage, these works distinguished themselves from the start by their 'classical compositional rigour, the balance of the structure, the synthesis, the purity of the plastic elements, the taste for order and fine proportions' (De Marchis 1982). The artist tended to further simplify these traits in his later work. Colla completed *Carro solare* in his studio on Viale Parioli in 1967, just a year before his death. The work was a resounding success when it was presented at exhibitions that same year, particularly at Foligno, where Colla had an entire section dedicated to him.

The parts that make up this assemblage probably come from farming machinery, perhaps a tractor or a harvester with three different sized wheels, all double rounded, with trunnions, bolts and a square-shafted, sharp-ended beam. Although the anthropomorphic element prevails and sometimes overshadows the formal result, in Colla's work it is not exclusive. In order to better illustrate his work we have decided to present a non-anthropomorphic piece.

Many of Colla's titles are inspired, with a tinge of humour, by mythology. In this work, for instance, the artist 'does not relate to a Medieval instrument of torture [...] but seems to suggest instead his habitual devaluation of classical myth: in this case the chariot of Apollo' (Pinto 1972).
R.C.

Informal to Post-Informal: Assemblage and Décollage

Mimmo Rotella
59. *La tigre* (The Tiger), 1962
Décollage of manifestos
on canvas, 110 x 85 cm
Rome, Giorgio Franchetti
collection

Rotella emerged in the second half of the 1950s when he started generating images from the reverse sides of torn advertising posters: hence the tearing technique labelled *décollage*, since it is the opposite of *collage*. He was influenced both by Action Painting in the United States, which 'instead of academising itself is evolving towards a New Dada awareness' (Pinto 1970), as well as by the Origine group milieu. The work was featured in the collective show *13 Pittori a Roma* at the Tartaruga gallery in 1963, a time during which Rotella was a follower of the Nouveau Réalisme movement. Those were the years in which 'the artist produced perhaps his best works, in which he abandoned the effects of matter in favour of retrieving the images of torn advertising posters, keeping his intervention down to a minimum. The act of tearing highlights the layer in which the image surfaces notwithstanding the gaps and encrustations, taking on an almost archaeological flavour' (De Marchis 1982). *R.C.*

Giulio Turcato

60. *Ricordo di New York*
(Souvenir of New York), 1963
Oil, collage and mixed media
on canvas, 231 x 180 cm
Signature on lower left side:
'Turcato'
Rome, Galleria Nazionale d'Arte
Moderna

In 1962 Turcato spent a month in New York, from which he developed a number of versions on the theme *Ricordo di New York*. The painting contains references to Turcato's trip as his moment of encounter with American artistic culture. He also draws a parallel between the common sensations of New York and Venice, two cities built between earth and sky and which Turcato sums up well by using cobalt and ultramarine blue. Since the end of the 1950s the artist had begun including materials such as sand, glue, powders and actual objects such as paper currency onto his canvases. In his *Lenzuolo di San Rocco* (St. Rocco Sheet) series there are sedative pills and paper. This culminated at the beginning of the 1960s in a wholehearted utilisation of everyday objects, showing up his proximity with American artistic currents such as New Dada and Pop art. This large-scale work was included in Turcato's solo exhibition at the Marlborough gallery in Rome in 1965. As De Marchis wrote in 1971, 'Turcato has returned to his most cherished techniques and motifs. The spatial value of the chromatically uniform surface is not defined by graphic indications but by the luminous iridescence of colour. The painting is interrupted one third up its height by a horizontal strip of carbon paper glued, like the passing of a mysterious message, onto a dark and stormy sky. Although essentially never metaphorical, Turcato's paintings do allow critics to use some metaphors, like in a gallant courtship'.
R.C.

Informal to Post-Informal: Mature Expression of Materic and Gestural Art

Emilio Vedova

61. *Scontro di situazioni n. 4*
(Clash of Situations No. 4), 1959
Oil on canvas, 276 x 272 cm
Signature with pen on reverse:
'Emilio Vedova / Ciclo Scontro
di situazioni, 1959'
Rome, Galleria Nazionale
d'Arte Moderna, Inv. No. 5197

The Galleria Nazionale d'Arte Moderna acquired the work directly from the artist in 1964. As De Marchis commented on the *Bollettino d'arte*, 'this work is the most significant of an already famous series of paintings based on the simple relation between black and white with occasional touches of bright colour'. The *Scontri di situazioni* cycle began in the early 1950s and was presented at the international exhibition *Vitalità dell'arte* in 1959 at Palazzo Grassi in Venice. The first installation of works was curated by Carlo Scarpa and featured works mounted on black and composed of angled canvases. From a 'neo-expressionist painting not devoid of reminiscences with the mixture of colour and light in Venetian tradition [...] [Vedova] renewed his interest in Futurism after the war, eventually arriving at a form of abstract gestural expressionism' (De Marchis 1964).
R.C.

The 1950s and the 1960s

Arnaldo Pomodoro

62. *Rotante dal foro centrale*
(Centrally Perforated Rotating
Sphere), 1966
Bronze, Ø 60 cm
Rome, Ugolini collection

This work is a fine example of Pomodoro's mature style. 'Beyond the *Informel* nature of action and matter which reached its culmination in 1960, Pomodoro carried out further research into so-called "continuous" expression. This entailed a rhythmical mutation and repetition of signs within the continuity of space. Pomodoro in fact privileges "continuous" forms such as the sphere or the cylinder where series of signs are either inscribed or "emitted", as if in a coded language. These series repeat each other and mutate, beating the eternally variable rhythm of time' (Bucarelli 1973).

In 1960 the artist took part in the Continuità group along with Novelli, Perilli, Dorazio, Consagra and his brother Giò. Argan presented the group at the Rome's Odyssia gallery. The aim of the group was to surpass *Informel* art whilst still maintaining a degree of continuity. In 1963 Pomodoro completed his first sphere, followed by others located in vital areas of various cities in Italy and abroad. As the artist himself declared in an interview with Marisa Volpi in 1981, 'the best location for my sculptures is in the open, in gardens and squares. And the best public for them is whoever sees them in this lively public context'. For the sculptor the spheres are '...perfect, magical forms that I break open to reveal their internal fermentation, mysterious and alive, monstrous and pure [...] By the same action I free myself from an absolute form. I destroy it. But at the same time I multiply it...' (cit. in Fagiolo 1966).
R.C.

Informal to Post-Informal: Masters Get Up to Date

Lucio Fontana

63. *Natura* (Nature), 1959
Bronze, 70 x 80 cm
Rome, Galleria Nazionale
d'Arte Moderna, Inv. No. 9323

This work is part of the 'nature' series of terracotta sculptures completed between 1959 and 1960, some of which (as in this case) were cast in bronze during the artist's lifetime and under his direct supervision. With their material evidence these works represent, along with the abstract and ideal purity of Fontana's 'cuts', a continuation of the artist's *Informel* experience in its definition of a cosmic dimension. As Fontana said, 'it really was reality because I was thinking about those worlds, about the moon with these [...] holes, this terrible silence that anguishes us, and astronauts in a new world. So then these [...] in an artist's fantasy [...] these immense things that have been there for millions of years [...] man arrives, in a deathly silence, in this anxiety, and leaves a vital sign of his arrival...' (cit. in Crispolti 1986). In 1960 Argan commented the series thus: '*Nature* are Fontana's latest disturbing images. Large irregular balls with swollen, burst seeds. And cruelly broken, almost violated by terrible cracks and holes like gorges. This is a return to the primeval symbolism of the female shape associated with that of a seed' (in Argan 1964).
R.C.

Lucio Fontana

64. *Concetto spaziale - Attese*
(Spatial Concept - Waiting), 1959
Water paint on canvas,
81 x 100 cm
Rome, Galleria Nazionale
d'Arte Moderna, Inv. No. 9324

From 1958 the work of Fontana was distinguished by neat, regular cuts all entitled *Concetti spaziali* and *Attese*. Of the early cuts, the series exhibited at Fontana's solo exhibition at the Naviglio gallery in Milan is the most important. By cutting the canvas Fontana lacerated the diaphragm of the picture and induced a substantial change in the perception of space, all with a single, swift action. As Argan said in 1960, 'The cuts or single cut always happen at exactly the right point. They obey a need to break the perfect plan. It is as if matter, brought to the final limit of rarefaction, wants to recover through such an accident a sense of reality in its own existence from the final limit of time and space, from definite and indefinite […] The artist turns back, because he is no longer attracted by the sky but by depth' (in Argan 1964).
R.C.

Informal to Post-Informal: Masters Get Up to Date

Giuseppe Capogrossi
65. *Superficie 290*
(Surface 290), 1958
Oil on canvas, 270 x 180 cm
Rome, Galleria Nazionale
d'Arte Moderna, Inv. No. 5686

The canvas is part of a nucleus of works donated to the Galleria Nazionale d'Arte Moderna in the 1970s by the art dealer Renato Cardazzo in memory of his brother Carlo and is from the artist's mature non-figurative period. The black signs that occupy the entire surface of the picture are magnified against the colourless white background. The composition is monumental but highly simplified. As Argan wrote in 1967, 'the system is [...] open to an infinite number of combinations, like an alphabet reduced to a single letter that can be written and pronounced in an infinite number of ways or with an infinite series of intervals'. The numerous small signs typical of the 1950s have grown larger and less frequent and 'depending on the situation, tend to repeat themselves to infinity, multiplying and shrinking, or enlarging themselves beyond measure, isolated against the background' (Argan 1959). If one were to draw a parallel between pictorial script and a musical score this painting could be compared to a *fortissimo*.
R.C.

Alberto Burri

66. *Nero* (Black), 1961
Various plastic materials
on wooden frame,
200 (h.) x 185 (w.) cm
Rome, Galleria Nazionale
d'Arte Moderna, Inv. No. 1954

After the 'sacks' and his experiments with the 'combustions' of woods and metals, Burri's research seemed to turn towards the transformation of substances, so much so that although this work is made from plastic its composition and iconography is akin to 'ferri'. 'Burri takes a material and transforms it into something different, aiming at the alchemy of the object itself. The perfection of matter can only be sought within matter itself. A large black sheet of plastic has been melted and divided in the same way as one of his large pieces of metal. Here Burri has managed to swap the properties of different matter' (Fagiolo 1966). As from 1961 Burri began working on the series of 'plastics' that were presented the following year by Brandi at the Marlborough gallery in Rome. 'In truth, if there was a substance that seemed less adequate for the materialisation of an image it was plastic... To surpass this stage of every-day life was for Burri the beginning of a fantasy, as well as a kind of redemption for transparent plastic...'
R.C.

Informal to Post-Informal: Masters Get Up to Date

Alberto Burri

67. *Nero cretto G5*
(Black Chapping G5), 1975
Acro-vynil on cellotex,
175 x 154 cm
Signature on reverse, top
centre with pen: 'Burri Alberto'
Rome, Galleria Nazionale d'Arte
Moderna, Inv. No. 9059

The work was donated by the artist to the Galleria Nazionale d'Arte Moderna during an exhibition in 1976. Only produced in black and white, 'cretti' seemed to heighten the research towards a formal reductivism of monochrome painting, which, in the wake of Minimal art, reached its international peak of recognition at this time. There was still a strong tie with matter in 'cretti', however, which would in due course grow weaker until it was finally reduced to the naked support of cellotex. Due to its composition of kaolin, vinavil and pigment, the technique for creating the 'cretti' was extremely time-consuming. As they dried, the components would produce the typical crack, or *cretto*. Thus the matter became 'canvas' and the *cretto* 'drawing'. The monochrome of this series was clearly the debt of a great master towards the new generation operating in the Minimal sphere advocating the reduction of painting to zero. Exactly what Burri had suggested at the beginning in his paintings 'without painting'. In the catalogue for the 1976 exhibition at the Galleria Nazionale d'Arte Moderna, Mantura commented thus: '*Cretti* show a new heaviness in Burri's palette of materials, a greater hardness and heaviness than that of *Metalli*. This matter is at times close to a black that is denser than the matter itself. Natural or synthetic? Its innocent resemblance to cracking mud is belied by the blacks and whites. Therefore is it clay, chalk or an element that has yet to be classified?' *R.C.*

The 1950s and the 1960s

VII. 1. From 1959 to 1968: Assimilation and Transformation of New and Different Avant-garde Languages
2. From 1967 to 1971: Arte Povera, the Original Declination of Italian Proto-Conceptualism

1. The new generation that appeared at the end of the 1950s inherited from its predecessors the awareness of the deep crisis of the object of art and of the consequent impossibility of producing art in the traditional sense of the word. The freedom from the bonds of traditional techniques and materials opened up a number of possibilities in the field of artistic research simultaneously in many Italian cities and abroad. For the first time there was a European connotation to the various movements, which nonetheless maintained a strongly national character.

Both in Milan and in Rome the disintegration of the concept of art engendered a 'resetting' process that found a privileged form of expression in the use of monochrome. International research by artists working exclusively with one colour was presented by Udo Kultermann in 1960 at the Civic Museum of Leverkusen in an international exhibition entitled *Monochrome Malerei*.

1960 saw the beginning of the *Miriorama* shows organised by Gruppo T, born in Milan amidst the cultural environment of Fontana and the Azimut group of Manzoni and Castellani. These exhibitions featured research in the kinetic-visual field that went in totally the opposite direction from the cultural climate that had fostered them. 'Kinetic-visual research rapidly became a generalised artistic theory, with strong ideological and political motivations [...] art was planned collectively according to agreed theories and produced in many versions using industrial techniques and materials, therefore excluding any form of charismatic intervention on behalf of the artist' (De Marchis 1982).

International novelties, including the new research of Italian artists, were presented in 1961 at the XII edition of the Premio Lissone. In this panorama of non-figurative post-war art appeared Paolini, who rethought the very idea of art to the extreme. This advanced research towards what would become Conceptual art is still continuing today.

This tendency clashed with Pop art, presented in 1964 in the American pavilion of the Venice Biennale, which was to influence and create upheaval in the international art scene for many years. All the artistic experiences of the first half of the decade were summarised in Italy by Pino Pascali, who used them as a stimulus for his constantly evolving inventiveness. For Pascali the work of art lost its last traditional connotations of permanence and durability in favour of art as a temporary experience.

Two collective shows organised in quick succession one after the other in 1967 were to be instrumental in the development of new artistic research in Italy during the 1970s. These were the June exhibition *Lo spazio degli elementi - Fuoco, immagine, acqua, terra* by Boatto and Calvesi at L'Attico gallery in Rome; and *Lo spazio dell'immagine* by De Marchis in Foligno, based on environmental art.
R.C.

2. Within the framework of conceptual and minimalist research going on in the mid-1960s, Arte Povera emerged as a specifically Italian phenomenon whilst being one of Italy's major contributions to the new international avant-garde.

With an exhibition at the Bertesca gallery in Genoa in 1967, the critic Germano Celant baptised a field of artistic research identified with works by artists such as Boetti, Pascali, Kounellis, Fabro, Merz, Pistoletto, Prini and Zorio.

Amidst the on-going celebration of the symbols of an opulent society still derived from the New Dada experience, Arte Povera opened up a new path towards re-evaluating the experience of daily life by using anonymous elements to forge moments of lyrical creativity. Around this notion Italian art gained a new autonomy, fully aware and free from any preconceived rule. The works and actions of Arte Povera also displayed considerable affinity with the socio-political utopias of the 1968 student uprisings.

Arte Povera produced a synthesis between artifice and nature, opposed to the world of technology, through the use of the simplest possible means to create a new poetical message. The rigour and total compositional simplicity

Piero Manzoni, *Socle du monde*,
1961
Herning, private collection

of these works was also opposed to the inheritance of the *Informel* masters such as Burri, Fautrier and Dubuffet, who despite their use of primary materials had ended up making them sumptuous with their chromatic sophistication and compositional rhythm.

Water, earth, air and fire now recalled a primary sense of nature intended as an existential matrix. Rags, paper, wood and stone isolated and emphasised common use objects, elevating the work of art to a level beyond its conventional sphere.

From this poverist matrix sprung up a variety of new linguistic variations made of new cultural developments, thereby confirming that art and poetry remain inalienable expressions of the human soul.
A.M.

Piero Manzoni
68. *Achrome*, 1959
Canvas sewn in large squares,
146 x 114 cm
Rome, Giorgio Franchetti
collection

Manzoni's work stands out on account of its startling succession of actions and ideas. In 1959 he founded Azimut with Castellani. In 1960 he took part in the Leverkusen monochrome exhibition. Dated 1959, this work is part of a series Manzoni himself labelled *Achromes*, which includes his entire production of white paintings. The first works of the series, in which the canvas was soaked in kaolin, date back to 1957. These were followed in 1959 by machine-sewn pieces. In 1960 Manzoni was working with cotton wool, expanded polystyrene and cobalt chloride, which changed colour according to the weather. The series continued with white pictures in straw and plastic, and in small cotton wool balls with clouds made of natural or artificial fibre.

In this work the canvas is made up of twelve squares, sewn with the seam clearly visible. As Pinto wrote in 1970, this was 'to eliminate any vestige of form and perhaps rediscover the absolute values of Mondrian outside painting technique'. The absence of colour that could be considered white, pure light or a concentration of all colours becomes for Manzoni a pure annihilating action, a 'clean slate'. Strongly related to Klein, this action unleashes a concentration of energy in which the artist reduces to a minimum any formal pretence or creative invention in favour of revealing the essential.
R.C.

From Annihilation of Art to Conceptualism: an Italian Avant-garde

Piero Manzoni
69. *Batuffoli* (Swabs), 1961
Cotton wool and wool fibre
on velvet glued to wood covered
with glass, 31 x 38 cm
Rome, Galleria Nazionale
d'Arte Moderna, Inv. No. 5407

This work also relates to Manzoni's
series of white paintings completed
between the end of the 1950s and
the beginning of the 1960s. In this
case Manzoni uses untraditional
materials to convey the cardinal the-
ories of the Azimut group: conse-
quence, rhythm and serialism.
The five rows of seven swabs fixed
onto black support bring *Informel*
impositions on matter to an ex-
treme that Manzoni surpasses.
While on the one hand the use of
cotton suggests the total insignifi-
cance of the subject matter chosen
by the artist, on the other hand its
serial arrangement is indicative of
an attitude that is more aesthetic
than practical.
R.C.

Francesco Lo Savio
70. *Spazio-Luce* (Space-Light),
1959
Synthetic resins on canvas,
100 x 120 cm
Rome, Giorgio Franchetti
collection

This canvas belongs to a cycle of paintings featured in the artist's first solo exhibition at the La Salita gallery in Rome in 1960. Only apparently similar, these works are the fruit of Lo Savio's study of refraction and intensity of light. The geometrical forms represent energy, systematically redistributed over the entire surface. With absolute precision Lo Savio arranges mirror-like, reflecting surfaces that create a space in its absolute essence of luminosity. These mono-chrome works are not therefore born from 'subversive or experimental principles as in the work of Manzoni, who considered the white canvas a field of infinite possibilities'. They depend instead 'on a totally formalistic research into light itself' (Pinto 1970).

Lo Savio's complex expressive language contains a visible anticipation of the problems of space and environment that today interest the most advanced generation of young artists.
R.C.

From Annihilation of Art to Conceptualism: an Italian Avant-garde

Enrico Castellani
71. *Superficie divergente*
(Diverging Surface), 1966
Oil and nails on canvas,
200 x 200 cm
Tokyo, Museum
of Contemporary Art

Castellani's surfaces in relief appeared for the first time in an exhibition held at Azimut gallery in 1960. The canvas is quilted monochrome. It has lost the characteristics of a screen, extending into space and kept tense by the pins fixing it to the frame. The white canvas presents a surface that is punctuated by reliefs at regular intervals. This effect is obtained by nails that inevitably, 'to avoid creating a totally raised surface but one that protrudes in points, go from inside to out and vice-versa' (Celant 2001). The effect of relief and recess changes depending on the light on the canvas thereby causing a constantly mutating visual perception in the spectator, as well as a prolonged viewing time.

The work was completed in 1966, the same year that Castellani took part in the Venice Biennale. It clearly testifies to the artist's interest in the study of surfaces also carried out by Fontana in his *Tagli* and which are also related to Manzoni's studies on monochrome.
R.C.

Gianni Colombo

72. *Strutturazione pulsante*
(Pulsating Structure), 1959
Expanded polystyrene, water
paint, electromagnetic animation,
wood, 135.5 x 127 cm
Signature on reverse top: 'Gianni
Colombo/1956/ Strutturazione
Pulsante / voltaggio 220-250
amp. = 30v.'
Rome, Galleria Nazionale
d'Arte Moderna, Inv. No. 5290

Part of a group work planned in
1956, this piece is one of the earli-
est and most interesting Italian ex-
periments in the field of kinetic-vi-
sual research. Kinetic-visual art
originated in the late 1950s from a
desire to transcend the *Informel* ex-
perience. To give, as far as it is pos-
sible, an objective analysis of this
movement it would be true to say
that it introduced a collective crite-
rion of separation between the
planning and execution of a work.
The execution of the work was in
fact to be delegated to serialised in-
dustrial production. The works al-
most always featured a self-gener-
ated movement either achieved
by mechanisms within the work or
by the movement of the viewer in
relation to it.

In *Strutturazione pulsante* the small
polystyrene blocks, all of the same
size, are rigorously arranged with-
in a frame so that they create a wall
effect. The blocks move outwards
at irregular intervals and for an ir-
regular length of time. The specta-
tor therefore loses his passive role
of observer and is involved in the
motion of a structure that is con-
tinually changing. Colombo's work
is the final stage in a process of giv-
ing a three-dimensional effect to
the canvas originating with the cuts
of Fontana through to the quilted
canvases of Castellani.

There are a number of different ex-
amples of this work, in varying
sizes, one of which is in the Muse-
um of Modern Art in New York. The
one presented here is part of an im-
portant collection of kinetic-visual
art at the Galleria Nazionale d'Arte
Moderna that was built up in the
late 1960s.
R.C.

From Annihilation of Art to Conceptualism: an Italian Avant-garde

Gabriele De Vecchi

73. *Superficie in vibrazione* (Vibrating Surface), 1963
Natural rubber, pins, electric motor, 55 x 54 cm
Signature on back: 'Gabriele De Vecchi / Gruppo T Milano / Vibrating Surface 1963 / Drawing 1959 / Motor 220 volt'
Rome, Galleria Nazionale d'Arte Moderna, Inv. No. 5348

This work is part of a series named by the artist *Superfici in vibrazione* which he started at the end of the 1950s. The research of De Vecchi, and more generally of the Gruppo T, was directed towards representing the variation in time of elements such as colour, form, volume and surface, in an attempt to surpass traditional artistic techniques and create a new plastic and pictorial reality. The spectator, no longer a passive consumer, assumed great importance as an accomplice of the artist.

The supporting panel of the work is an elastic sheet of natural rubber, into which a number of pins have been nailed to form a uniform surface of points. Each point is stimulated into movement by an electric device located underneath the panel and returns to its original position thanks to the panel's elasticity. The kinetic function of the work, as well as its fruition, lies in the constant change of image and structure through time, another integral part of the work, governed in advance by the mechanism.
R.C.

Giulio Paolini
74. *Senza titolo* (Untitled), 1961
Tin of varnish and polyethylene
on frame, 20 x 20 cm
Artist's collection

This work is from the same period as *Telaio* (Frame), featured at the XII exhibition of the Premio Lissone in 1961, which consisted of a wooden frame covered with transparent plastic, containing a much smaller canvas without an image as its subject. *Untitled* is also composed of a small, square, empty frame that supports only a real tin of colour enclosed by a layer of transparent plastic. 'The objects are therefore strictly tied with painting. They are the ingredients or tools of painting featured in a frame instead of a picture. It is impossible not to think of Duchamp, who said that any painting is nothing more than a modified ready-made [...] We are in a very different line of research from the objectualism of New Dada and Nouveau Réalisme. A totally opposite direction, in fact. This is rather a subtle gnoseological thought on art itself and on its own tools that would take Paolini towards Conceptualism, vital for the development of artistic research in the 1960s' (De Marchis 1982).
R.C.

From Annihilation of Art to Conceptualism: an Italian Avant-garde

Jannis Kounellis
75. *Senza titolo - Lettere e numeri*
(Untitled - Letters and Numbers),
1960
Printing ink on frame drawn
paper, 144 x 300 cm
Rome, Ugolini collection

In 1959 Kounellis first started paint-
ing with industrial stencils, that fea-
tured in his work for the following
three years until 1962. De Marchis
wrote in 1982, 'The large page of
white cloth is clearly the field of ac-
tion onto which the artist's action
is registered and not the clean slate
onto which one paints. By using
texts taken from an ordinary con-
text of visual communication […]
the closest reference is to American
New Dada, in particular to Jasper
Johns […] as well as to the "writ-
ten" paintings of Cy Twombly,
Mimmo Rotella's décollages and,
back even further, to Capogrossi'.
From all these components Kounel-
lis makes a 'happy contamination
thanks to his typically instinctive,
pleasantly down to earth ability to
reorganise the information he takes
from reality into a higher order for
the sake of art' (Pinto 1970).
R.C.

Pino Pascali
76. *Il dinosauro riposa*
(The Resting Dinosaur), 1966
Canvas on wood frame,
120 x 200 cm
Rome, Galleria Nazionale
d'Arte Moderna, Inv. No. 9220

Completed in the autumn of 1966, during the same period as Pascali's *Sea* series, this work belongs to the *Animal* series, and was exhibited for the first time that same year at L'Attico gallery in Rome. 'These are objects built with a model-making technique, wood frames covered in white cloth. They are "fake" sculptures but also the components and tools of a *mise en scène*, a game that requires an imaginative integration on behalf of the spectator' (De Marchis 1982). 'Through a game or a "do-it-yourself" idea, these make-believe white sculptures intuitively, and therefore more authentically, promote the culture and creative drive that are the conscious and thereby often illusionary aim of many poverist artists' (Pinto 1970).
R.C.

From Annihilation of Art to Conceptualism: an Italian Avant-garde

Pino Pascali

77. *32 mq di mare circa*
(Approximately 32 Square Metres
of Sea), 1967
Water coloured with
methylene blue in 30 tanks
of zinc-plated aluminium,
113 x 113 x 6.5 cm each
Rome, Galleria Nazionale
d'Arte Moderna, Inv. No. 9225

Presented for the first time at the *Lo spazio dell'immagine* exhibition in Foligno in 1967, this work is part of the natural elements series on which the artist had started working at the beginning of the same year. 'Always arranged differently, with the water freshly dyed each time, the industrial trays mimic not just the sea, of which this work is the first example, but also rivers and canals, etc.' Pascali's poetical expression 'appeals to the most childish and creative side of the imagination. The work plays on the ambiguous answer to the question of theatrical make-believe: maximum or minimum illusion? The minimum consists of representing the sea with industrial trays, the maximum is representing water with water' (Pinto 1968).

Pascali was to complete and exhibit a variety of works with water, at San Marino, at the Biennale des Jeunes in Paris, in Milan, Rome and at the Galleria Nazionale d'Arte Moderna.

'Although there have been several variations on the idea of representing water with water […] it is also true that these variations […] identify this as an "open" work, unique and ephemeral at the same time' (Rubiu 1976).
R.C.

From 1959 to 1968

From Annihilation of Art to Conceptualism: an Italian Avant-garde

Luciano Fabro

78. *Hole* (Buco), 1963–66
Mirror, varnish and iron,
105 x 80 cm
Signature in the lower right-hand
corner 'Buco 63/66 9/L Fabro'
Rome, Galleria Nazionale
d'Arte Moderna, Inv. No. 5451

This work is part of Fabro's early
output, completed immediately af-
ter his personal assimilation of the
Milanese research into the relation
between the work of art and its sur-
rounding space. This theme had at
first been promoted by Fontana, to
whom Fabro responded by entitling
this work *Buco*, and then by the Az-
imut group. *Buco* was featured at
the artist's first one-man show in
1965 at the Vismara gallery in Mi-
lan, along with other works made
from half transparent and half re-
flecting glass slabs. Fabro said:
'When an artist manages to create
a reflection of his own conscience
he creates a work that enables oth-
er artists to reflect themselves as
well. This simplicity, this correla-
tion, this awareness, allow the
artist to enter the circuit of energy
that ties him to others [...] This is
the fist result of the interpretation
of two opposite spaces, the one in
front of the mirror and the one be-
hind [...]. It is as if conscience were
three-dimensional, you have to re-
construct it in two different times.
In fact you can't observe them both
at the same time; first you can look
at one and then at the other'.
R.C.

Michelangelo Pistoletto
79. *I visitatori* (Visitors), 1968
Photographs on stainless steel,
230 x 240 cm
Rome, Galleria Nazionale
d'Arte Moderna, Inv. No. 5413

This work was made especially to be exhibited within a museum. It is a 'mirror, onto which life-size photographs of people have been applied. The visitor sees his own reflected image in contact and in combination with the photographic images [...] The artist in fact believes that a work of art should be made for the place and for the circumstances in which it will be enjoyed. With a touch of irony Pistoletto reminds the visitor of his role, which is to enter the work as an element of context' (Bucarelli 1973). In 1964 the artist declared that 'Paintings are always hung on walls but it is on those same walls that the mirrors are also attached. I believe that the first real figurative experience of man is to recognise his own image in the mirror, which is the closest fiction to reality'.
R.C.

Maurizio Mochetti
80. Filo inox (Stainless
Steel Wire), 1983–84
Stainless steel wire, laser
and rope, dimensions determined
by environment
Rome, Galleria Nazionale
d'Arte Moderna

Although of a much later date, this work develops a theme the artist had approached at the time of his debut in 1968.
Mochetti executed the work for the Palace of Fine Art Exploration in San Francisco, where he had been invited as artist in residence. *Filo inox* was shown at the L'Isola gallery in Rome in 1984 and at the Marconi gallery in Milan in 1987. It is composed of a thin polished metal wire that varies in size according to the

available surrounding space. A light source generates a shadow-projection of the string on one of the wall surfaces designed by the artist. A laser illuminates and connects the end of the string with its own projection.
In this installation, where light is reduced to a basic sign, Mochetti has developed to the extreme a process of research into light and progressive rarefaction of technology that he had begun in 1965. He has conceived a work at the limit of perception, where technology is cleverly hidden and only the idea is visible. Although it has been used unnaturally, as from 1981 natural light became a laser ray, allowing the artist to work in an indefinite space.
R.C.

Alighiero Boetti

81. *Lampada annuale*
(Annual Lamp), 1966
Wood, glass, electric device
Turin, Ruben and Sarah Levi
collection

Presented at the artist's first solo exhibition at the Christian Stein gallery in 1967, *Lampada annuale* is considered one of the works that best represent Boetti's research in the field of Conceptualism. As the patron and first collector of the work Corrado Levi wrote in 1980, 'the most ephemeral mechanisms to which we pay no attention, the movements, the most basic thoughts we overlook, all these represent an important part of our lives that is worthwhile noticing'. The light is programmed to switch on for a few seconds just once a year, at an unpredictable time. Complete fruition of the work is therefore left to chance. As the artist himself underlined, the lamp seems to allude 'to the many events that take place without our knowledge or participation'. The work clearly illustrates Boetti's research in that the lamp-object acquires a magical dimension in time, a mysterious quality given to it by the fact that it is totally unpredictable. Through an exquisitely conceptual action the artist takes possession of time and imprisons it within the work of art, whose complete functionality can only be seen by a privileged few. A replica of the work is on show in the *Zero to Infinity. Arte Povera 1962–72* exhibition travelling through the United States. *A.M.*

Gilberto Zorio
82. *Sedia* (Chair), 1966
Scaffolding poles, coloured
polyurethane, cement
Tokyo, Museum
of Contemporary Art

Completed in 1966, *Sedia* is from
the early phase of Zorio's career
and was exhibited for the first
time in 1967 at the Sperone gallery
in Turin.
Gian Enzo Sperone was struck by
the work when he saw it at the stu-
dio of Piero Gilardi, where Zorio
had provisionally left it. He decid-
ed to introduce the artist to Ileana
Sonnabend who became interest-
ed in the artist and launched his
first international recognition at
her notorious Parisian gallery.
In this period Zorio used industrial
materials such as cement and scaf-
folding poles in a reductive metre
that came from American Mini-
malism. *Sedia* is therefore one of
the first works completed by the
artist during this experimental
phase. It is a fusion between the
soft, coloured polyurethane, the
compact and heavy block of cement
and the light, linear scaffolding
poles.
By playing on the juxtaposition of
materials with a different consis-
tency and weight, the artist creates
an external and internal tension
that transforms matter into an an-
imated element, generating a sys-
tem of balanced energy.
A.M.

Jannis Kounellis

83. *Senza titolo* (Untitled), 1968
Rocks on metal and wood trolley,
120 x 120 x 30 cm
Rome, private collection

By 1967 Kounellis, inspired by the research of Burri and Manzoni, decided to abandon traditional painting and concentrate on experimenting with industrial materials and natural elements, with a view to revealing their hidden properties and highlight their dazzling, magical value. From the end of the 1960s in fact Kounellis' work is underlined by this need to re-establish a contact with elements from nature and every-day life.

In his trolleys, which appeared as from 1968, Kounellis combines an industrial artefact with wood and stones, thereby creating a kind of alchemy that broadens perception of objects and opens up a new relation with the world of things. The artist developed his approach to natural elements by observing the animal world, minerals and plants. Coal, for example, was used by Kounellis to represent the expressive power of matter, black and hard.

In an interview in 1996 Kounellis declared 'they labelled me a 1960s' artist because they didn't know how to label a pile of coal. But I am a painter, because painting is building images and doesn't specify the means or technique used to achieve that '. Every painter creates an image according to his own visions and the tools he has available. Kounellis' artistic action is to surround himself with common but natural elements, such as a parrot, cotton or coal.
A.M.

Mario Merz

84. *Accelerazione + sogno + fantasma* (Acceleration + Dream + Ghost), 1972
Motorbike, neon tubes, horns, dimensions determined by environment
Tokyo, Museum of Contemporary Art

Neon tubes appear in most of the work of Mario Merz, either branding the basic outline of the shapes or piercing them with energy, like spears. Objects are thus stripped of their every-day utility and begin a new, disquieting and surreal form of existence. Familiar objects such as an umbrella, a raincoat or a bottle stand out on blank walls, magnificent in their uselessness, transformed into shapes that take over their surrounding space thanks to the numerical progressions of the mathematician Fibonacci.

The theories of the Pisan monk, who lived in the Middle Ages and who was inspired by the progressive growth of nature, were for the artist 'the real chance to understand space and realise who we are' (Merz 1984 in Corà 1995). By relating simple numbers to light and objects the artist delineates space, transforming it into a mental dimension.

Accelerazione Sogno, Numeri Fibonacci al neon e Motocicletta Fantasma (Acceleration Dream, Neon Fibonacci Numbers and Ghost Motorbike) completed in 1972 for the Kassel Documenta, contains all the elements that made up the artist's research. With its deer horns and trail of increasing numbers the work occupied pride of place at the Fredericianum in Kassel, hung in mid-air on a curved wall at the entrance. Deprived of its original function, the motorcycle becomes an image from a dream, assuming a mysterious and disturbing quality.
A.M.

Giuseppe Penone
85. *Albero libro* (Tree Book),
1986–89
Wood, 401 x 181 x 26 cm
Tokyo, Museum
of Contemporary Art

Giuseppe Penone's interest since his beginnings in the 1960s was in elements from the natural environment, seen as depositories of uncontaminated primordial forms. From 1967–68 this focused on the tree as its privileged vehicle. Through a process of 'unveiling' original shapes the artist arrived at the essence of what had been transformed by the human hand. As Penone himself explained, behind every piece of wood 'there is the shape of a tree, fossilised within'. At the basis of this operation lies the '…curiosity to discover it, behind the appearance of every door, table or window, that enclose each time a new adventure story'. Through Michelangelesque sculpture of 'removal' the artist reconstructed the image of the tree at a given age.

Albero libro is from the artist's mature period and exemplifies well his research. Seven wooden beams casually leaning against a wall have been progressively carved out to reveal a thin tree trunk within. This recovered natural form appears within each beam, which has been transformed by the work of the artist to resemble an open book. An ancient depository of knowledge, the book seems to tell the story of the natural evolutionary process, 'from growth up to the moment when human hands, or perhaps a natural event, brought it to a halt' (Penone 1980, in Celant 1989).
A.M.

By the end of the 1960s most of the Italian protagonists of the brief but decisive Arte Povera moment that was quickly gaining international recognition identified with conceptual artistic research, with its uninterrupted exploration of a metaphorical language. In the early years Arte Povera artists had felt the need to verify the level of existence in real things, perceived as natural entities. A decade later, however, artists such as Pistoletto, Merz and Boetti progressively directed their research towards Conceptualism, from action to thought, privileging almost exclusively the thought process rather than the material execution of the work.

In Italy Giulio Paolini was the artist closest to this trend. His work creatively investigated history in a purely conceptual key, establishing a continued relation between the image and the way in which it is 'conceived'. Made up of obvious signs, ambiguous meanings and 'successive discoveries', Paolini's work gradually developed also with the use of words.

In those same years Alighiero Boetti theorised on the priority ideas should have over the realisation process in a work: order and disorder, chance and necessity, similar and different. Art was therefore questioning itself, the only duty it had to perform was to investigate on its own essence and arrive inevitably at the pure tautological affirmation that 'art is art'. Therefore, if all forms of expression have been tried, along with all materials, means and representational techniques, art has no other choice but to reflect on what it is made of.

Although not their exclusive expression, this context was certainly the privileged environment of Gino De Dominicis and Luigi Ontani. The conceptual behavioural performances of De Dominicis, in which he investigated the principles that govern life and death through impossible feats, have become legendary. Ontani instead used his own body in an ironic, self-referential key. From the end of the 1960s the artist's performances, photographs and ceramics complacently featured Ontani posing as saints, heroes and mythological characters from the traditional iconographies of eastern and western cultures.

A.M.

Jannis Kounellis,
Senza titolo (12 cavalli), 1969
Installation in Rome,
Galleria L'Attico

Michelangelo Pistoletto
86. *Dietrofront, Piazza Tienanmen* (About Turn, Tienanmen Square), from the *Anno Bianco* project, 1989
Photographs and wood, 370 x 123 cm each
Biella, Pistoletto Foundation

The *Anno Bianco* project was conceived in December 1988 for the artist's solo exhibition at the Perugia Academy. It is the result of several works completed in 1989 and intended to be a kind of mirror of the year's events.

The expression *Anno Bianco* is meant to signify a period of time that unfolds over 365 days alongside the artist's actions and works (Corà 1992), like a perpetually open breach ready to absorb historical and artistic phenomena. Like the pages of an unwritten book the *Anno Bianco* is immaculate, spotless, ready to the traces of history as it develops.

It is impossible to establish exactly the number of works that make up the project. The first was certainly a simple blank card with the *Anno Bianco* inscription used as the invitation to the Opera gallery in Perugia, where Pistoletto was presenting his book *Quarta generazione* (Fourth Generation). In February the artist exhibited a large poster with the *Anno Bianco* inscription in the street outside Turin's Persano gallery, among other advertising billboards. The same month he exhibited in New York some large white chalk slabs, similar to sheets of paper, leaning on the walls of the Jay Gallery. As the year went by these works were joined by some photographs of works and events considered by the artist as particularly representative. Although conceived at different times, *Dietrofront* and *Piazza Tienanmen* are two photographs that should be considered as two pages of history. *Dietrofront* is the image of a sculpture completed by Pistoletto in 1981, while *Piazza Tienanmen* is an image that documents the statue built by Chinese students on Tienanmen Square in 1989 and destroyed during the suppression of the revolt.

For mankind the statue has always represented an atavic means to recognise itself. In this case there is a striking formal analogy between the two works, which resemble one another despite having been made by two different people in two totally alien situations. The photograph in this case creates an extemporal tie between the works, revealing totally unforeseeable analogies.
A.M.

Mature Conceptualism of the Arte Povera Protagonists

Alighiero Boetti
87. *Mappa* (Map), 1972
Embroidered fabric, 170 x 220 cm
Rome, Agata Boetti collection

The embroidered maps complete the series of geographical works started by Boetti in 1967. Like the series of works on time, they stem from the artist's conceptual research. The idea of the map adheres to two of the principles at the basis of Boetti's art: the exclusion of the ego or any action on behalf of the artist (who can still be substituted by someone else), and an attention to a notion of beauty produced by combining the artist's idea with the skill of those actually carrying out the work.

The idea was conceived in June 1967, when Boetti cut out the borders of twelve nations at war featured on the Turin daily *La Stampa* and etched them on twelve copper sheets. 'These drawings were not the fruit of my imagination but came from artillery fire, air raids and diplomatic negotiations.'

Two years later Boetti used the colours on each country's flag to colour the national territories of his *Planisfero politico* (Political Geo-Sphere). The artist was careful to show the real relations of power in the world without specifically giving a single shape to each state. The two large blocks of colour represented by the US and the USSR and their satellite nations show how much the artist is interested in how man has split up the world, always keen to divide himself from his neighbour rather than unite or connect. From the starting point of the idea of maps begun in *Planisfero*, Boetti arrived at a methodological extremism. 'The work of embroidering maps epitomises beauty for me. I haven't done anything in this work. I didn't choose anything in the sense that I didn't draw the world. Once the basic idea has emerged, the concept, I don't choose anything of the rest.' In March 1971 Boetti travelled for the first time to Afghanistan. In September of the same year he visited the country a second time with a project for the first map which he gave to be embroidered by Afghan women. He was to remain strongly tied to the country thereafter, even returning to the Pakistani city of Peshawar to visit the Afghan refugee camps after the Soviet invasion in 1979. All Boetti's successive embroidered works were completed by local workers, from his maps to his tapestries and his last carpets. As well as assuming some of the Afghan customs, Boetti also became a collector of local craft and rugs.

This map was embroidered by Afghan women to celebrate the birth of Boetti's daughter Agata. The writing around the edge reads 'Agata Boetti, 16 March 1972, 29 made in Kabul, Afghanistan, Spring 1972'. The same text is embroidered also in Farsi and dated according to the local calendar.
This work has never previously been displayed to the public.
A.M.

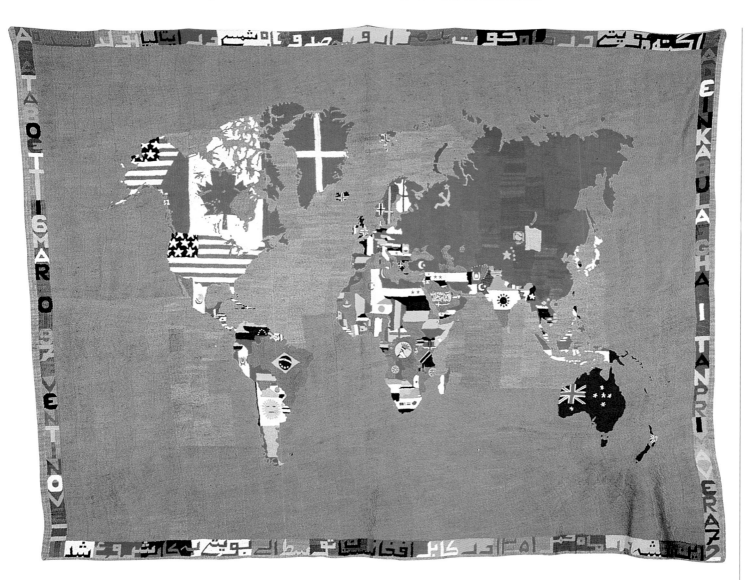

Luciano Fabro

88. *Nord Sud Est Ovest giocano a Shanghai (North South East West Play Mikado)*, 1989–94
Aluminium and iron,
c. 300 x 300 cm
Naples, Museo di Capodimonte

The value of *Nord Sud Est Ovest giocano a Shanghai* lies in the refined and complex equilibrium between its geometrical scheme and casual arrangement.

The work is composed of an aluminium frame suspended by cables on which rest two dozen thin coloured tubes that form an irregular grill shape similar to the casual arrangement of sticks in the Oriental game of Mikado, also called Shanghai. Beneath the frame Fabro has freely arranged seven thin shafts of coloured metal that are slightly curved at the centre. As Bruno Corà wrote, '...the metal shafts are the only presence in the room, almost like hypothetical "players". They mark out an area of the floor in the museum decorated with a grill of polychrome marble'. For Fabro the exhibition space was a meeting point between external reality and the inner world. His research in this direction took him over a number of years and brought him to create in early 1980 environments that involved the viewer in a sensorial experience. He labelled these works *Habitat*. In them he used instantly recognisable images of which he altered the original function, as in *Shanghai*, conferring on them an unpredictable and outsized significance.

The work stemmed from the various projects Fabro made for the *La Casa di Melani* exhibition held at the Castle of Rivoli as a tribute to the deceased Pistoiese artist. It was given a preview showing in the Salone dei Camuccini of the Capodimonte museum in Naples. As Fabro himself underlined, '...the image stands on the borderline between the free and the geometrical [...] an important element is the sense of the Shanghai game, a recurring theme in my work because I play with chance'.
A.M.

Mature Conceptualism of the Arte Povera Protagonists

Giulio Paolini

89. *Ennesima* (Umpteenth),
1975–88
Rome, Galleria Nazionale
d'Arte Moderna

Ennesima is one of Paolini's mature works after his involvement with Arte Povera. The artist has given a nominal value to the three elements that make up the work: colour, writing and time. By following a process of progressive linguistic condensation, the work starts off with writing, passes to signs and a simple chequering of the sheet and ends up totally black to indicate total absence. Paolini's insistence on the logical and linguistic structure of painting, as well as what lies at the limit of a picture, brought him to create a refined semantic manipulation.

It is impossible to give a definitive interpretation of Paolini's work since he does not follow established theses. The works instead develop through a sequence of logical thoughts.
Ennesima could therefore also be read the other way round, from total absence and denial of colour to the progressive manifestation of language. The very title of the work in fact indicates the infinite nature of this process.
A.M.

Gino De Dominicis

90. *Foto ricordo della Seconda soluzione d'immortalità (l'universo è immobile)* (Souvenir Photo of the Second Solution to Immortality [The Universe is Motionless]), 1972
Photograph, 51 x 63 cm
Naples, Lia Rumma collection
L'immortale, L'invisibile e Il luogo (The Immortal, The Invisible and The Place), 1989
Wooden chair, 100 x 50 x 50 cm
Switzerland, Guntis Brands collection

Foto ricordo della Seconda soluzione d'immortalità was the only image directly authorised by the artist to be presented at the 1972 Venice Biennale. The *Seconda soluzione d'immortalità (l'universo è immobile)* is in fact one of the most significant results of De Dominicis' research.

It deals with fundamental and complex themes such as the problem of death and physical immortality, the end of history, artistic creation seen as an 'anti-entropic' practise capable of contrasting the irreversible nature of time. In the 1972 installation the artist invited Paolo Rosa, a Venetian affected by Down's Syndrome, to sit in the corner of a room. The room contained an 'invisible' cube, a rubber ball 'in the moment just before bouncing' and a stone 'awaiting a casual and general molecular movement'. For De Dominicis these three geometric shapes best summarised the eternal dimension.

The mentally handicapped young man sitting in motionless contemplation of the objects in the room suggested the inadequacy and the inability of man to understand the truly eternal dimension of things. Judged to be scandalous on account of its using a young man affected by Down's Syndrome, the installation ran for only a week and has never been reproduced since. Given that the artist himself chose the angle of the *Foto ricordo*, this work has acquired a special historical value as a specific document.

Like his life, the work of De Dominicis was the result of his awareness of the vices of contemporary art circles, which he constantly challenged with his derisory behaviour. The subversive and non-aligned features of his art were the fruit of his own unpredictable and irreverent strategy.

It could be true to say that *L'immortale, L'invisibile e Il luogo* is yet another face of the same coin, another ironical angle of his art. De Dominicis completed the work in 1989, drawing on themes he had already dealt with at the beginning of the 1970s.

In November 1971, at the Rome exhibition *Incontri Internazionali d'Arte*, De Dominicis seated an old man and a young man on two metal chairs suspended opposite one another some three metres from the floor. The two men stayed like this for the entire evening, almost touching the vaulted ceiling of Palazzo Taverna, unable to move or converse. They were in a dimension with no spatial or temporal coordinates, utterly in a void.

In *L'immortale, L'invisibile e Il luogo*, although the artist is again suggesting the existence of a dimension other than the terrestrial, he is denying this experience to mankind. A small wooden chair in fact hangs empty from the ceiling in a corner of a room. The work appears to exemplify one of De Dominicis' personal beliefs: 'art concerns genius and its space is vertical. It doesn't move horizontally from right to left, or vice versa, but from high to low, immobile'.The chair is suspended in the air and therefore unusable. The extra-temporal dimension has therefore been denied and man remains in his condition of immobility.
A.M.

Neo-Conceptual Provocations: Gino De Dominicis and Luigi Ontani

Luigi Ontani

91. *Autoritratto in cartamodelli dorati* (Self Portrait in Golden Paper Patterns), 1980–81
35 Indian inks on shaped card, sewing needles, urn, gilded wood and silk
Private collection of the artist

Since his debut in the early 1970s Ontani's research has focused on the infinite manipulations of his own body and his multi-faceted personality.

As Francesca Alinovi aptly stated, the artist in his *tableaux vivants* 'projects his own ego into a gallery of familiar figures taken from mythology, literature and the figurative arts'. Thus Ontani has always appeared in a variety of guises, from Narcissus to Bacchus or a centaur. The artist's many appearances are taken from the Renaissance tradition of myths and saints. Ontani seems to have an utterly mental vision of his own body, which only becomes flesh in a state of perennial immobility when it takes on the semblance of this or that unreal figure. His entire work is utterly self-referential, underlined by a playful narcissism that only reaches satisfaction in his by now many travesties.

In an exhibition in 1981at the Diacono gallery in Rome Ontani decided to show one of the most fascinating and precious of his countless self-portraits. Along the walls of the gallery he spread 'like liturgical vestments, the gilded fragments of his paper being', while a gilded wooden urn lay sumptuously on the floor, padded with cardinal red silk. Alinovi described this work as Ontani's finest self-portrait. The artist has finally freed himself of his own semblance and 'spread his skin like a tailor's paper pattern, a skin that makes no shadow because it sticks to the walls as if itself were a shadow'.

A.M.

IX. The 1980s and the Crisis of the Concept of Modernity

The early 1980s marked a decisive turning point for art in Italy, previously known internationally for its research in Conceptualism.

By now two decades old, Conceptual art was evidently beginning to lose its impetus. An opposition expressed itself through a progressive return to traditional painting and sculpting techniques and to the origins of art history. This occurred in tandem with post-Modernism in architecture. In art this new movement was labelled Transavanguardia, represented here with works by Cucchi, Clemente, Chia and Paladino.

Backed by the theories of the art critic Achille Bonito Oliva, Transavanguardia created a new strain of iconic painting that, in its more convincing manifestations, featured a return to Italy's past. The movement in fact 'revisited' the familiar haunts of the Italian pictorial language, even going as far as re-exhuming the expressive motifs of past avant-garde movements. Through this form of stylistic 'nomadism' 'Transavanguardia considers language an instrument of transit from one work to the next [...] following a nomadic attitude of reversibility concerning all past forms of expression' (Bonito Oliva 1980).

Art had once more become the vehicle for the artist to express his emotions. The canvas was thus covered once more with a dense pictorial matter in a succession of hallucinatory or visionary images charged with the pulsation of the subconscious and of the artist's inner dimension.

After its launch at the 1980 Venice Biennale the repercussions unleashed by Transavanguardia soon spread outside Italy. The group established itself either collectively or in one-man shows in a series of highly successful exhibitions in Europe and the United States, making it Italy's most important contribution to the post-modernist international art scene.

A.M.

Aldo Rossi, *Il teatro del mondo*, Venice, 1980

Mimmo Paladino
92. *Il visitatore della sera*
(Evening Visitor), 1985
Oil on canvas, 200 x 155 cm
Rome, Giorgio Franchetti
collection

The work of Mimmo Paladino depicts a primitive, enigmatic universe populated by powerful and elementary forms. The artist embraces traditional expressive means such as painting, sculpture and graphic art, using them to create deeply magical images that are an anthropological thought on contemporary mankind in an exquisitely Mediterranean light. Like other artists of Transavanguardia, Paladino makes ample use of quotation in his work, combining this with a return to man's deepest memories where shapes are suspended in time. Paladino's visions draw on a variety of artistic territories that range from distant history to far-reaching geography, and use a complex but controlled game of metaphors.

Il visitatore della sera is a re-elaboration of one of the best known works of the 17th century, Diego Velázquez's *Las Meninas* (1656). Paladino has kept the composition and essential elements of the original painting, thereby allowing the viewer to recognise the original work despite its distortion. Paladino re-interprets this masterpiece by Velázquez by stripping it of every period detail in an effort to heighten the work's intrinsic message.
A.M.

The 'Italian Manner' in Post-Modernism: Transavanguardia and Return to Classic Techniques

Sandro Chia

93. *Malinconico accampamento* (Sad Encampment), 1982
Oil on canvas, 290 x 404 cm
Tokyo, Museum
of Contemporary Art

The expressive language of Sandro Chia combines motifs from ancient and modern art in a brightly coloured style of painting that relies on heavy brushwork. As Achille Bonito Oliva underlined in his *La Transavanguardia Italiana*, 'Through painting Sandro Chia puts into practise the theory of a manual ability assisted by an idea, by a hypothesis that takes form through a figure or sign'.

The importance of the manual action and of a re-discovered pleasure in painting are combined with constant references to past history, both of art and of man to form a vision that is both cultural and psychological.

Malinconico accampamento features an assortment of evocative images of different worlds, a Native American, symbol of a primitive culture in touch with nature, is lying in a typically melancholic pose; a medieval-style tent; piles of huge paintings surrounding it.

The protagonist is placed in a dream-like landscape full of quotations and charged with symbols, as so often occurs in the work of Chia. The incongruous, unstable surroundings appear as if they were a direct projection of the figure's dreams.

One of Chia's most convincing works, abundant use has been made of intense colours. The painting is fully part of that intellectual and stylistic 'nomadism' characteristic to exponents of the Transavanguardia movement, a practise that allowed them to re-evoke and bring up to date any moment from the history of culture and mankind.
A.M.

135

Enzo Cucchi

94. *Succede ai pianoforti
di fiamme nere* (It Happens
to Black Flaming Pianos), 1983
Oil on canvas, 207 x 291 cm

One of the leading exponents of the Transavanguardia movement backed by the theories of the critic Achille Bonito Oliva, Enzo Cucchi's style is of a strongly experimental nature. Not only did he use alternative materials and supporting elements such as wood and iron, Cucchi also combined his own great visionary capacity.

For Marches-born Cucchi the space of the image was an extension of his own ego, a never-ending source of energy. Although his paintings feature elements from the real world they offer a transfigured vi-

sion, a microcosm of figures and objects descended directly from his own fantasy. In 1984 Cucchi started working on a series entitled *Vitebsk/Arar*, indicating the place where Kazimir Malevich started teaching in 1919 and the Ethiopian city to which the French poet Arthur Rimbaud moved. Images of a piano and skulls feature with an almost *leitmotif* frequency in these paintings and are associated by the artist with the vision of a disturbing desert landscape. Completed in 1983, *Succede ai pianoforti di fiamme nere* appears to be fully in line with the *Vitebsk/Arar* series. A black piano spouting flames is placed in the foreground of a dark and desolate landscape in which dozens of skulls lie half buried in an oblong pit. Despite having been

completed a year before Cucchi's famous *Vitebsk/Arar* series, the substance and colour of the painting in *Succede ai pianoforti di fiamme nere* is much along the same lines, making this one of the finest examples of the artist's research.
A.M.

The 'Italian Manner' in Post-Modernism: Transavanguardia and Return to Classic Techniques

Francesco Clemente
95. *Rudo*, 1981
Fresco, 211 x 145 cm
Milan, private collection
(courtesy of Claudia Gian Ferrari)

In 1980 Francesco Clemente took part in the 39th edition of the Venice Biennale, which marked the successful debut of the Transavanguardia movement. Presented at the Biennale by the critic Achille Bonito Oliva, Clemente's immediate success was shortly repeated in New York, where he settled in 1981. *Rudo* was completed the same year the artist moved to the United States using the fresco technique that he had already experimented with in the 1970s when he was living in Rome. Although one of Clemente's early works, *Rudo* contains all the characteristics typical of the artist's obsessive symbolism: a strong and lively chromatic range, biomorphic elements and grotesque inventions that verge on the absurd. Clemente draws on a variety of sources for the images in his paintings, ranging from the Italian Renaissance to Indian miniature painting, Romanticism and Expressionism.

The artistic language in *Rudo* is purely evocative, with the forms suspended between dream and reality that lack any precise descriptive or narrative purpose. They are mythological figures caught in a fraction of a story that will remain forever a mystery. Perhaps they are the fruit of simple mental associations, or mere presences from an enchanted world only visible in fragment form.
A.M.

X. From 1989 to the Present Day.
A Historical Turning Point: the Fall of the Berlin Wall and the End to the Power Blockade.
Virtual Universe and Global Communication.
The Artist's Answer: Individualism, Nomadism, Neo-Romanticism

By the end of the 1980s the whole contemporary art system was undergoing a crisis. The interest in Arte Povera that had long outlived the movement itself had been followed by the explosion onto the world art scene of Transavanguardia.

The economic crisis that followed badly affected high-profile galleries and the critics associated with them, leaving the field open to a new generation of artists, young curators and independent galleries.

Young artists now seemed to turn away from museums and large cities in favour of abandoned industrial buildings, venues offered by their gallerist friends and all sorts of public spaces in small towns. In 1985 Stefano Arienti had an almost casual debut when he coloured in chalk the walls of Brown Boveri, an industrial structure at the outskirts of Milan. The same randomness marked the entire generation of artists born after 1960, apparently bound by a common lack of structure in their artistic forms of expression as well as by the cultural nomadism of globalisation and the virtual world.

Whilst allowing the use of traditional techniques that had nonetheless been transposed from the Conceptual, there is a highly developed aesthetic sense that is the common denominator of artists such as Arienti, Airò, Beecroft and Toderi. Their works all display a meticulous attention to detail and draw on a vast range of expressive means, be they drawing, environment art, performance or video, proof of the desire to experiment with as many linguistic tools as possible.

The autobiographical and self-referential element strongly distinguishes a whole generation of artists who use images from every day, transitory life lived amidst uncertain values that has fired the need for a return to the roots of poetic expression and individuality.
A.M.

Zaha Hadid, model for the
Centro Nazionale per le Arti
Contemporanee in Rome, 1999

Stefano Arienti
96. *Senza titolo* (Untitled), 1996
Electrostatic print on paper,
120 x 320 cm
Rome, Galleria Nazionale d'Arte
Moderna

Despite his young age, this work is part of Arienti's mature period of artistic research. It was featured in the 12th edition of the Quadriennale *Ultime Generazioni* (Young Generations) in 1996 and in the *Partito Preso* serial exhibition of 1996 at the Galleria Nazionale d'Arte Moderna in Rome, dedicated to recent Italian artistic phenomena.
Since the year of his 'casual' debut in 1985 at the Brown Boveri factory in Milan Arienti began working with a variety of materials including pastel, chalk, plastic and paper.

The endless and laborious techniques he adopted either created or destroyed the objects and subjects that he modified and manipulated through a slow process of deconstruction and reconstruction.
A wry and pitiless critic of the obsessive use of images, Arienti puts himself continually on the line before the responsible gaze of the viewer. He performs a conceptual and experimental exercise on the expressive potential of the most ordinary materials, always with a different treatment that results in a different image and a different meaning.
Arienti's production in the 1990s was made up of a series of specific but completely independent researches. It is therefore difficult to represent this artist with one single

work. We have chosen to show a photographic work whose large surface has been entirely lacerated by cuts from a blade. The face of the woman portrayed is totally erased in several places, rendering it utterly unrecognisable.
This repeated and simple manual action, deprived of any apparent artistic sense, of propping up a piece of paper and then erasing parts of it with meticulous precision, is the process of affirmation and eradication of an image that Arienti continually unleashes with different and surprising results each time.
A.M.

Recent Researches through New Techniques: Non-Style and Installation

Mario Airò
97. *Springandela*, 2000
Five projectors, slides,
mini-disc audio system, sand,
dimensions determined by
environment
Rome, Centro Nazionale
per le Arti Contemporanee

Springandela is the work for which
Airò was chosen as one of the four-
teen finalists for the Young Italian
Art Prize 2000. It was presented at
the *Migrazioni* exhibition for the in-
auguration of Rome's national cen-
tre for the contemporary arts.
Arranged in a darkened room the
installation offers the viewer a
stimulating perceptual experience.
Five projectors placed on the ceil-
ing project images of tracks left by
lizards and other small animals in
the desert towards the floor. The
floor is covered in some areas by
a thin layer of fine white sand. The
images within the projectors also
display a petri-dish containing
some prints by Giordano Bruno.
As the artist explains, the combi-
nation of the sand projected in the
images and the real sand on the
floor creates a totally unique im-
pression of 'tactile clarity and opti-
cal fluidity'. The mysterious draw-
ings by the philosopher combine
with the tracks on the sand and the
music that fills the room. This mu-
sic has been mixed by the artist
himself, taking Aborigine chants
and combining them with a record-
ing of the voice of his infant son,
'like an echoing countermelody'.
The adult chants are therefore
mixed with the playful refrain of the
child, almost as an expression of
the feeling of vastness and mystery
that surrounds the legendary 'song
lines'. The work is evocative of
these 'pathways', told of in the sto-
ries of the ancestors, that formed a
network for orientation and were
used to explore unknown parts of
the world. Within this context of
memory and tradition Airò has
placed 'the drawings of Giordano
Bruno, the fruit of his desire to de-
pict and outline the invisible'.
Springandela is therefore a work
animated by subtle correspon-
dences: the casual and voluntary
signs on the sand are almost or-
ganised as a system of orientation,
ultimately becoming memory and
seat of knowledge.
A.M.

Grazia Toderi

98. *Il fiore delle mille e una notte*
(The Flower of a Thousand and
One Nights), 1998–99
Video projection
Milan, Rosa and Gilberto
Sandretto collection

Of the younger Italian artists Grazia
Toderi is the one who has most fre-
quently and continuously made
use of video, the privileged creative
medium of the latest generation.
The video *Il fiore delle mille e una
notte* was first presented in Febru-
ary 1999 as part of a theatrical pro-
duction by the Virgilio Sieni com-
pany inspired by the Pier Paolo Pa-
solini film of the same name. The
same year it won the Leone d'Oro
at the Venice Biennale.
The work is made up of a title and
eight nocturnal scenes set in Bagh-
dad, 'a land of fairytales, deserts
and spaceships', in which the artist
evokes an imaginary and fantasti-
cal Orient. 'The palindrome number
1001 appears in one of the se-
quences and symbolises the pro-
gression towards infinity in that it
is reversible. Visually the number
can be a 10 or a 01 when placed in
front of a mirror, the numbers 1 and
0 being the two absolute numbers
that represent existence and non-
existence'. The decision to include
eight sequences in the work is al-
so symbolically related to the idea
of infinity, signified by the hori-
zontal 8.
The work of Toderi is underlined by
a lyrical sense within a minimal
tale. Each single still frame of the
work sublimates the moment cho-
sen by the artist. Compared to the
purely documentary nature of pre-
vious works, however, *Il fiore delle
mille e una notte* adds 'greater ar-
ticulation to the tale, that becomes
a window to lean out of and dream
of a universe of fantasy' (Pinto
2001). The artist has attempted to
create on a table in her own home
the atmosphere of a Baghdad on-
ly ever seen in her imagination.
A.M.

Recent Researches through New Techniques: Video and Performance

Vanessa Beecroft

99. *Senza titolo* (Untitled), 1994
(two elements)
Acrylic on canvas,
150 x 100 cm each
Property of the artist, on free loan
to the Galleria Nazionale d'Arte
Moderna, Rome
Suzanne, 1996
Tine, 1996
Photographic prints,
100 x 100 cm each
Rome, Galleria Nazionale d'Arte
Moderna

Presented at the 12th edition of the
Quadriennale *Ultime Generazioni* in
1996 and at the *Partito Preso* seri-
al show organised in June 1997 by
the Galleria Nazionale d'Arte Mo-
derna in Rome, these four works
are part of Vanessa Beecroft's ear-

ly output. Both the acrylics (1994)
and the two large Polaroid prints
(1996) contain elements that typify
the research of this young Genoese
artist. Ever since her first exhibition
in 1993 Beecroft has focused on the
female personality and on the uni-
formity and identity loss in post-
modern society.

The thin women Beecroft uses in
her performances are all in fact cho-
sen for their strange and disturbing
resemblance, rendered even more
striking by the use of wigs, clothes
and other accessories. These works
display the artist's obsession with
physical appearance personified
by these silent, almost robotic and
increasingly similar girls. The girls
therefore form the basic material
for Beecroft's compositions, be
they performance art, photography

or her thinly traced drawings. In
each of the red and blue acrylics the
figure is only vaguely outlined, al-
most resembling a blot of colour on
the white canvas. The two Polaroid
snapshots echo the essential nature
of the acrylics. They are among the
first ever taken by Beecroft, who in
fact instead of using models has
probably photographed two of her
art school friends. Although the two
sitters are completely different they
appear surprisingly similar thanks
to the binding element of the wig
and their absent expression.
A.M.

Luisa Lambri

100. *Untitled (Apartment Block)*,
2000
Cibachrome on aluminium,
100 x 70 cm
Courtesy of Studio Guenzani,
Milan

Although lacking any human presence, the spaces photographed by Luisa Lambri do not have any negative connotations with desolation. To the contrary: the silence and total absence of things or people serve to underline the geometrical purity of the represented forms. The subjects chosen by the artist are rooms, corridors, doors, windows and transit areas encountered by Lambri on her travels. She is particularly attracted to examples of Modernist architecture by architects such as Le Corbusier, Alvar Aalto and Mies van der Rohe. The rationalist nature of these buildings functions as the starting point for Lambri's research into meaning.

In her *Apartment Block* series completed in 2000, Lambri has photographed the recent work in Tokyo by the Japanese architect Kazuyo Sejima. This is the first time Lambri has photographed a building by a living architect, as well as by a woman. The artist has highlighted the lightness and immaterial transparency of the interiors, presenting them as neutral and abstract places, almost a projection of her own mind. The only active element is provided by light, that shapes the spaces.

The long corridors paved with veined marble along with the bluish reflections cast by the windows are simply 'hypothetical places', virtual rooms that exist in a totally psychological dimension.
A.M.

Recent Researches through New Techniques: Photography

Indexes

Biographic Index

The initials S.F. refer
to the editorial collaboration
of Stefania Frezzotti

Biographies

Carla Accardi
Trapani 1924

Accardi began painting soon after the Second World War as part of the Rome abstract group Forma 1, whose manifesto she subscribed in 1947. Her references were the great turn of the century abstract masters: Kandinsky, Klee, Mondrian. Her crisis year in 1953 marked a shift in style towards the use of signs, beginning with her black and white period. Accardi declared: 'I began in 1947 but until 1954 I was mastering form, experimenting with language. Before 1954 I had a year of crisis during which I had the idea of trying black and white painting, as a form of anti-painting…'. In 1955 Accardi was invited by Tapié along with Burri, Capogrossi and Fontana to the *Individualités d'aujourd'hui* show in Paris. In 1959 Restany presented her solo exhibition at La Salita gallery in Rome, displaying her most recent work in which the first colour appeared and in which the sign structure had changed. In 1964 Accardi stopped using bright colours and began working with sicofil. The same year she had been allocated her own room at the 32nd Venice Biennale and had been featured in a group show at the Notizie gallery in Turin where she had exhibited her first works with fluorescent colour painted on transparent plastic surfaces, *Rotoli* (Rolls). Throughout the latter part of the 1960s Accardi was involved in the artistic climate of the period in which art is placed within its environment. From this period came her works *Tenda* (Tent), *Ambiente arancio* (Orange Environment) and *Triplice tenda* (Triple Tent) of her *Tenda* series. During the following decade Accardi continued to work mainly with plastic, while her colours lost their intensity. By the middle of the 1970s the sicofil had become completely transparent. In the 1980s Accardi went back to the canvas. In 1999 she was appointed a member of the commission for the 47th Venice Biennale, curated by Germano Celant. She lives and works in Rome.
R.C.

Mario Airò
Pavia 1961

Mario Airò studied at the Brera Academy with Luciano Fabro. In 1989 he founded along with other young Milanese artists the magazine *Tiracorrendo* and began collaborating with the independently managed exhibition space in Via Lazzaro Palazzi, together with artists such as Liliana Moro and Bernhard Rudiger. Every-day objects such as hats, beach parasols and chairs had strong poetic connotations for Airò, who included them in his unusually symbolic installations. This procedure of giving importance to otherwise banal objects induces the viewer to contemplate them as if they had never been seen before. His installations, which use a variety of materials and techniques, rely strongly on the architectural element and stand out for their ability to mould their surrounding space, broadening the boundaries of the work beyond normal perception.
As from 1991 Airò began collaborating with the gallerists Massimo Mininni in Brescia and Massimo De Carlo in Milan. In 1994 he completed *Unité d'Abitation* (Living Unit), a small brick house built inside De Carlo's gallery. During the same period Airò took part in a variety of international shows such as Sonsbeek in 1993, the Kwangju Biennale in 1995 and *Zeichen und Wunder* in Zurich in 1995. In 1997 he took part in the Venice Biennale and two years later at New York's *Minimalia* show organised by PS1. In 2000 Airò was among the fifteen finalists for the Young Italian Art Prize organised by Rome's Centro Nazionale per le Arti Contemporanee, for which he completed the evocative installation *Springandela* presented here. Like many of Airò's works, this installation acts on the viewer's emotions before his intellect, unleashing a chain of simple but intense feelings.
In 2001 Airò had his first solo exhibition, *La Stanza dove Marsilio sognava di dormire… e altri racconti* (The Room Where Marsilio Dreamt of Sleeping… and Other Tales) in a museum space. The Turin Galleria d'Arte Moderna has in fact dedicated a large exhibition to his work, confirming him as one of the most interesting figures on the contemporary Italian art scene.
A.M.

Stefano Arienti
Asola (Mantua) 1961

Born in a small village in Lombardy, Stefano Arienti graduated in agriculture. Of the youngest generation of artists he is the one whose artistic development ties in most with events in Italian art history, tinged with a feeling of transience and nomadism. His artistic career, however, started almost by chance, when in the spring of 1985 he decorated the walls of the abandoned Brown Boveri factory on the outskirts of Milan.
Descended from Conceptualism, Arienti's work purposefully negates a personal style and draws on a variety of sources, from the still relevant work of Alighiero Boetti in the mid-1980s to the transgressive teachings of the critic and patron Corrado Levi, who had just returned from his experience of the euphoric New York art scene. Arienti emerged in such a major moment of crisis on the Italian art market.
Still followed by Corrado Levi, in 1986 Arienti exhibited at former Zenit shoe factory in Ferrara and at Volpaia, where he presented his *Turbine* made from train timetables and comic strips folded into cylinders.
Arienti's first solo exhibition was in 1987 at the Guido Carbone gallery in Turin. At the Studio Guenzani in Milan, in 1989, he presented his puzzles made up of sections of riddles, images of flowers, landscapes and works of art. At the beginning of the 1990s he took part in the *Aperto* section of the Venice Biennale, where he presented corroded pieces of polystyrene on which he had traced images. The same year he took part in the exhibition *Una scena emergente* organised by Hamnon Barzel at the Museo Pecci in Prato.
At this point Arienti began his manipulation of images with perforations and scratches, to the extent that the original images were cancelled out. He presented these works at the Centro de Arte Reina Sofia in Madrid and at the serial exhibition *Partito Preso* organised by the Galleria in 1996.
In 2000 Arienti won the Young Italian Art Prize organised by the Cul-

ture Ministry, completing a work for *Migrazioni*, the opening exhibition of the Centro Nazionale per le Arti Contemporanee. Entitled *S.B.Q.R. Orsi italiani, netnude...* (S.B.Q.R. Italian Bears, netnude...), the work is from the artist's most recent period in which he has worked on images of gay couples in loving and affectionate poses.

A.M.

Giacomo Balla
Turin 1871 - Rome 1958

In 1895 Balla moved to Rome after following the courses of the Accademia Albertina in Turin and frequenting the divisionists Pellizza and Segantini. In Rome he met artists and writers of the Agro Pontino School, among whom were Duilio Cambellotti and Giovanni Cena. In 1903 Balla took part for the first time at the Venice Biennale. He was featured at the Salon d'Automne in Paris in 1909. His first works made use of divisionist techniques and displayed an interest in social issues, particularly in social outcasts, such as the poor, beggars, the old and the sick. In a very short time Balla became a leading light in the Rome art circle. Among his pupils were Boccioni and Severini. 1910 marked the end of Balla's divisionist period when he joined Futurism, subscribing to the *Manifesto dei pittori futuristi* (Manifesto of Futurist Painters) and the *Manifesto tecnico della pittura futurista* (Technical Manifesto of Futurist Painting). Balla began analysing dynamism, helped also by the experiments in photo-dynamics made by Bragaglia (*Le mani del violinista*, The Violinist's Hands, 1911–12; *Dinamismo di un cane al guinzaglio*, Dynamism of a Dog on a Leash). Between 1912 and 1913 Balla completed his *Compenetrazioni iridescenti* cycle, in which he experimented with the breaking down of light into abstract geometric shapes. Balla continued to develop his study of movement by researching into kinetics and the velocity of cycles. Although he obtained very different results (*Voli di rondini*, Swallows in Flight, and *Velocità di automobili*, Speed of Cars), this brought him close to the work of Duchamp. In 1913 Balla met Prampolini and Depero the following year, with whom in 1915 he signed *Ricostruzione futurista dell'universo* (Futurist Reconstruction of the Universe). Balla now began composing his *parolibere* (free words) and published the manifesto *Vestito antineutrale* (Anti-Neutral

Dress), as well as painting patriotically inspired and interventionist works such as *Insidie di guerra* (War Snares), *Forme grido Viva l'Italia* (Long Live Italy Cry Form). On several occasions he was arrested during demonstrations in favour of Italy joining the war. In 1917 Balla designed the luminous sets for *Feu d'Artifice* by Stravinsky, performed in Rome by Diaghilev's Ballets Russes. A year later the Bragaglia gallery dedicated a one-man show to him. From this moment onwards Balla concentrated more on work in the applied arts. Between 1918 and 1924 he produced his *Stagioni* (Seasons) series of 'new spiritual landscapes of the cosmic soul', in which he developed the theme of 'universal vibration'. The vision of space lost the plastic construction present in his previous paintings in favour of a return to the atmospheric transparency of vortexes and sideral visions. In the *Stagioni* series, the spiritual element transpires both in the title and in the rippling colours and thought. Throughout the 1920s Balla continued to act as mentor also for young artists of the second futurist period. Along with Benedetta, Depero, Fillia, Marinetti, Prampolini and Tato in 1929 Balla signed the *Manifesto dell'aeropittura* (Aero-Painting Manifesto). In the 1920s he passed through a deep crisis with Futurism, now considered unable to produce anything new. As far as his painting was concerned, from 1925 Futurism was only vaguely alluded to. Balla introduced an autobiographical element to his work and an attention to the mystical effects of light within compositions that were by now realist in style. After Balla's formal break with the futurists in 1931 his work became exclusively figurative, albeit with the occasional privately nostalgic relapse into the genre. The works presented at the 1930 Venice Biennale, the I and II Rome Quadriennales and at Balla's solo exhibition at the San Marco gallery in Rome in 1942 all confirm this tendency towards absolute realism, which Balla himself declared to be 'pure art'.

S.F. - M.M.

Vanessa Beecroft
Genoa 1969

Born in Genoa, Vanessa Beecroft graduated from the Brera Academy in 1994 and is one of Italy's internationally best-known artists from the younger generation. Beecroft started her career with pencil draw-

ings and watercolours of fragile, lightly sketched female figures. Her first exhibition entitled *VHS* in Milan, in 1993, featured a series of drawings accompanied by an intimate diary of the previous eight years of her life. In a way similar to the famous notebooks of Pontormo, to quote an illustrious predecessor, Beecroft had made daily annotations of the food she ate according to her own personal nutritional theory. The colours of the food, such as the red of apples, the green of kiwis and the yellow of oranges were instantly reflected in the bodies of the figures. The same sharp, strong colours were to appear also in many of her future performances, which she started in the early 1990s. In her daring performances Beecroft featured groups of girls either dressed identically or completely naked, wearing coloured wigs as their only accessory. Immobile to begin with, the girls performed slow movements without doing anything in particular, to then collapse on the floor after several hours. Beecroft considered the girls as the raw material for these *tableaux vivants*.
In 1994 the artist exhibited for the first time in New York — her adopted home — at the Andrea Rosen Gallery, and later at the prestigious PS1. Her swift rise to notoriety culminated in an exhibition at the Guggenheim Museum. In 1997 she took part in the Venice Biennale and in other important group shows such as *Fatto in Italia* (Made in Italy, ICA, London) and the international edition of the serial show *Partito Preso* at the Galleria. As from 1999 Beecroft introduced the male element to her work. In her series entitled *US NAVY* she substituted girls with soldiers from the Marines. In 2000 she was among the finalists of the Young Italian Art Prize launched by the Culture Ministry. Her latest work, *Sister Project*, was included in the *Migrazioni* exhibition at Rome's Centro Nazionale per le Arti Contemporanee in December 2000. This project was also featured at the 49th Venice Biennale in 2001.

A.M.

Umberto Boccioni
Reggio Calabria 1882 - Sorte (Verona) 1916

In 1899 Boccioni moved to Rome where he attended courses at the Scuola Libera del Nudo and followed drawing lessons with the poster designer Mataloni. A year

later he became friends with Gino Severini with whom he frequented the studio of Giacomo Balla. Balla introduced them both to the techniques of Divisionism and to *plein air* landscape painting chiefly in the newly built suburban areas of Rome. In 1906 Boccioni spent several months in Paris, where he came into direct contact with impressionist and post-impressionist art and was particularly stricken by the work of Cézanne. After touring Russia, Padua and Venice, he settled in Milan at the end of 1907. Although he continued to experiment with Divisionism, Boccioni's interest focused on the dynamic nature of the city's expansion. His paintings began to feature a growing number of factories, workshops, city suburbs and urban spaces undergoing transformation. The artist found that the analytical approach of Balla was not adequate to convey this new reality. He therefore entered a period of tormented thought marked by idealistic aspirations that has echoes with the work of Segantini and Previati. Previati, whom Boccioni met in March 1908, was to be a decisive turning point with his intellectual and spiritual suggestions. He advised Boccioni to fuse the real and the ideal, progressive tendencies with symbolist tensions. At this time Boccioni's painting was totally absorbed with expressing the forward drive of modern life and of the psychological and perceptive aspects of this reality. His meditation on the symbolist culture of Secessionism in the painting of Munch was to be fundamental in his painting at this time. During 1908 the divisionist brushwork he had inherited from Balla gave way to longer, vibrant and filamented strokes that were more suitable to portray emotions. In January 1910 Boccioni met Marinetti. A month later he wrote with Russolo, Carrà, Balla and Severini the *Manifesto dei pittori futuristi* (Manifesto of Futurist Painters), in turn followed in April of the same year by the *Manifesto tecnico della pittura futurista* (Technical Manifesto of Futurist Painting). Henceforth Boccioni's research concentrated on concepts of dynamism and simultaneity, in a new interpretation of the vitalism of Bergson in which time is conveyed as a conscious dimension and where actions from different moments in time are perceived simultaneously. As from 1911 Boccioni also absorbed suggestions from Cubism, achieving mutual plane penetration, the breaking down of

shapes and spatial unity between the object and its surrounding space. In 1911 he turned to sculpture and the following year published the *Manifesto tecnico della scultura futurista* (Technical Manifesto of Futurist Sculpture) in which he expounded the theory of plastic fusion between object, movement and atmospheric planes. In February 1912 he took part in the exhibition of futurist artists at the Bernheim-Jeune gallery in Paris. He then became involved with futurist propaganda that included articles on *Lacerba*, the so-called 'futurist evenings' at the Teatro Costanzi in Rome and at the Dal Verme in Milan as well as a variety of actions with Marinetti. Boccioni clashed with Apollinaire on the subject of Orphism and simultaneity. In 1914 he published the book *Pittura Scultura Futuriste (Dinamismo plastico)* (Futurist Painting and Sculpture, Plastic Dynamism) and wrote the *Manifesto dell'architettura futurista* (Manifesto of Futurist Architecture). Along with Marinetti, Carrà and Russolo, Boccioni organised demonstrations in favour of military intervention in the war. A new phase of critical reflection now began in the work of Boccioni, in which he attenuated the dynamic element in favour of a return to the construction of Cézanne. In 1915 he left for the front, having volunteered in the Volontari Ciclisti battalion. Posted to Sorte, near Verona, Boccioni died in a riding accident.
S.F. - M.M.

Alighiero Boetti
Turin 1940 - Rome 1994

Boetti made his debut in the second half of the 1960s. Self taught, after his first exhibition at the Christian Stein gallery of Turin in 1967, he took part in the shows of Arte Povera.
Boetti was interested in eastern culture and in a variety of other disciplines such as philosophy and alchemy. His strongly conceptual nature brought him to experiment with finding the artistic formula for expressing his intense activity as a thinker. His experimenting took him to reflect on ideas, themes and formal concepts that were to become essential in his later work.
Late in 1972 Boetti moved to Rome and began signing his works 'Alighiero e Boetti'. This theme of duplicity was often used in works and projects completed with outside help, collectively and with anonymous means.

Although Boetti always claimed his role was to direct others in the completion of a work rather than do it manually himself, he was almost obsessive in his supervision during the process of bringing his ideas into being as a physical object.
Boetti openly declared that he had entrusted a number of workers to complete his works, including his biro pen lined sheets of paper and his embroidered maps completed as from 1971 in Afghanistan, where each country is coloured with the colours of its flag. Boetti also used workers to complete the embroidered Italian and Farsi texts, or his *Tutto* (Everything) tapestries in which figurative elements are placed alongside one another totally filling the entire surface of the work.
A playful and colourful element often accompanied the processes experimented by Boetti. Speaking of the embroidery in *Tutto* in an interview to the daily *Corriere della Sera* on 19 January 1992, Boetti declared 'to avoid creating a hierarchy of colours I use them all. My problem in fact is that I don't make choices according to my taste but invent systems that then make the choices on my behalf.'
A.M.

Alberto Burri
Città di Castello (Perugia) 1915 - Nice 1995

Burri returned to Italy in 1947 from the United States, where he had been a prisoner of war in Texas and had just taken up painting. Having abandoned his profession as a doctor, that same year Burri exhibited his first figurative works in Rome and in 1948 his first abstract paintings. Between 1948 and 1949 he completed his first series of 'neri' (Blacks), 'muffe' (Moulds), 'catrami' (Tars) and the work *SZ1*, which were all the anticipators of his 'sacchi' (Sacks) series. 1950 saw the appearance of Burri's first 'gobbi' (Hunches), named after the irregularly curved surface of the canvas, as well as his first works made using sacks, in which the identification between matter and image is absolute. In 1953 the *Sacchi* were shown at the gallery of the Origine group made up of Colla, Burri and Capogrossi. Emilio Villa presented the show which immediately afterwards went to Chicago and New York. A poet, Villa also acted as a guide for an entire generation of new avant-garde artists. In 1953 Burri hit the international scene when he took part in

Sweeney's *Young European Painters* exhibition at the Guggenheim Museum in New York. Sweeney would dedicate a monograph to the artist in 1955. The same year Burri was invited by the Museum of Modern Art in New York to take part in the show *The New Decade: 22 European Painters and Sculptors*.
Late in 1962 Brandi, who was to publish the first real monograph of Burri's work in 1963, presented *Plastiche* (Plastics) at the Marlborough gallery in Rome. These followed a period during which Burri had experimented with fire in his *Combustioni* (Combustions) on wood and iron. In 1969 Burri showed his first *Cellotex* at the San Luca gallery in Bologna. 1973 marked the beginning of the 'cretti' (Cracks) period. In 1975 a comprehensive retrospective of Burri was held at the Galleria Nazionale d'Arte Moderna, thereby establishing his work as the spearhead of research into significance of materials. In 1978 the artist completed two *Grandi cretti*, for Los Angeles University and the Capodimonte Museum in Naples. In 1979 he completed his *Il viaggio* (The Journey) cycle. In 1981 he planned a giant *Cretto* for Ghibellina and inaugurated the Burri Foundation at Palazzo Albizzini at Città di Castello. In 1983 he produced *Sestante* (Sextant), a group of seventeen large paintings and a sculpture for the Venice Biennale. In 1985 Burri completed his first cycle of 'neri' , *Annottarsi* (Drawing Night In).
He died in Nice in 1995. That same year an important retrospective was dedicated to him at Rome's Palazzo delle Esposizioni.
R.C.

Massimo Campigli
Berlin 1895 - Saint-Tropez 1971

Campigli moved from Germany to Milan in 1909, where he met Boccioni and Carrà and wrote literary essays and *parole in libertà* (free words) poetry for the magazines *Letteratura* and *Lacerba*. In 1919 he was posted as the correspondent for the daily *Corriere della Sera* from Paris, where his keen interest in painting emerged. Campigli frequented Italian artists, was attracted by the painting of Léger, Picasso's latest period and discovered the hieratic nature of Egyptian art at the Louvre. Influenced by the writings of Apollinaire and the principles of formal rigour sustained in France by the purist man-

ifesto *Après le cubisme*, written by Le Corbusier and Ozenfant in 1918, and in Italy by the Valori Plastici group, Campigli turned towards a post-cubist form of geometric order, concentrating particularly on the human figure. In 1923 he held his first solo exhibition at the Bragaglia gallery in Rome. Along with de Chirico, De Pisis, Paresce, Savinio, Severini and Tozzi, Campigli was one of the group of Seven Italian artists in Paris, from which he derived a Novecento-style imprinting for the gigantic figures in paintings such as *Donna seduta* (Seated Woman) and *Le cucitrici* (The Seamstresses), both from 1925 and featured at the first Novecento exhibition, as well as in *Le amiche* (The Girlfriends), *Ritratto metafisico* (Metaphysical Portrait, 1925), *Le acrobate* (The Women Acrobats), *Le equilibriste* (The Women Tight-rope Walkers, 1926). Like the German painter and sculptor Oskar Schlemmer, whose contemporary work he was not unfamiliar with, Campigli seemed to draw on essential and rigorous forms in a kind of synthesis between nature and geometry. His visit to the Villa Giulia museum of Etruscan art in 1928 added to his existing inclinations towards post-Cubism brought Campigli to a decisive turning point in his painting. Now he privileged earthy colours and archaic figures of women shaped as amphorae, hour glasses, guitars. His solemn, frontal figures are placed in an atmosphere suspended between the pre-Hellenic world and the present, visible in works such as *Donne al sole* (Women in the Sun, 1931), *Donne con l'ombrello* (Women with Umbrellas, 1932), *Le spose dei marinai* (The Sailors' Wives) and *Le bagnanti* (Bathing Women, 1934, shown at the Rome Quadriennale). At the 1928 Venice Biennale Campigli exhibited thirteen works from this new phase. In 1929 he took part in the second exhibition of Italian artists at Geneva, also holding in the same year a solo exhibition at the Bucher gallery in Paris and in 1931 at the Milione gallery in Milan. At the 1932 Venice Biennale works by Campigli were featured in the room dedicated to the Italian artists in Paris, presented by Gino Severini. He returned to Milan for good in 1933. Along with Sironi, Carrà and Funi, Campigli subscribed to the mural painting manifesto in which he supported the social utility of the decorative arts. With Sironi, Funi and de Chirico he completed the wall decoration for the Palazzo dell'Arte at the **151**

V Milan Triennale, the first of a series of large-scale public commissions. In 1948 the Venice Biennale dedicated Campigli his own room, set up by Carlo Carrà.
M.M.

Giuseppe Capogrossi
Rome 1900–72

Born into an important family of the Roman aristocracy, Capogrossi graduated in law in 1922. The following year he turned to painting, studying under Felice Carena in whose studio he met Emanuele Cavalli with whom he was to remain in close contact until his conversion to Abstraction. After several trips to Paris in 1933 Waldemar George included Capogrossi in what he hailed as a new phase in young Italian painting, labelled by him the *école de Rome*. Meanwhile his initial research into tonality was followed by a period of greater chromatic intensity.
Immediately after the war Capogrossi sought new forms of expression, passing through a neo-cubist phase and eventually arriving at his abstract style. From his initial simplification of reality Capogrossi attained a recurring 'character' able to take on different meanings according to its size, colour and position. In 1950 Capogrossi presented his first *Superfici* (Surfaces) at a one-man show held at Rome's Secolo gallery. Both public and critics greeted the works with considerable perplexity. In 1951 he took part along with Burri and Colla in the foundation of the Origine abstract group and was the only Italian to be invited to take part in the *Véhémences confrontées* (Compared Vehemences) show curated by Tapié at the Nina Dausset gallery in Paris. The show also featured Pollock, de Kooning, Wols and many others. From here on Capogrossi took part in a succession of important events. In 1953 Sweeney invited him to the *Young European Painters* exhibition at the New York Guggenheim Museum. That same year Seuphor introduced his solo exhibition at the Naviglio gallery. In 1954 Tapié presented him at the Venice Biennale. A succession of three monographs followed, respectively written by Seuphor in 1954, Tapié in 1962 and Argan in 1967. The artist died in Rome in 1972. In 1974 the Galleria Nazionale d'Arte Moderna dedicated a large retrospective to him. In 2000 the same institution held a show to commemorate the centenary of the artist's birth.
R.C.

Carlo Carrà
Quargnento (Alessandria) 1881 - Milan 1966

After studying decoration Carrà worked as a decorator and followed evening painting classes. From 1904 to 1907 he then studied at Milan's Academy of Arts. In 1900 Carrà went to Paris to work on the decoration of some of the pavilions for the Universal Exhibition, after which he made a short visit to London. In Milan he took part in the still lively divisionist climate. In 1908 Carrà held a one-man show at Famiglia Artistica and also met Boccioni and Russolo. In his works completed between 1909 and 1910 Carrà displays a thematic and stylistic affinity with the early work of Boccioni in his treatment of urban scenes and in his analysis of nocturnal illumination (*Piazza Duomo*, 1909; *La stazione di Milano*, 1910). In 1910 Carrà joined Futurism and subscribed to its manifestos, painting *Notturno in Piazza Beccaria* (1910) and *I funerali dell'anarchico Galli*, that depicted the police killing of the anarchist Galli during a general strike, an episode that Carrà had witnessed in 1904. In 1912 he was with Boccioni in Paris at the futurist exhibition at the Bernheim-Jeune gallery. On this occasion he became acquainted with works by cubist artists. Although he continued to paint and exhibit in the futurist style until 1915, in 1912 and 1913 Carrà worked mainly on cubist-derived collage, gradually straying from the themes of speed and dynamism towards a more constructive approach to reality. Carrà tightened his ties with Ardengo Soffici and with the magazine *Lacerba*, to which he contributed texts and illustrations from 1913. At this time he embarked on his career as theorist and art critic that was to be particularly influential over the following twenty years. In 1916 he published in *La Voce* his 'Parlata su Giotto' (Speech on Giotto) and 'Paolo Uccello costruttore' (Paolo Uccello Constructor), where he summed up his studies on the plastic volume of bodies within space and on the unadorned composition in 14th- and 15th-century art. Whilst doing his military service in 1917 at Ferrara with de Chirico, Savinio and De Pisis, Carrà approached Metaphysics. After some works inspired by de Chirico, such as *La Musa metafisica* (The Metaphysical Muse, 1917), Carrà achieved a more personal interpretation of the mystery of ordinary things in *Natura morta con squadra* (Still Life with Set Square, 1917), eventually attaining extreme

purity in his metaphysical language. In 1920–21 the artist subscribed to the ideas of *Valori Plastici* and contributed eight works to the magazine's 1921 exhibition in Berlin. At this time Carrà's painting evolved towards Primitivism, fired by his need to absorb the lessons of the first modern painters Giotto and Paolo Uccello. The narrative capacities gleaned by Carrà from these historical lessons made him one of the period's most original painters. In 1922 he began his collaboration as art critic for *L'Ambrosiano*. The same year Carrà took part for the first time at the Venice Biennale. In 1925 he was given his own room at the Rome Biennale. In 1926 Carrà exhibited alongside de Chirico at the Pesaro gallery in Milan, as well as at the Novecento exhibition even though he did not officially adhere to the movement. During the summers of 1927 and 1928 at Forte dei Marmi (Versilia) Carrà concentrated mainly on landscape painting, and on the human figure from 1930 (*Estate*, Summer, 1930). In 1933 he took part in the V Milan Triennale with a mural. In 1936 Carrà completed a series of decorative panels for the VI Triennale, and in 1938 completed a mural for Milan's Palazzo di Giustizia. From 1941 he began teaching at Milan's Academy of Arts. In 1950 Carrà was awarded first prize at the Venice Biennale.
In 1962 his volume of critical texts was published under the title *Segreto professionale* (Under Professional Oath).
S.F. - M.M.

Felice Casorati
Novara 1883 - Turin 1963

Casorati made his debut at the 1907 Venice Biennale. In 1911 he was invited by Nino Barbantini to join the Ca' Pesaro group of artists alongside Arturo Martini, Gino Rossi, Pio Semeghini, etc. The elegant stylistic touch that distinguished the work of Casorati around 1910 brought him in line with the culture of central Europe and with the novelties of the secessionist language used by Klimt, whose work Casorati had seen in Venice in 1910. Casorati then became the leading exponent of a refined pictorial language inspired by Symbolism, meeting with a moderate degree of success even at the Secessione exhibition in Rome in 1915, where he was allocated his own room. In 1918 he settled in Turin. In the lively cultural climate of the Piedmontese capital he met the Gualino family of industri-

alists and collectors, the critic Lionello Venturi and the writer Pietro Gobetti, who in 1923 published the first monograph study on Casorati. Along with the younger Gigi Chessa he designed the Gualino family theatre in 1925. He also collaborated with the entire Turin Group of Six artists on editions of the decorative arts Biennales in Monza. During the 1920s Casorati developed his own personal style made up of rigorous space, enigmatic metaphysicism, a cold and 'cerebral' colour range and a purity of form reminiscent of Piero della Francesca. He also embraced the Renaissance concept of perspectively constructed space in which figures are arranged with the classical function of conveying scale. Casorati's preferred subjects were still lives, portraits and compositions of figures arranged in his studio. With his university lectures on Impressionism Lionello Venturi had opened the path towards a phase of cultural renewal in Turin. In such a climate of renewal Casorati opened up an art school for younger artists in 1923 and co-founded with Sartoris and Sobrero the Società Fontanesi, that featured exhibitions of Italian 19th-century art. In 1934 he founded the Casorati-Paulucci studio, the first to present in Turin Milanese abstract artists in 1935. He was a reference point for pupils such as Menzio, Chessa, Levi, Galante, Jessie Boswell and Daphne Maugham, whom he was to marry in 1930. Casorati exhibited at the shows of Novecento artists and at the 1931 Rome Quadriennale, where he was awarded third prize for painting. Roughly in the mid-1920s Casorati began enriching the chromatic range of his works and move towards a softer, more pearly colour range that tended to blend shapes into one another. Casorati's use of clear colours bathed in a bright luminescence heralded the evolution that his painting was to take during the 1930s, when he worked on large-scale compositions that he presented at official exhibitions. He also designed the entrance hall of the 1933 Milan Triennale. In the 1940s Casorati's painting acquired an increasingly 'unfinished' feel while his images returned to neo-secessionist themes.
S.F. - M.M.

Enrico Castellani
Castelmassa (Rovigo) 1930

After studying art and graduating in architecture in Brussels Castellani moved to Milan in 1956 where

along with Manzoni and Bonalumi he founded the *Azimuth* magazine, and the short lived gallery of the same name. In 2001 Germano Celant wrote of artists who had started work between 1957 and 1960 and who had aimed at outgrowing the *Informel* trend: 'the idea was […] to discover a new synthesis by which the action and involvement of the individual end up with the annihilation of the individual in favour of the promise of a rebirth in a new dimension'. Initially very close to Manzoni, the work of Castellani identified its first vital reference point in the spatialism of Fontana. By focusing his analysis on the canvas itself Castellani adopted monochrome painting. Through a system of nails going inwardly and outwardly from the frame the canvas presents a mostly regular quilted surface to the light. In January 1960 at the Azimut gallery Castellani first exhibited his quilted *Superfici* (Surfaces) alongside monochrome works by Klein, as well as works by Manzoni and the Zero group. The 1960s work of Castellani was typified by rigorous monochrome, either white, yellow, red or blue largely tempera on quilted canvases. During this period he took part in important international exhibitions such as *Monochrome Malerei* organised by Kultermann for the Kunstmuseum of Leverkusen in 1960. These years were also Castellani's most fertile. The works presented by him at the 1966 Venice Biennale displayed a spatial language that hinted at the developments he would carry out to the full a year later in Foligno, for the exhibition *Lo spazio dell'immagine* (The Space of Image). On this occasion the artist created a three-dimensional environment with a sophisticated illusion of perspective for the viewer. All of Castellani's successive work stands out for his continued and solitary coherence, producing reliefs also in aluminium and based on a rigorous constructive planning logic.
R.C.

Sandro Chia
Florence 1946

Sandro Chia moved to Rome in 1970, where the following year he presented his first solo exhibition entitled *L'ombra e il suo doppio* (The Shadow and its Double) at La Salita gallery. Between 1971 and 1975 he made several trips to the Far East, which were to prove essential to his formation. After a few early experiences with Conceptual art in the 1970s Chia moved towards a more figurative style in his painting, becoming one of the main figures of Transavanguardia. His participation in the *Aperto 80* section of the Venice Biennale and at a show at the Sperone Westwater Fisher Gallery in New York in 1980 launched his international career. This was backed by a series of important solo exhibitions throughout the 1980s, such as at the Stedelijk Museum in Amsterdam in 1983, the Staatliche Kunsthalle of Berlin in 1984 and the Metropolitan Museum of New York in 1984.

The success of Chia's painting can be attributed to the liberal use of historical quotation in his work and to a marked sophistication in his iconography. These were soon to 'break', however, gradually growing out of control and free from any tradition.

Between 1984 and 1985 Chia taught painting at the School of Visual Arts in New York. His large-scale paintings displayed considerable energy, drawing freely on mythology and art history but at the same time charged with autobiographical references. The 1989 edition of the Venice Biennale featured an entire room dedicated to the work of Chia. Other exhibitions have included the Nationalgalerie of Berlin in 1992, the Sydney Janis Gallery of New York in 1996 and Milan's Palazzo Reale in 1997. Chia lives and works between New York and Montalcino, in Tuscany.
A.M.

Francesco Clemente
Naples 1952

Born in Naples in 1952, Clemente moved to Rome in 1970, the same year he also began his frequent trips to India and Afghanistan. In Rome he met Cy Twombly and Alighiero Boetti, with whom he was to remain bound in a close and tormented friendship.

Like his colleagues from Transavanguardia Clemente achieved immediate international success right from his first collective shows. Presented by Achille Bonito Oliva at the 1980 Venice Biennale, the same year Sperone took Clemente to New York. In 1981 he left Italy and moved definitively to this city, where he still lives and works.

Clemente's early work displays influences from his 'oriental' travels, such as in his series of miniatures painted with artists from Madras *Francesco Clemente pinxit* (1981). Clemente's un-dramatic idea of art manages to 'find through his light-hearted nomadism the possibility of an image in which repetition and difference are interlaced' (Achille Bonito Oliva). In all his mediums, ranging from drawing to painting, watercolour, pastel and later even fresco, Clemente represents figures that are immobile, enchanted. Sad and full of grace, his figures have an interior resonance that exonerates them from their apparent 'conventionality' and takes them beyond any temporal reference towards a condition of peace that betrays no emotions.

Clemente's participation in five editions of the Venice Biennale (1980, 1988, 1995, 1997) and his solo exhibitions in Europe, USA and Japan, were the prelude to his most recent and significant solo exhibition in 1999 at the Guggenheim museums in New York and Bilbao.
A.M.

Ettore Colla
Parma 1896 - Rome 1968

In 1926 Colla settled in Rome, from where he was rarely to move. In his early years Colla alternated portrait sculpture with monumental commissions in Novecento style that had archaic suggestions and frequent references to the work of Arturo Martini. As from 1941–42 he gave up sculpture and went through a long period of meditation, during which he worked as an organiser of cultural activities. As De Marchis wrote in 1972, 'For a long time, like Arturo Martini, he must have believed that sculpture was dead and he made no effort to revive it until he found a new dimension for it'. Meanwhile Colla met Burri and Capogrossi, with whom in 1951 he founded the group Origine. After 1948–49 he first experienced with abstract collage and painting, which was followed by reliefs in wood and geometric sculptures in iron inspired by Max Bill.

In 1952 the first issue of the Origine group magazine *Arti Visive* was published, in touch with all the great international novelties.

Thanks to the interests of Origine during the winter of 1954–55 he completed his first objectural sculptures, assemblages of scrap metal 'in their shapes as objectual residue, fragments or parts of cars, equipment or system parts, a variety of objects that Colla found in scrapyards like a writer finds words in a dictionary' (De Marchis 1982). Colla assembled his works in a compositional and spatial order reminiscent of Constructivism, as well as of the Dada idea of the *objet trouvé*. In 1957 he met Alloway who presented him in 1959 at his major solo exhibition at ICA in London, which was repeated in Amsterdam on an invitation by Sandberg and organised by Argan. The first important group of reliefs comes from this period. In 1961 Colla took part with two works in the *Art of Assemblage* show in New York. In 1962 he completed the monumental work *La grande spirale* (The Great Spiral) for Spoleto, which is now located in front of the Galleria in Rome. During this last period he returned to simpler, geometric shapes always obtained from mass-produced industrial materials. Colla died in Rome in 1968.
R.C.

Gianni Colombo
Milan 1937 - Melzo (Milan) 1993

After studying at the Brera Academy Colombo made his debut in the second half of the 1950s with abstract, concretist works. Influenced by Fontana, he experimented with multi-materialism. In 1959 Colombo completed his first *Rilievi intermutabili* (Intermutable Reliefs) involving participation from the viewer, as well as his first electro-mechanical animation. In 1959 he took part in the activities of the Azimut gallery along with Manzoni, Anceschi, Boriani and De Vecchi. With the same artists except Manzoni in 1960 Colombo founded Gruppo T. As from 1960 Gruppo T organised a series of exhibition-happenings that re-elaborated the themes of historical avant-garde movements in view of the most recent experimentation in art, from the spatialism of Fontana to the lines of Manzoni. The marked anti-*Informel* spirit of these exhibitions was redolent of the New Dada spirit of Azimuth. Lasting three years, the exhibitions were entitled *Miriorama*, or thousand images, and were held in Milan, Genoa, Tokyo, Rome and Venice. The main theme was the relation between space and time with the passage of time increasingly identified with the real or virtual movement of objects built with industrial materials and techniques. From this moment onwards Colombo deepened and developed the problem of perceptual ambiguity, creating moving works and environments in which the spectator was often directly involved. These ranged from his pulsating structures in 1959 to his 1961 works using artificial light, and

from 1964 to 1970 his environments that created particular visual or tactile situations. In 1968 Colombo was invited to take part in the Venice Biennale, where he won the first painting prize with *Spazio elastico* (Elastic Space). In the years that followed Colombo deepened his studies in kinetics and the visual, completing a succession of performances, installations and projects that were featured in major events throughout Europe. He presented his last work, *Spazio diagoniometrico* (Diagonometric Space) in 1992 at the *Carambolage* show in Baden-Baden. He died suddenly in 1992 while in hospital at Melzo.
R.C.

Enzo Cucchi
Morro d'Alba (Ancona) 1950

Born in Morro d'Alba, in the Marches, Cucchi moved to Rome where he started painting after a long period dedicated chiefly to poetry. He met Sandro Chia and Francesco Clemente, who were already painting in a figurative, neo-expressionist style. Mimmo Paladino and Nicola De Maria also approached this line of thinking. All together these artists came to be bracketed under the term Transavanguardia by the critic Achille Bonito Oliva.
Success came for Cucchi right from his first solo exhibitions in Rome at *Incontri internazionali d'arte* (International Art Meetings) and in Milan in 1977. This was consolidated in 1980 when he took part in the Venice Biennale and, still further, the following year with an exhibition at the Sperone Westwater Gallery in New York.
The Transavanguardia group was consolidating its linguistic recovery of traditional art. With them Cucchi exhibited in major museums around the world, including the Guggenheim in New York, the Kunsthalle in Basel, the Stedelijk in Amsterdam and the Tate in London (1982).
With his painting that reflected a figurative form of expression Cucchi drew his subjects from the tragedy of human existence under the universal influence of good and evil. He also resorted to evocations from popular culture and used them to re-interpret the present.
As Bonito Oliva wrote in 1980, 'art has finally returned to its internal motivations, to the creative reasons for its existence, to the labyrinth that is its place *par excellence* in terms of its "internal work", as a continuous excavation of the substance of painting'. As well as his large paintings that used a stratification of matter Cucchi also completed drawings and sculptures. His art books mainly published by B. Kluser in Munich and Bischofberger in Zurich contributed to his multi-faceted and incessant activity that also included close collaborations with architects, the theatre and writers such as Goffredo Parise, Paolo Volponi and Giovanni Testori.
A.M.

Giorgio de Chirico
Volos (Greece) 1888 - Rome 1978

De Chirico received his first painting lessons in Athens. After the death of his father in 1905 the family returned to Italy, staying in Venice, Milan and Florence. De Chirico studied at the Munich Academy of Arts from 1906 to 1908, where he closely studied the work of Arnold Böcklin and Max Klinger. At the same time he approached the philosophy of Schopenhauer, Nietzsche and Weininger. Although de Chirico's early works such as *Lotta di centauri* (Fight of the Centaurs, 1909) were strongly Böcklinian in flavour, the canvases he painted in 1910 combined quotations from Böcklin with a mysterious atmosphere that anticipated his later metaphysical works. In 1911 de Chirico joined his brother Alberto Savinio in Paris, stopping in Florence and Turin on the way. Turin particularly struck him for its deserted squares and monumental architecture bathed in summer light. In 1913 de Chirico exhibited for the first time at the Salon d'Automne and then at the Salon des Indépendants. At this time he forged ties with the critic Apollinaire and frequented Picasso, Braque, Brancusi, Derain and Max Jacob. He also signed a contract with the art dealer Paul Guillaume. His work of the period featured *Piazze italiane* (Italian Squares) and mannequins. When war broke out de Chirico returned to Italy and performed his military service in Ferrara where, along with Carrà, De Pisis and later Morandi, he formed the nucleus of Metaphysical Painting. In 1918 he was posted to Rome. The following year de Chirico held a solo exhibition at the Bragaglia gallery, for which he published *Noi metafisici* (We Metaphysics). He then began his collaboration with Broglio's magazine *Valori Plastici*, taking part in all the exhibitions organised by the magazine between 1921 and 1924. In the early 1920s de Chirico progressively abandoned metaphysical subjects on the grounds that a return to studying in museums and copying old masters was necessary. De Chirico now advocated a return to traditional painting techniques and to the 'craft' of art. After the III Rome Biennale, in 1925 he moved to Paris, where he lived until 1932. During this period de Chirico developed a series of subjects that he was to use in his later works, such as gladiators, archaeologists, horses on the shore, etc. His relations with the surrealist group, who judged his post-metaphysical painting anti-modern, had been deteriorating since 1925. De Chirico took part in the exhibitions featuring artists from the Novecento movement. In 1928 the monograph dedicated to him by Waldemar George was published. In 1929 de Chirico published his own novel *Hebdomeron* and took part in almost all exhibitions featuring Italian artists in Paris. In 1930 he designed the sets and costumes for Diaghilev's *Le Bal*. In the 1930s he looked to Renoir for inspiration, painting naturalistic nudes and still lives and displaying a programmatic return to traditional artistic language. In 1932 de Chirico took part in the Venice Biennale. The following year he completed a tempera mural, *Cultura*, for the Milan Triennale. In 1935 the second edition of the Quadriennale honoured him with his own room. The following decade was taken up by de Chirico's Baroque phase, during which he painted self-portraits in costume and resorted to quotations from the great masters of the 16th and 17th centuries. In 1947 he settled in Rome until his death. In the 1950s and early 1960s de Chirico reused past iconography and themes, successfully both with the public and commercially.
M.M.

Gino De Dominicis
Ancona 1947 - Rome 1998

Gino De Dominicis can be considered one of the most original figures in Italian art over the past thirty years. Distinguished by an ironic, almost irreverent thought on the themes of life and death, De Dominicis' research resorted to a variety of mediums including painting, photography, installation, performance. Having arrived in Rome in 1969, already in 1970 De Dominicis exhibited his twelve live signs of the zodiac that included a bull, a caged lion and a little girl. With a gesture that was regarded as excessively provocative, in 1972 De Dominicis presented one of his most significant works, *Seconda soluzione d'immortalità (l'universo è immobile)* (Second Solution to Immortality [The Universe is Motionless]) at the Venice Biennale, which featured a boy affected by Down's Syndrome (Paolo Rosa) sitting immobile in a corner of a room contemplating some of the artist's works. The 1975 Nobel prize-winner for literature Eugenio Montale was the only person who publicly recognised the value of this work, of which there only remains one photograph. The fact that Paolo Rosa had been used in the installation caused widespread protest and attracted a good deal of criticism.
As a provocative gesture against the scientist Alfonso Liguori, with whom De Dominicis had a public dispute on the theory of immortality, in 1973 he organised a performance at Palazzo Taverna to celebrate the overtaking of the second principle of thermo-dynamics.
In his paintings from the end of the 1970s De Dominicis featured the figures of Urvashi and Gilgamesh, the legendary king of Sumeria who gave himself to searching for the grass of life and with whom the artist identified. In 1990 he exhibited a 24 metre-long enlargement of a human skeleton at the Centre National d'Art Contemporain in Grenoble, repeating the operation in 1996 at the Capodimonte museum in Naples.
In 1997 De Dominicis took part for the third time in the Venice Biennale, after he had been given his own room in 1993. In 1999, a year after his death, the Venice Biennale again honoured him with his own room and the Galleria held a major exhibition of his work.
A.M.

Filippo De Pisis
Ferrara 1896 - Milan 1956

Art and literature were the two primary creative interests for De Pisis, who throughout his life equally divided his activities between these two genres. His best known text is *Il marchesino pittore* (The Little Marquis Painter), published posthumously in 1969. Meeting the de Chirico brothers and Carlo Carrà in Ferrara in 1916 represented a turning point in the cultural formation of De Pisis, who supported their metaphysical research in a series of conferences and magazine articles. Through Savinio De Pisis met exponents of the French avant-garde such as Apollinaire and Max Jacob. He also entertained a strong epis-

tolary friendship with Tristan Tzara and Ardengo Soffici. After moving to Rome in 1920 De Pisis had a fairly unsuccessful solo exhibition at the Bragaglia gallery, repeated in the foyer of the Teatro Nazionale in November 1924. His circle of friends included *Ronda* artists and writers, among which was his great friend the writer Giovanni Comisso, with whom he collaborated. De Pisis painted in the open with Armando Spadini, who encouraged him to take up painting more seriously. Spadini's influence is particularly clear in the bright colours used by De Pisis initially. After the III Roman Biennale in 1925 De Pisis moved to Paris, where he stayed until 1939, only returning to Italy for short periods. After seeing impressionist works first hand De Pisis defined his style, lightening his palette and developing his pictorial signature of capturing the fleeting nature of visual impressions with his quick strokes. De Pisis took part in a number of important events and collaborated with magazines such as *Emporium*, *Il Selvaggio* and *Frontespizio*. The still life had always been and continued to be De Pisis' almost obsessively preferred medium throughout his life. De Pisis was particularly fascinated by the 17th-century-derived sense of dissolution and death linked to this particular genre. When the war broke out in 1939 De Pisis was forced to return home, first staying in Milan and then in Venice from 1943 to 1947, where he dedicated himself almost entirely to painting, producing a number of cityscapes, still lives and portraits. De Pisis made considerable lithographic prints, including an illustrated version of Catullus' *Odes*, keeping up a constant presence at exhibitions both in Italy and abroad. He returned again to Paris in 1947 but health reasons forced him back to Italy once more.
M.M.

Gabriele De Vecchi
Milan 1938

After studying at the Brera Academy from 1957 to 1959 De Vecchi produced his first multi-material works. In 1959 he founded the Gruppo T in Milan along with Anceschi, Boriani and Colombo, which represented the nucleus of Italian research into kinetic art. Until 1963 De Vecchi worked assiduously on events promoted by Gruppo T. *Miriorama* was the first programmatic anti-*Informel* position adopt-

ed in Italy, where young artists 'imposed an image of reality that was variable according to scientific procedures and annexed a series of scientific qualities into the realm of aesthetics: the concept of a prototype as opposed to the idea of art as unique, the prolonged observation of the phenomenon as opposed to the concept of contemplating truths that have been formulated once and for all' (Pinto 1970). Gruppo T took part in the European Nuove Tendenze (New Trends) movement along with the German Zero, the Spanish Equipo 57 and the French Groupe de Recherche d'Art Visuel. The work of De Vecchi strongly underlined also in a provocative manner the problem of instability and variability of forms. Combined with a playful element, De Vecchi completed his *Scultura da prendere a calci* (Sculpture to be Kicked) and *Superfici in vibrazione* (Surfaces in Vibration) at the end of the 1950s. Another feature of kinetic-visual art, which proposed collective experiments on the variations of reality and on the perception of reality itself and which in this sense make it a non-subjective art, was the active involvement of the spectator through aesthetic actions that progressively extended to include a broader social context. In these years works by De Vecchi were featured in many group shows both in Italy and Europe, from the Venice Biennale to the Rome Quadriennale, the Musée des Arts Décoratifs in Paris, the Kunsthalle in Baden-Baden and the Kunsthalle in Düsseldorf. In the 1980s De Vecchi became primarily involved in design and architecture for the city areas of Milan, where he lives.
R.C.

Renato Di Bosso (Renato Righetti)
Verona 1905 - Arbizzano di Valpolicella (Verona) 1982

Renato Righetti is known as Di Bosso from the name invented for him by Filippo Tommaso Marinetti in the early 1940s that is allusive (*bosso* being the Italian for boxwood) of the artist's predilection for sculpting in wood. Di Bosso's early works date from the mid-1920s and display the influence of Adolf Wildt. After reading Boccioni's *Pittura e scultura futuriste*, Di Bosso tended towards the futurist idea of plastic synthesis. This is clearly visible in his wooden sculpture *Il violinista* (1930), where the dynamic tension of the musician blends with the waves of sound produced by the musical in-

strument in a reciprocal penetration. In 1931 Di Bosso formally established the Verona group of futurists in the presence of Marinetti, to whom he had addressed an open letter in June the same year. Di Bosso's work during the 1930s displays his commitment to futurist aero-painting subjects and concepts of space. This is visible in works such as *Balilla* (1934), *Paracadutista* (Parachuter, 1934) and subtitled by Di Bosso *Complesso plastico in alluminio e cristallo azzurro per sala d'attesa d'aeroporto* (Plastic complex in aluminium and blue crystal for airport waiting room), and *Pilota stratosferico* (1938). Di Bosso also dedicated himself to painting at this time, chiefly portraits of his futurist friends and typically aero-painting subjects as in *Aerovisioni sintetiche e simultanee del lago di Garda* (Synthetic and Simultaneous Arial Views of Lake Garda, 1933). To give his paintings an added dynamic feel and convey the simultaneous nature of aerial vision, Di Bosso resorted to designing works on boards that rotated around a central pivot. The titles he gave to these works suggest a spiral motion, such as *Spiralando sull'Arena di Verona* (Spiralling on the Arena of Verona, 1935) or *Spiralando sul paese* (Spiralling on the Village, 1935). Di Bosso also wrote a number of programmatic manifestos including the *Manifesto futurista per la scenografia del teatro lirico all'aperto nell'arena di Verona* (Futurist Manifesto for Open Air Set Design in the Verona Arena, 1932), *Manifesto futurista della cravatta italiana* (Futurist Manifesto of the Italian Tie, 1933), *Il Macchinesimo* (1933). He took part in the First National Futurist Exhibition in Rome in 1933, at the 1934, 1936 and 1942 editions of the Venice Biennale and at the 1935, 1939 and 1943 editions of the Rome Quadriennale. Di Bosso also exhibited at the *Mostra nazionale per la plastica murale dell'edilizia fascista* (National Exhibition of Mural Art in Fascist Buildings) held in Genoa in 1934 and in Rome in 1936. During the Second World War he continued painting works in the aero-futurist style such as *Paracadutista in caduta* (Falling Parachutist) and *Macchine di guerra* (War Machines), both from 1942. He also published his essay *Eroi Macchine Ali contro Nature morte* (Heroes Machines Wings Against Still Lives). In 1945 his studio was almost totally destroyed in the conflict. After a long period of inactivity Di Bosso resumed painting and sculpting his usual subjects in the 1960s.
M.M.

Julius Evola
Rome 1898–1974

Having studied literature and philosophy, Evola is known mainly as a scholar of philosophical theory and religious spiritualism tinged with esoterica. His painting activity is limited to a period between 1915 to the early 1920s, first in a futurist style and then in an original synthesis of Abstract and Dada. He frequented the studio of Giacomo Balla and in particular Fortunato Depero and Enrico Prampolini, with whom between 1918 and 1920 he collaborated on the magazine *Noi* (Us). His debut was at the Futurist Exhibition of Palazzo Cova in Milan in 1919, with a group of works linked to the spiritualistic dynamism of Balla and reminiscent of Kandinsky. At his solo exhibition in the Bragaglia gallery in Rome Evola divided his works into two sections, 'Tendenze di idealismo sensoriale' (Sensorial Idealism Tendencies, 1915–18) for his more markedly futurist works, and 'Tendenze di astrattismo mistico' (Mystical Abstract Tendencies, 1918–20) for his more abstract works. Early in the 1920s Evola approached Dadaism, also thanks to his friendship with Tristan Tzara. His works from this period feature abstract forms influenced by Constructivism and by an interest in spiritualism and esoterica.
Keeping up his activity as a poet, in 1920 Evola published the short poem *La parole obscure du paysage intérieur* (The Obscure Word of Interior Landscape) and the theoretical text *Arte astratta* (Abstract Art) for the *Collection Dada* in Zurich, where he outlined his vision of art as a mystical abstraction.
In 1921 he held two important exhibitions in Geneva and Berlin. Between 1921 and 1922 he collaborated for the Mantua magazine *Blue* which also featured pieces by Van Doesburg, Tzara, Picabia and Ernst. The same year Evola got the chance to organise a 'Dada season' at the Roman cabaret Grotte dell'Augusteo. After taking part in the Salon Dada of Paris in 1922 Evola gave up painting and dedicated himself entirely to writing and philosophy.
S.F. - M.M.

Luciano Fabro
Turin 1936

Educated in Milan and in the Azimut circle Fabro immediately proposed an alternative to the research of Fontana, Manzoni and Klein, perceiving space as the result of a 'sen-

sorial experience'. Fabro himself declared that 'to deny that space extends through the structure that determines it or that it is the result of our sensorial perception is an illusion and a necessarily metaphorical one at that. Its reason for being is in its limitations, its expressive reason is in its blending in with its surroundings'. Fabro's partly reflective and partly transparent works in glass, completed between 1963 and 1965, imply an open relation with the viewer and underline the importance the artist attached to light and dynamism in the matter itself. In 1965 he held his first solo exhibition at the Vismara gallery in Milan, where he presented his first version of *Buco* (Hole), later repeated in several other versions. Close to Pistoletto, in 1967 Fabro took part in the launch show for Arte Povera organised by Celant at the Bertesca gallery in Genoa. Fabro conceived making art as a perceptive opening capable of activating mental stimuli both for the artist and for the public. Between 1968 and 1972 Fabro worked on his *Piede* (Foot) cycle and on a series of photographic close-ups of pressed and pleated women's skirts. In 1968 he also completed his first *Italia* series featuring the country's inverted boot shape in a variety of materials including glass, lead, fur and gold. Throughout the 1970s and 1980s he continued to create novel iconography and experiment with every-day materials. In the 1980s Fabro held classes at the Milan Academy, which proved to be enormously stimulating for the younger generations, and completed a series of works entitled *Habitat*. Fabro also executed a variety of works intended to provoke thought on specific subjects such as perspective, with *Paolo Uccello* in 1984 and *Due nudi che scendono le scale ballando il Boogie-Woogie* (Two Nudes Descending the Stairs Dancing the Boogie-Woogie) in 1989. This work quoted from works by the two masters of modern American figurative culture, Duchamp and Mondrian. Towards the end of the 1990s Fabro realised *L'immagine al naturale* (Natural Image), a series of theoretical thoughts and exhibitions that focused on the concept of image in its nascent state.
R.C.

Lucio Fontana
Rosario de Santa Fe (Argentina) 1899 - Comabbio (Varese) 1968

After beginning as a sculptor in the 1920s between Argentina and Italy, in 1931 Fontana produced some ab-stractions scratched onto tablets, and in 1934 joined the Parisian group Abstraction-Création. His research into abstraction co-existed for a long time alongside his figurative work without conflict. Fontana used both styles as a means to enrich himself and experiment linguistically, notwithstanding obvious contrasts; each style sharing elements of experimentation and linguistic enrichment. In 1946 he created a series of automatically operated drawings, derived from Surrealism. With a group of students and young artists from the Academy he drew up the *Manifesto Blanco* (White Manifesto) in Buenos Aires, a precursor to the spatialist movement he was to launch in 1947 when he returned to Milan and which was followed by a second manifesto in 1948. From this moment onwards the art of Fontana was mainly concerned with the inseparability of sign, matter and space, along with breaking down the distinction between painting, sculpture and graphic work. Fontana opted for the 'just' nature of the sign, that creates a change in matter and consequently in the image of space. His activity had by now reached global recognition and was named *Spatial Concept*. The various series of works featured in turn 'holes', 'cuts', 'natures' and 'environments'. In 1952 he showed his first *Concetti spaziali* (Spatial Concepts) at the Naviglio gallery in Milan. These had been created by puncturing a sheet of paper spread on a canvas frame, thereby opening space towards infinite dimensions. In 1958 he started his 'cuts', which he presented for the first time a year later at a solo exhibition at the Naviglio gallery. These were to produce the series entitled *Concetti spaziali - Attese* (Spatial Concepts - Waiting). At the same time Fontana experimented with the series of terracotta sculptures, *Nature*, from 1959 and on metal from 1961. His last works also belonged to cycles, such as *La fine di Dio* (The End of God) shown in 1963 at Milan's Ariete gallery, his *Teatrini* (Puppet Theatres) in 1964, and *Ellissi* (Ellipses) in 1967.
R.C.

Renato Guttuso
Bagheria (Palermo) 1912 - Rome 1987

Guttuso trained in the Palermo studio of Domenico Quattrociocchi and then with Pippo Rizzo. His two paintings featured at the I Rome Quadriennale in 1931 were spotted by Francesco Trombadori, who mentioned them in his reviews of the show. The following year Guttuso took part in the group show of young Sicilian artists organised by the Milanese Milione gallery, whereupon he abandoned his law studies and dedicated himself entirely to painting. In the 1930s cultivated a number of key friendships. In Rome he met Cagli, Mafai, Mirko, Melli, Fazzini, Ziveri, who represented the group of artists that revolved around the Cometa gallery. During his military service from 1935 to 1937 in Milan he met Birolli, Sassu, Manzù, Treccani, Cantatore, De Grada, Persico and Pagano. Guttuso took part in both the Rome Quadriennale shows of 1935 and 1939, as well as in the 1936 Venice Biennale with an already strongly realist style of painting. With its dense chromatic range, Guttuso's work was in open conflict with the Novecento movement. When he finally settled in Rome in 1937 the studio he shared with Colacicchi and Scialoja became a reference point for anti-fascist writers and artists such as Libero De Libero, Antonello Trombadori, Giorgio Vigolo, Alberto Moravia, Alicata, Vittorini and Nino Franchina. In 1938 Guttuso held his first solo exhibition at Rome's Cometa gallery. In 1939 he took part in the Milan exhibition organised by *Corrente* for which Maccari's publication *Il Selvaggio* (with which Guttuso already collaborated) dedicated a special edition to him. He also collaborated as an art critic with *Primato*, *Prospettive* and, after the war, with *Rinascita*, *L'Unità* and *La Fiera Letteraria*. Guttuso's most important works date from this period. They display a clear political message and strong moral tension, such as in *Fucilazione in campagna* (Firing Squad in the Country), dedicated to the memory of Federico García Lorca who was shot by Franco's militia. *Fuga dall'Etna* (Flight from Etna), a large-scale composition inspired by Picasso's *Guérnica* was awarded third prize at Bergamo in 1940, while *Ritratto della madre* anticipated the mutual penetration between figures and objects that was to appear constantly in Guttuso's subsequent works. In 1942 he painted his most significant work of the period, *La Crocifissione* (The Crucifixion), reminiscent of the *Crocifissione* by Rosso Fiorentino and in which the cubist composition is animated by a violent expressionist colour. In 1944 Guttuso became actively involved in the Resistance. His cycle of watercolours featuring the blind cruelty of the Nazis and the massacre at the Fosse Ardeatine were published in 1945 in the *Gott mit uns* volume. In 1944 Guttuso took part in the group show *Arte contro la barbarie* (Art Against Barbarism) organised by the daily *L'Unità*. In 1948 he took part with the group Fronte nuovo delle Arti (New Arts Front), of which he was one of the founders, in the Venice Biennale. In France he met Picasso, who encouraged him towards an emotional involvement in the real world. After the war Guttuso continued to execute works with a social theme, such as *Occupazione di terre incolte in Sicilia* (Occupation of the Unfarmed Lands in Sicily, Venice Biennale 1950), which placed him in the ranks of the figurative artists against abstraction. Throughout the 1960s and 1970s his more favoured subjects were still lives, nudes, portraits, views of lower class and city life and current events. In 1960 the Venice Biennale honoured him with his own room. Guttuso's most memorable works from the last decades of his life are the large-scale 'reportage fresco' *Funerali di Togliatti* (The Funeral of Togliatti, 1972) and his 1974 *La Vucciria* (the noisy market in Palermo that has extended its name to an entire area), which he donated to the University of Palermo. One of his later masterpieces, this work depicts an every-day scene from the market that is one of the symbols of the Sicilian capital.
M.M.

Jannis Kounellis
Piraeus (Greece) 1936

Kounellis moved definitively from Greece to Rome in 1957, where he studied at the Academy of Arts. Through the education imparted to him by Scialoja, the only Accademia teacher with up-to-date ideas, Kounellis filtered all the information of New Dada, neglecting out of principle certain Italian and particularly Roman painting that was going out of favour. From 1959 Kounellis proposed a pictorial language that received and quoted visual features of metropolitan life and the mass media. He used words, letters, numbers and traffic signs, reorganising onto the monochrome white canvas suggestions of Capogrossi's 'signs' and Twombly's poetical writing. Kounellis first presented these paintings at a solo exhibition organised at the Tartaruga gallery in the summer of 1960. As from the end of the 1960s Kounellis went beyond paint-

ing and experimented with new research goals. He used natural materials such as minerals, empty or grain-filled sacks, wool or powdered coffee displayed within a variety of metallic structures. Kounellis also used live plant and animal elements from nature, such as cacti, parrots, and the horses presented at the Attico gallery in Rome in 1969. By using primary materials and objects from every-day life in his work Kounellis subverted the very language of art itself. In 1967 he was featured at Celant's exhibition of Arte Povera artists at La Bertesca gallery in Genoa, which launched the movement. Kounellis' successive work alternated between concepts of history as fragments of collective memory and the energy of fire as a symbol of change, destruction, purification and renewal. Since the 1970s the work of Kounellis represents the contradictions in contemporary society by associating classical elements with items from the society of today. His most recent installations underline his thoughts on contemporary art, which he sees as a means to understand reality rather than transcend it.
R.C.

Luisa Lambri
Como 1969

Lambri made her debut aged 26 at the group show *Aperto 95* organised by the Galleria d'Arte Moderna in Bologna. Just a year later she took part in a series of prestigious events such as the XII Quadriennale d'Arte *Ultime Generazioni* (Latest Generations) and the serial exhibition *Partito Preso* organised by the Galleria in Rome.
From the start Lambri has used photography as a means for expressing herself rather than as a mere technical instrument. The places she photographs are reduced to abstract, almost neutral form from which any geographical, topographical or historical element is eliminated. Lambri's preferred spaces, the architecture of the great rationalist masters, are presented in a mental, timeless and immaterial way to the viewer.
A tribute to Terragni, her earliest works such as her photographs of the Casa del Fascio in Como are deprived of any human presence whatsoever. Empty and bathed in an unreal light, these places assume an almost metaphysical dimension that is both disturbing and fascinating.

Lambri's work is a kind of travel notebook, such as her series *Blind Room*, in which she has photographed the ceilings of the buildings of Alvaar Alto, thereby offering a partial and subjective vision of the space. Lambri also visited the Czech Republic where she photographed the house designed by Mies van der Rohe in Brno. In 1999 Lambri took part in the Venice Biennale with a video tribute to the deceased artist Gina Pane, for which she won the Leone d'Oro. In 2000 she travelled to Japan to immortalise the buildings of Kazuyo Sejima, the female Japanese architect of world renown.
A.M.

Osvaldo Licini
Monte Vidon Corrado
(Ascoli Piceno) 1894–1958

Licini attended the Academy of Arts in Bologna with Giorgio Morandi, Severo Pozzati and Mario Bacchelli. In 1914 he exhibited alongside the futurists at the Baglioni Hotel in Bologna. Although he never joined the movement, his contacts with the futurists gave him a taste for experimenting with geometric shapes. After serving voluntarily in the war Licini joined his family in Paris in 1918. During this first stay in France he took part in a number of shows, such as the Salon d'Automne and the Salon des Indépendants, with chromatically lively works of a strongly naturalistic taste. Up to date with Europe's latest avant-garde movements, Licini met Picasso, Derain, Cendrars and all the Italian artists then living in the French capital. He also met Kandinsky, Kupka and Magnelli. In the late 1920s he moved back to Monte Vidon Corrado, where he lived a solitary existence. Licini exhibited works at the Novecento movement shows in Milan, in 1926 and 1929, as well as in Europe. At the beginning of the 1930s, he abandoned his successful painting from life in favour of abstraction, in which free, minute geometric shapes were arranged on layers of vivid colour reminiscent of Klee and Miró, as well as of the theories of Kandinsky. In 1935 Licini took part, along with artists from the Milione gallery, in the first Italian exhibition of Abstract art at Turin's Studio Casorati-Paulucci, presented by Edoardo Persico. Because his abstraction did not derive from Constructivism, Licini could not be classified as one of the Lombard group of abstract artists that included Veronesi, Radice and Reggiani, also featured

at the show. Licini's own brand of abstraction was labelled 'lyrical' on account of his powerfully evocative colours and his free combination of geometric forms. Licini himself sought this combination through 'geometry and sentiment', giving highly evocative titles to his paintings. After the Second World War he retired to his hometown and continued his abstract pictorial production. His geometric arrangements began to acquire an ever increasing fantastical character that verged on the surreal. Strange creatures of the mind, lights and signs seemed to indicate the way through an imaginary space. At the 1950 Venice Biennale he exhibited nine works on the *Amalassunta* theme to great critical acclaim. The 1958 Biennale dedicated an entire room to him and awarded him the international painting prize.
S.F. - M.M.

Francesco Lo Savio
Rome 1935 - Marseilles 1963

After studying architecture up until 1955, Lo Savio's first paintings date from 1959, when he was featured in a group exhibition at L'Appunto gallery. A year later Lo Savio held his first solo exhibition at the Selecta gallery. This exhibition caught the eye of Kultermann, who invited him to take part in the Leverkusen *Monochrome Malerei* show in March of the same year, featuring artists who only worked in a single colour. Lo Savio completed his second series, *Filtri* (Filters), between 1959 and 1960 using layers of superimposed semi-transparent, coloured sheets covered by metal gauze. In 1960 he started work on his *Metalli* (Metals) series of straight and curved steel surfaces covered with matt black paint. These were shown the same year in Rome at a group show organised by Restany at La Salita. At this time Lo Savio was also in contact with Zero, a group researching in the visual field established in Düsseldorf in 1958. He exhibited at La Salita gallery first in 1961 and then in 1962, as well as at the *Nul* show at the Stedelijik Museum of Amsterdam in 1962. The same year he completed *Articolazioni totali* (Total Articulations), a series of white cement cubes 'inhabited' by bent black metal sheets. He also published *Spazio-luce, evoluzione di un'idea* (Space-Light, the Evolution of an Idea), a theoretical synthesis of the work of Mondrian that he dedicated to Mondrian himself. Following Lo Savio's sui-

cide in 1963 a retrospective show was dedicated to him at Rome's Palazzo delle Esposizioni. Since the second half of the 1960s Lo Savio's work received full recognition and was re-interpreted as a precursor of minimalist research.
R.C.

Mario Mafai
Rome 1902–65

In 1922 Mafai enrolled at the Scuola Libera del Nudo and frequented Scipione, Mazzacurati and his future wife Antonietta Raphaël. Bound by common aesthetic ideals, Mafai and his group of friends started what was to be termed the 'Scuola Romana di Via Cavour', the first nucleus of the Roman School, named thus by Longhi after the street where Mafai and Raphaël had their studio-home. He painted still lives, views of Rome and portraits. Whilst studying the work of Titian and El Greco, Mafai was also attracted to the painting of Henri Rousseau and Derain. He exhibited for the first time in 1925 at the III Rome Biennale, where he attracted the attention of C.E. Oppo. At the Sindacale del Lazio artists guild exhibition in 1929 Longhi used the term 'expressionism' to describe the work of Mafai. Between 1930 and 1933 he and Raphaël lived in Paris, only returning for short periods to Italy for exhibitions. In the 1930s Mafai produced his most important works, such as *Donne che si distendono al sole* (Women Lying in the Sun), *Nudo in riposo* (Resting Nude), *Lezione di piano* (The Piano Lesson), and particularly his *Fiori* (Flowers) series. His *Demolizione dei borghi* (Demolition of the Old Quarters) cycle of paintings was largely completed between 1935 and 1939 and features the gutting of central Rome carried out by the fascist regime, particularly behind St Peter's, the Pantheon, and the Roman Forum. The dense matter and dark colour range used by Mafai in his portraits at this time were to re-surface in the expressionist language of his mature period. He met with public and critical acclaim at the 1935 Rome Quadriennale, where he exhibited 29 paintings. In 1937 he presented his *Demolizioni* series at the Cometa gallery. In 1939 he moved with his family to Genoa in an attempt to escape the racial persecution laws. Here he met Manzù, Guttuso, Birolli, Sbarbaro and the collectors Alberto Della Ragione and Emilio Jesi. In 1939 he took part in the second Corrente exhibition in Milan. After

winning the Premio Bergamo in 1940 with *Modelli nello studio* (Sitters in the Studio), Mafai moved back to Rome. In 1944 he exhibited *Fantasia* at the *Arte contro la barbarie* (Art Against Barbarism) show organised by the daily *L'Unità* at the Galleria di Roma. In 1948 he joined the Fronte nuovo delle Arti (New Arts Front), a movement that opposed all formalism in art. At the end of the 1950s he briefly experimented with abstraction. Mafai's last show was in 1964 at the Attico gallery in Rome.
M.M.

Alberto Magnelli
Florence 1888 - Paris 1971

During his youth, spent in Florence, Magnelli frequented the futurist artists and writers associated with the magazines *La Voce* and *Lacerba* but his most important inspiration derived from the vivid chromatism of the 14th- and 15th-century Senese school, Piero della Francesca and Paolo Uccello, from whom he inherited the architectural quality of his large-scale compositions. During a trip to Marseilles in 1913 he purchased a primitive mask, the first piece of his collection of African art. After arriving in Paris with Palazzeschi in 1914 he became part of the avant-garde circles of Apollinaire and Picasso, meeting Léger and Archipenko. Although the still lives painted by Magnelli during this period suggest cubist influences, the dark outlines and un-modulated areas of colour are reminiscent of Matisse. Following suggestions from Apollinaire for a brief time he painted totally abstract, Orphic works that were, in his own words, 'completely invented'. He resumed figurative painting as soon as he had returned to Italy at the outbreak of war, however. This research culminated in 1918 with his series of *Esplosioni liriche* (Lyrical Explosions). After several trips to Germany, Switzerland and Austria, and the first solo exhibition in Florence in 1921, Magnelli completed some almost monochromatic paintings. After 1924 he turned to painting Tuscan landscapes, static and silent images with a metaphysical tinge and with an interior need for formal 'obedience'. A period of crisis that put a block on his painting followed, notwithstanding his participation in the 1928 Venice Biennale, an exhibition at the Pesaro gallery in Milan and his own room at the Rome Quadriennale in 1931. The great marble

blocks in the quarries of Carrara during the summer of 1931, which reminded him of Michelangelo's *Prigioni* (Prisons), prompted Magnelli to return to Paris where he started work on his series *Pietre* (Stones), jagged and stony compositions similar to those of Léger. A series of thirty *Pietre* were exhibited at the Pierre Loeb gallery in Paris in 1934 and at the 1935 Rome Quadriennale. In 1937 he took part in the exhibition *Origines et développement de l'art international indépendant* (Origins and Development of Independent International Art) in Paris and prepared a solo exhibition at the Boyer Galleries in New York. During the war he took refuge in Provence along with his wife, Delaunay and Arp. In 1950 a collection of his lithographs was published. He experimented with new materials and techniques such as gouache painting on slate sheets in his *Ardoises*, and *Collages musique* on musical scores. In 1945 he took part in the *Art concret* review at the Drouin gallery in Paris along with Arp, Delaunay, Kandinsky, Mondrian, Pevsner and Van Doesburg. Two years later a retrospective of his work was held at the Drouin gallery, where he was recognised as a leading exponent of international abstract art. In the 1950s Magnelli closed his forms within a more severe compositional grid accentuated by rhythmical linear elements. The 1950 and 1960 editions of the Venice Biennale featured an entire room dedicated to his work.
M.M.

Piero Manzoni
Soncino (Cremona) 1933 - Milan 1963

After an *Informel*-materic beginning in 1956 under the influence of Klein, Burri and Fontana, Manzoni produced his *Manifesto programmatico per la scoperta di una zona di immagini* (Towards the Discovery of a Source of Images), followed by a series of other manifestos a year later. In 1958 he exhibited his first *Achromes* made from scratched and marked plaster or from cut canvas covered with kaolin. Manzoni thus underlined not so much his interest in matter or monochrome colour but rather his striving for a space deprived of any image and identified with the starting point of the picture. The same year Manzoni came into contact with the Düsseldorf Zero group. The influence of this group is clearly visible in the new series of *Achromes* 'in which

every "materic" residue of anti-traditional taste is deleted and the white canvas divided into a sewn chessboard made from irregular patches' (De Marchis 1982). In the autumn of 1959 Manzoni approached the purist extreme of visual-concrete research represented by Castellani and Agnetti, with whom he drew up plans for the magazine *Azimuth* and later for the underground gallery of the same name. In 1960 Manzoni took part in the Leverkusen exhibition on monochrome art. The same year the artist pushed his work in different directions. At the Azimut gallery he presented a show featuring eggs marked with his thumb print that were hard boiled on the spot and which the public was invited to eat. After an exhibition in Rome with Castellani in the summer of 1961 Manzoni produced his first *Linee*, lines traced on a long strip of canvas or paper that was then rolled up into a holder on which was inscribed the length and completion date. 'This radical gesture caused a sensation and marks Manzoni's new direction towards Dada and anti-visuality that was to characterise all his successive work' (De Marchis 1982). At his solo exhibition at La Tartaruga gallery Manzoni signed people displayed as living sculptures and then issued certificates of authenticity. In these years he displayed strong Dada influences in his work and actions, such as in his *Corpi d'aria* (Bodies of Air) instantly inflatable sculptures, his *Fiato d'artista* (Artist's Breath) and his *90 scatolette di merda d'artista* (90 Tins of Artist's Shit). Manzoni continued with his *Achromes* series using expanded polystyrene, cotton swabs and wool, all treated with cobalt chloride that changed their colour according to the weather. By placing objects on the surface of the painting Manzoni was again referring to the dadaist desecration of the inspired nature of the artist's craft. He died suddenly in 1963 in his studio in Milan.
R.C.

Giacomo Manzù
Bergamo 1908 - Ardea (Rome) 1991

Having followed evening plastic arts classes since 1925, in 1929 Manzù made a first trip to Paris. In 1930 he moved to Milan, where he found a more congenial artistic and cultural climate. His studies of the San Zeno door in Verona during his youth directed him towards an archaic style that he developed with

considerable elegance. He exhibited at the Milano gallery in a group exhibition with Tomea, Pancheri, Sassu, Birolli, and again with the same artists at the Milione gallery. His 1934 trip to Rome inspired Manzù for his *Cardinali* (Cardinals), a theme that was to be recurrent in his career until the 1950s. With his father a sacristan and coming from a highly religious family, these were images from Manzù's youth. But he was also inspired by the evocative sight of the Pope seated on his high-backed chair amidst the cardinals. Wrapped in their vestments, Manzù's cardinals at times appear to be the friendly local bishops of Bergamo, at others they appear closed within themselves, in hieratic solitude. In 1938 Manzù made a second trip to Paris, where he studied the sculpture of Rodin, Maillol and Degas. In 1943 he won the first prize at the Rome Quadriennale with *Francesca Blanc*. Between 1939 and 1942 he completed his series of *Crocifissioni* (Crucifixions) bas-reliefs, in which the evangelical event assumes a historical meaning with ideological connotations. Derived from the dramatic nature of war, the theme was also the fruit of Manzù's clear political and moralistic stance. The *Crocifissioni* theme however is a universal representation of the drama of man exposed to the cruelty and violence of a terrible historical moment. This unorthodox iconography caused such a stir that it provoked the direct intervention of Pope Pius XII. In 1948 Manzù was awarded the first prize for sculpture at the Venice Biennale for his *Cardinali*. In 1950 he won the competition to design the St Peter door in the Vatican. Initially the theme was to be the triumph of the saints and martyrs of the Church but Manzù did not find this subject congenial. Subsequently and with the intervention of Pope John XXIII the theme was in fact changed to *La porta della Morte* (Door of Death). In this form it was completed and inaugurated in 1946. In 1954 Manzù completed a first portrait of Inge Schnabel, who was to become his favourite model and then his wife. In 1955 he received the commission for the central door of the cathedral of Salzburg, *La porta dell'Amore* (Door of Love), which was inaugurated in 1958. With his wife and two children Giulia and Mileto Manzù moved from Milan to his studio-home at Ardea, near Rome. In 1965 he received the commission for the *Porta della Guerra e della Pace* (Door of War and Peace) for the Saint Laurence church of Rotterdam, completed in 1968. Large-

scale sculptures continued to occupy Manzù also in the 1970s, such as *Il grande cardinale* (The Great Cardinal) in Salzburg, the relief *Giustizia e Pace* (Justice and Peace) for the European Community High Court in Luxembourg, the monument to the partisan, which he donated in 1977 to the city of Bergamo. Aside sculpting Manzù has also had a rich and interesting activity as a graphic artist, medallist, jewellery designer and set designer for theatre.
M.M.

Marino Marini
Pistoia 1901 - Viareggio 1980

A pupil of Domenico Trentacoste at the Academy of Arts in Florence, since his youth Marini displayed a predilection for the archaic, rough forms of Romanesque and Gothic Tuscan art. He did also however study the light-sprayed mouldings of Medardo Rosso and the dynamism of Umberto Boccioni. Marini made his painting debut at the II Roman Biennale in 1923. He settled in Florence in 1926 and took part along with the Novecento group in the 1928 exhibition of the Milano gallery with *Ritratto di Costetti* (Portrait of Costetti) and *Bagnante* (Bathing Woman). In 1927 he took part in the Decorative Arts Exhibition in Monza where he met Arturo Martini, who in 1929 invited him to succeed him in his post of professor of sculpture at the Monza school of art. The same year, during a stay in Paris, Marini visited the studios of Picasso and Maillol, met Lipchitz, Braque and Laurens and took part in the exhibition of Italian artists organised by Mario Tozzi with the terracotta sculpture *Il Popolo* (The People) inspired by Etruscan sarcophagi. He then took part in the second Novecento show in Milan, where he moved, travelling frequently to Paris, Holland, Great Britain, Belgium and Austria. During a major trip to Germany in 1934 Marini was deeply impressed by Gothic equestrian statues in the cathedrals of Frankfurt, Nuremberg and Bamberg. At this time he developed his archetypal theme of horse and knight and the *Pomona* nudes, a mythical image of fertility, as well as his numerous variations on *Giocolieri* (Jugglers) and athletes such as *Pugile in riposo* (Resting Boxer). At the 1935 Rome Quadriennale he was awarded the sculpture prize. After 1940 Marini taught at the Brera Academy in Milan. In 1942 he took refuge in Switzerland and returned to Milan in 1946. He met Henry Moore, who was to become a long-term acquaintance, and the art dealer Curt Valentin, who organised his first exhibition in New York in 1950. In 1952 he was awarded the sculpture prize at the Venice Biennale. The war and its tragic events had affected the serene balance of Marini's sculptures, which were now charged with an existential anguish as in *Cavaliere* (Knight, 1949). In the 1950s Marini worked on his most dramatic series, *Miracoli* (Miracles), *Guerrieri* (Warriors) and *Grido* (Cry).
S.F. - M.M.

Arturo Martini
Treviso 1889 - Milan 1947

After working as an apprentice in a ceramic factory Martini enrolled in the Venice Academy of Arts in 1907. In 1908 he took part in the first exhibition at Ca' Pesaro. Thanks to the financial support of the ceramic manufacturer G. Gregorj in 1909 he was able to travel to Munich, where he visited the studio of Adolf Hildebrand. In 1911 Nino Barbantini dedicated an entire room to him at the Ca' Pesaro show, where he presented ceramics, pottery, sculptures and engravings. In 1912 Martini was in Paris with Gino Rossi, with whom he exhibited at the Salon d'Automne along with de Chirico, Andreotti and Modigliani. Martini's work from this period was particularly influenced by German Secessionism. On his return to Italy the artist became briefly associated with Boccioni and the futurists, with whom he exhibited at the Sprovieri gallery in Rome. During the war he worked as a welder in an arms factory, where he learned welding technique. In 1919 he settled in Milan where he met Margherita Sarfatti and the industrialist Pietro Prada. In exchange for some of his works Prada had Martini to stay on Lake Como. In 1920 Martini was presented by Carrà for his first solo exhibition in Milan. After accepting Mario Broglio's invitation to join *Valori Plastici* Martini exhibited with this group of artists in Germany in 1921. In 1922 he was featured at the *Primaverile Fiorentina* show. Martini then won the competition for the War Memorial monument in Vado Ligure (1922–23). Dividing his time between Vado Ligure, Rome and Anticoli Corrado, Martini produced eight tiles for the 1925 Rome Biennale, where he had his own room. He then exhibited at the first and second Novecento shows in Milan and at the Venice Bi-ennale for the first time in 1926. His production at this time included reliefs, tiles and ceramic. In the late 1920s and early 1930s Martini displayed his original interpretation of Greek and Etruscan statuary. He worked in stone and marble. Martini's best known works date from this period, such as *Il cieco* (The Blind Man), *Il bevitore* (The Drinker), *La Pisana* (The Pisan Woman), *Donna al sole* (Woman in the Sun) and *Maternità* (Maternity). In 1931 he was awarded first prize for sculpture at the I Rome Quadriennale, where he had shown seven large scale works. In 1935 he completed the bronze statue *Athena* for the main square of Rome University. In 1937 he executed a marble relief for the Milan law courts. From 1942 he taught at the Venice Fine Arts Academy. Tired of working, in 1954 Martini wrote *Scultura lingua morta* (Sculpture, a Dead Language), in which he voiced his thoughts on what he believed to be the irreversible crisis of statuary.
M.M.

Mario Merz
Milan 1925

Born in Milan in 1925, at a very young age Mario Merz moved to Turin, which became his adopted city. A medicine student as well as poet, graphic artist and *Informel* painter, Merz remained largely unnoticed until the critic Celant spotted him in 1967. The same year Celant invited him to take part in an exhibition at the Bertesca gallery in Genoa, which was to mark the official birth of the Arte Povera movement of which Merz became one of the leading exponents. From this year onwards Merz concentrated on common materials which he 'transfixed' with neon lights, thereby localising the fields of energy within the work. In piercing the primary shapes of igloos, Merz's neons sometimes follow the numerical progressions of the mathematician Leonardo Fibonacci, who was inspired by progressive growth patterns in nature. In this way objects become the focal points of energy, altering their own static origin into a dynamic force. After his debut Merz was invited to take part in a variety of historically important exhibitions such as *Prospect 68* (Düsseldorf 1968), *When Attitudes Become Form* (Bern 1969) and the fifth edition of *Documenta* (Kassel 1972). The end of the 1970s marked a return to figurativism in the work of Merz, who used large images of animals often placed within the context of an installation. In 1989 New York's Solomon Guggenheim museum dedicated an anthology to Merz, confirming him as one of the most important post-war artists.
A.M.

Maurizio Mochetti
Rome 1940

Immediately after graduating from the Academy of Arts in Rome Mochetti became interested in scientific issues based on geometry, physics, optical phenomena and on the possibilities offered by technology to produce visual phenomena in space. From his beginnings Mochetti analysed 'the spatial influence of light and shadow, playing on the ties between void and full, opaque and transparent, concave and convex, the interchangeable nature of real measurements with perceived measurements, optical effects with tactile reality' (Volpi 1968). In 1968 Mochetti had his first solo exhibition at La Salita, one of Rome's cutting edge galleries alongside La Tartaruga, L'Attico and L'Obelisco. At La Salita he exhibited his *Generatrice* (Generator), in which an aluminium axis moved by a small engine inside marks a semi-circle on the floor. This work won Mochetti the Pino Pascali prize in 1969. The same year Mochetti also won a prize at the Paris Young Artists Biennale. From this moment onwards he constantly updated his research with objects and installations in which the spatial value was given by the universe of relations existing between the single elements and their surrounding space. The threads, spheres, arrows or model planes often used by Mochetti are the functional pretext to the movement of light rays or shadows of the objects themselves. From the 1980s the artist often resorted to using laser as an ideal form of connecting places and representing his simultaneous and conscious omnipresence at the same moment. In this way every work becomes an event.
R.C.

Amedeo Modigliani
Leghorn 1883 - Paris 1920

The *grand tour* style journey made by Modigliani along with his mother in 1902 to the galleries and museums of Florence, Rome, Naples and Venice was of fundamental importance to his formation. He was particularly stricken by the Greek

and Roman sculptures at the archaeological museum in Naples. Modigliani decided to learn the techniques of sculpting in marble at the Pietrasanta quarries near Carrara but he found the physical strain too much for his constitution already weakened by tuberculosis. His models at this time were Trecento and Quattrocento Italian sculptors, particularly Verrocchio, the Medici tombs designed by Michelangelo and the Trecento Senese sculptor Tino di Camaino. Dissatisfied with the teaching at the Venice Academy of Arts and with the small town environment of Leghorn, Modigliani moved to Paris in 1906. In the French capital he frequented Italian artists such as Severini and Anselmo Bucci, as well as Utrillo, the fauves and the sculptor Henri Laurens. He drew extensively and was impressed by the large forms of Matisse, Gauguin and above all Picasso. It was through Picasso and the other Bateau-Lavoir artists that Modigliani discovered African sculpture and the art of Australia and Asia. He exhibited seven works at the Salon d'Automne in 1907, which also featured a retrospective of Cézanne. Modigliani then met the collector Paul Alexandre, who offered him a studio home and encouraged him to exhibit some of his paintings at the Salon des Indépendants in 1908. These included *L'ebrea* (The Jewish Woman) and *Nudo seduto* (Seated Nude). In 1909 Modigliani met Constantin Brancusi, who was instrumental in directing him towards an archaic flavour in sculpture and towards black art. He showed Brancusi his studies of caryatids and studied Egyptian art at the Louvre. In 1910 he exhibited six paintings at the Salon des Indépendants and seven sculptures, his *Teste* (Heads), at the Salon d'Automne in 1912, alongside works by de Chirico, Arturo Martini and Gino Rossi. In 1914 he met the English poet Beatrice Hastings, with whom he lived for about two years and who posed as his model. Max Jacob introduced him to the art dealer Paul Guillaume, who commissioned a number of works and of whom the artist was to paint a series of portraits. Between 1915 and 1916 Modigliani's work load grew more intense. In 1916 he met the Polish poet Leopold Zborowsky, who became his dealer and patron by paying him a regular income in exchange for work. In 1917 he had a relationship with Jeanne Hébuterne, with whom he had a daughter in 1918. Through Zborowsky Modigliani exhibited at

the Berthe Weil gallery but the scandal aroused by his large nudes caused the exhibition to close. In 1919 he went to the Côte d'Azur to convalesce, his poor health worsened by his abuse of drink and drugs. Zborowsky managed to get Modigliani featured at a group show in London, at the Mansard Gallery, which turned out to be his first success both in terms of sales and reviews. A further decline in his health resulted in his death in January 1920. A retrospective exhibition was dedicated to Modigliani by the 1922 edition of the Venice Biennale.
M.M.

Giorgio Morandi
Bologna 1890–1964

From 1907 to 1913 Morandi studied at the Bologna Academy of Arts. With his friends Osvaldo Licini, Severo and Mario Pozzati, Giacomo Vespignani and Mario Bacchelli he took part in an exhibition at the Baglioni Hotel in 1914. Morandi also came into contact with the futurist artists, with whom he exhibited in Rome at the Sprovieri gallery. This fleeting encounter was to have no real influence on his style, however. The same year Morandi also took part in the second exhibition of the Roman Secessionist movement. Already in the landscapes featuring the small Apennine village of Grizzana, where he spent his summers as from 1913, the artist displayed a very personal and independent style based on compositional rigour and clarity of shapes. Morandi himself indicated his artistic reference points as being primarily Cézanne and his painting as meditation and conscience of reality. Also influential was the Cubism of Braque, Henri Rousseau and Derain. Roughly ten paintings completed between 1918 and 1920 testify to his interest in metaphysical painting. He was in fact familiar with the writings and paintings of de Chirico, Carrà and Mario Broglio. Morandi collaborated with *Valori Plastici* and exhibited with the magazine's group of artists at the itinerant show organised by Broglio in Berlin in 1921. He was presented at the *Fiorentina Primaverile* in 1922 by de Chirico, who defined his artistic expression as being the 'Metaphysics of daily things'. His metaphysics in fact derived from his internal need for rigour and clarity rather than the desire to follow this movement. Morandi's more mature painting phase began after he saw the works of Cézanne at the 1920

Venice Biennale. This period was characterised by a rigorous attention to form, controlled emotions and meditation on few basic themes repeated with fine variations in detail such as his still lives and the landscape of hills around Grizzana. The metaphysical element expressed by objects devoid of any human element was also present in the late works from the 1940s, while the tension that had animated his work from the previous decade had dissolved into clear compositions. In 1930 Morandi exhibited a number of etchings at the Venice Biennale and obtained a post as professor of engraving techniques at the Bologna Arts Academy. In 1932 *L'Italiano* dedicated a special issue to him, with the critical text written by Ardengo Soffici. In 1939 Morandi was given his own room at the III Rome Quadriennale and won the second prize for painting, causing considerable controversy. Critical acclaim in Italy and abroad was nonetheless unanimously in Morandi's favour. Morandi's frequent meetings with Roberto Longhi contributed to define his formal values that would reach full balance in his landscapes from the 1940s and in his works after the Second World War.
M.M.

Gastone Novelli
Vienna 1925 - Milan 1968

After fighting in the Resistance during the war and then graduating in political science in 1947, Novelli began to paint. Between 1948 and 1954 he lived for the most part in Brazil, where he took part in group shows and worked as a designer for exhibitions.
On returning to Rome at the end of 1954 Novelli went through an *Informel* phase before approaching Emilio Villa, Corrado Cagli and Achille Perilli. With Perilli he founded the highly experimental magazine *Esperienza Moderna* (1957–59), which was to be at the base of many of his excursions into literature, music and theatre. In this period Novelli's painting included words, fragments of texts and items taken from every-day life. As Vivarelli wrote in 1988, 'notwithstanding his deep Dada roots, in 1960 Novelli's real development was not in the direction of New Dada and neither was he influenced by the passage in 1967–68 of Arte Povera'.
Novelli became increasingly close to American painters, particularly Twombly. His canvases were cov-

ered in words, thus transforming his work into an autobiographical 'diary'. During the 1960s Novelli became increasingly interested in the relation between painting and writing. He approached some avantgarde Italian writers and worked with them on the creation of a new 'mythical' language. After taking part in the conference 'La nuova letteratura' (New Literature) he adhered to the newly created Gruppo '63. During the summer of 1962 he travelled to Greece where he kept a sort of travel diary in which he gathered and re-elaborated drawings and writings. This was printed in 1966 and followed by other illustrated books. Between 1966 and 1968 Novelli emphasised the critical nature of painting at a time when he became publicly concerned with social issues. This had repercussions on his formal language: signs became an obsessive element, while the canvas expanded to unusual sizes and shapes. At the opening of the 1968 Venice Biennale Novelli, like many other artists, decided to close down his room in protest against the presence of the police in the Giardini area of the show. Novelli died of a post-operation collapse in December of the same year.
R.C.

Luigi Ontani
Vergato (Bologna) 1943

Ontani made his debut at the San Petronio gallery in Bologna in 1965, where he presented some works in tempera and his *Oggetti pleonastici* (Pleonastic Objects). In 1969 he exhibited some works at the San Fedele gallery in Milan, where he began to use photographs to immortalise himself in religious and mythological guises as *St Michael* and *Theophany*.
The fairy-tale and whimsical aspect of Ontani's work featured prominently at his 1971 show at the Fiori gallery in Milan, where he presented a series of cardboard objects cut out with scissors, as well as in his performance in the gallery of Fabio Sargentini at six o'clock in the morning. On this occasion Ontani appeared dressed as Dracula, pretending to sleep for hours inside a glass case until dawn. Rooted in Italian performance art of the 1960s, Ontani's happenings are notable for the playful way in which he makes use of his own body, adopting a variety of new and spectacular interpretations of characters ambiguously perched between reality and

fiction. His participation in the 1978 Venice Biennale acted as a kind of launch pad for Ontani's career. In the early 1980s he soared to international fame with a variety of exhibitions abroad in prestigious venues such as the Stedelijk Museum in Amsterdam (1980), the Centre Pompidou in Paris (1981), and the Solomon Guggenheim Museum in New York (1982). Over the years Ontani has created a 'total' work of art at Grizzana, the birthplace of Morandi and near to where Ontani himself was born. This work, an ideal house called RomAmor, contains elements from all of Ontani's research.

In the last few years Ontani has been widely acclaimed both in Italy and abroad. In 2000 he was featured in a large anthology in Belluno, curated by the critic Renato Barilli. in 2001 New York's PS1 featured a retrospective of his work.
A.M.

Mimmo Paladino
Paduli (Benevento) 1948

Paladino's debut at the gallery of Lucio Amelio in Naples, the most prestigious exhibition space in southern Italy, contributed to his immediate success in Italy and abroad. This success was sealed along with that of other artists from Transavanguardia when Achille Bonito Oliva presented the group in the *Aperto* section of the 1980 Venice Biennale. Paladino's success continued in 1981 at his solo exhibition at the Badischer Kunstverein of Karlsruhe, at his Basel exhibition that then travelled to Hanover and Mannheim and at Bologna's Galleria d'Arte Moderna. His most significant exhibitions in these years included Royal Academy of London, the *Documenta 7* of Kassel and, along with his Transavanguardia colleagues at Barcelona in 1983 and at the Tate in London. The intelligent play of metaphors used by Paladino in his combination of materials was based on a highly complex conception and controlled use of signs. Paladino's sculptures and mosaics also displayed a language of ever multiplying figures with highly evocative touches. He combined real situations and imaginary ones with mystical and archaic formulae, where colour supported the whole.

The good fortune of Paladino's career continued in 1983 and 1984, with a series of shows from Newport Harbour to Los Angeles, Lyon, the Hirshhorn Gallery in Washington, Chicago and Basel. His works can be found in the most prestigious international collections while his large installations are increasingly in demand for public spaces and urban decoration.
A.M.

Giulio Paolini
Genoa 1940

In 1959 Paolini moved to Turin. A year later, aged 20, he started his artistic activity and became involved with contemporary research aimed at overcoming the *Informel* experience and right from his very first works showed signs of taking another direction. His debut was in 1961 at the XII Premio Lissone. Paolini's field of research was into structure, or rather into the meaning of vision by bringing to an extreme the tendency to modify artistic experience in conceptual terms. The project for a work is therefore more important than the work itself, which is merely the realisation of an idea rather than a traditional 'work of art'. Despite his minimalism and unspectacular approach in 1964 he attracted attention at his first solo exhibition at La Salita gallery in Rome where he displayed white wood panels, partly placed on the floor and partly hung on the walls. His research still seemed to be of a spatial nature. After 1965, however, Paolini's dominant theme was his focusing on the being of art history and on the relation between the viewer and the object. Lorenzo Lotto, Diego Velázquez and Jan Vermeer became the icons of this experience. In 1967 with Celant he exhibited at the show that launched Arte Povera at La Bertesca gallery in Genoa. In 1970 he had his own room at the Venice Biennale and in 1972 Ileana Sonnabend organised his first American solo exhibition in New York. After 1972 Paolini favoured reproductive media such as photography and plaster casts since they called into question the meaning of fine arts, originality and reproduction. In 1975 he started work on his *Mimesis* series, plaster copies of famous classical busts and structures in silent dialogue referring to the temporal and spatial distance between the original artist and our times. Paolini's investigations into history of art prompted him to work in the theatre while his philosophical and critical images accompanied texts by Cassiano and Heidegger. Over the years Paolini conceived every new exhibition as a new and unprecedented work in which he could include past works.
R.C.

Pino Pascali
Polignano a Mare (Bari) 1935 - Rome 1968

Pascali graduated in set design in 1959 from the Academy of Fine Arts in Rome. From 1960 to 1964 he worked in advertising and set design for television. In January 1965 his artistic career effectively began, with his first one-man show at the Tartaruga gallery in Rome. The works exhibited, which had been completed in 1964 on moulded canvas painted with glaze, were 'indebted to Pop art and in particular to Claes Oldenburg and Andy Warhol'. In *Pezzi di donna*, *Ruderi su prato* and *Colosseo* there was an '...element of contamination, bricolage, between the images of consumerism and every-day materials devoid of any "cultural" connotation...' (De Marchis 1982). In the summer of 1965 he built a series of fake weapons, his *Cannoni*, life sized and assembled with the 'ability of a props designer' (De Marchis 1982). These were presented in 1966 in Turin. By having himself photographed next to the works dressed as a soldier Pascali underlined both the jesting and accusatory aspects of the whole operation. After the weapons series came a series of animals and a series on the sea. In 1967 followed the elements series, featured in two collective exhibitions, one in Foligno entitled *Spazio dell'immagine* and the other in Rome called *Spazio degli elementi - Fuoco, immagine, acqua, terra*. From this moment onwards Pascali no longer completed his works in his studio but assembled directly in situ, for a more transitory effect. After the 'staging' of his first works, Pascali now presented his items in cycles rather than as singly so that they totally invaded the space. His last one-man exhibition was at the Venice Biennale, where he presented works made from acrylic and wire wool. Pascali died on 11 September 1968 after a motorcycle accident.
R.C.

Giuseppe Pellizza da Volpedo
Volpedo (Alessandria) 1868–1907

After studying at the Brera Academy of Arts Pellizza moved to Rome in 1888 where he attended the Accademia di San Luca and the French Academy. He then moved to Florence and was a pupil of Giovanni Fattori for a period. He met Silvestro Lega and Plinio Nomellini, with whom he was to become friends and collaborate professionally. Between 1889 and 1890 he studied still life with Cesare Tallone in Bergamo and completed a series of works of this genre. In 1889 he visited the Universal Exhibition in Paris, where he was particularly stricken by the work of Bastien-Lepage, Corot and Manet. As a result of the variety of cultural experiences in his education Pellizza painted *Mammine* (Little Mothers) in 1892, a large work painted from real life, in the open air, in which he studied the effects of light and used a well-developed pyramid form of construction in the composition. In Genoa he again met Nomellini and began analysing the principles of division of colour as a means for obtaining maximum brightness. In 1891 he took part in the first edition of the Milan Triennale, still with paintings in the verist style. On this occasion Pellizza was able to evaluate the results of divisionist research in the works of Morbelli, Previati and Segantini. With Morbelli he then deepened his theoretical knowledge on the division of colour and brought himself up to date on the subject by reading texts in French, English and Italian, by Chevreul to Rood, Mile and Guaita. Between 1892 and 1894 Pellizza experimented with this new technique and his paintings met with success at the Esposizioni Riunite show in Milan in 1894. The composition of these works is 'varied, as objects appear varied in nature and like a variety of means are necessary to achieve a communicative harmony in colour and forms...'. Beginning from the more scientific and analytical divisionism practised by Morbelli, Pellizza adapted his technical solutions to the ideal of 'making art for humanity'. At this time, in fact, his belief in the important social role of art and his active participation in the political struggles of the proletariat induced him to deepen his knowledge of social issues by reading a variety of socialist texts. Pellizza attended the lectures of the historian Pasquale Villari on contemporary issues and met the idealist philosopher Angelo Conti, who in turn introduced him to the spirituality of pre-Raphaelite culture and to the thought of John Ruskin. Pellizza became increasingly concerned with exploring a new language of symbolism in forms and colour, able to convey the dominant humanitarian content of his work. Around 1896 he analysed the relation between colour and emotional states of mind in an attempt to find tonalities

161

psychologically in tune with his strongly symbolist paintings such as *Lo specchio della vita* (The Mirror of Life), presented at the Paris International Exhibition in 1900. He frequented the circle of critics and writers who collaborated with *Marzocco*, the Florentine magazine that supported Idealism in art, where in 1897 he published the essay *Il pittore e la solitudine* (The Painter and Solitude). At the same time Pellizza began to work on the large-scale painting *Quarto Stato* (The Fourth Estate), completed after several versions in 1901 and which remains a fundamental key for the interpretation of Italian social issues at the end of century. In 1906 he went to Rome, initially as a guest of the Turinese writer Giovanni Cena who was actively committed to humanitarian and social work. In Rome Pellizza dedicated himself to real-life study of nature in Villa Borghese and in the Roman *campagna*, re-interpreting the landscape painting tradition of Antonio Fontanesi and the Barbizon School who perceived nature as a place governed by primeval forces in opposition to the city and the new civilisation based on industry.
M.M.

Giuseppe Penone
Garessio (Cuneo) 1947

Penone had his first show in 1968 at the Deposito di Arte Presente (Present Art Repository), a space directed by Corrado Levi.
In late-1960s Turin he joined Kounellis, Zorio, Merz, Anselmo, Fabro, Paolini and Boetti in the early stages of Arte Povera, nonetheless maintaining an independent stance from the group.
Penone's first actions directly on natural elements in fact date from this period. Having received a lay, peasant upbringing, Penone's entire activity uses material actions to affirm the reciprocal nature of relations between human and plant life. Just by carrying them out, these actions assume the features of something cultural. Since the 1980s Penone's experimentations have also earned him international fame with major exhibitions at the Stedelijk Museum, in Mönchengladbach, Zurich and in private galleries in New York. In recent years his works have featured several times at the Museo d'Arte Contemporanea Castello di Rivoli, which dedicated an entire room to Zorio during its Arte Povera exhibition in 2000.
A.M.

Fausto Pirandello
Rome 1899–1975

Son of the playwright Luigi Pirandello, Fausto Pirandello began his artistic career as a sculptor, following drawing classes with Sigismondo Lipimsky. In 1920 he enrolled in the Scuola Libera del Nudo in Rome, abandoning sculpture in favour of painting and was captivated by the work of Van Gogh, Gauguin and Kokoschka. His official debut was in 1925 at the Rome Biennale with *Bagnanti* (Bathers). Pirandello's Parisian sojourn with Capogrossi from 1927 to 1930 proved to be highly influential in his artistic formation. In the French capital Pirandello studied the work of Cézanne, the cubists and above all Braque. He met the Italian artists Tozzi, Severini, de Chirico, Campigli and De Pisis. He exhibited alongside Cavalli and Di Cocco in a solo exhibition at the Galerie Vidrac in 1929. Through his direct contact with cubist works Pirandello learnt how to depict objects by structuring the different levels of perspective and layers of matter, managing to bring out objects also through the composition. In 1930 he exhibited in Berlin, then at the Bakun gallery in Vienna and lastly at the *Moderne Italianer* show at the Kunsthalle in Basel. Back in Rome in 1931 Pirandello held a solo exhibition at the Galleria di Roma, followed in 1932 by a group show featuring Roman and Milanese artists. He frequented artists of the Rome School, in particular Melli, as well as the artists and writers who gathered around the Cometa gallery such as Cagli, Capogrossi, Cavalli and De Libero. Although he exhibited alongside artists of the Roman School, Pirandello maintained a more autonomous position. While his works from between the 1920s and early 1930s were rigorously composed still lives and interiors close to Capogrossi and Cavalli in their tonal range, around 1935 Pirandello started producing large canvases using brighter and more earthy colours. Examples of these include *Pioggia d'oro* (The Shower of Gold) in 1933, *Donne che scendono le scale* (Women Descending Stairs) in 1934, and *Il bagno* (The Bath) in 1935. Pirandello's composition grew increasingly dramatic at the end of the 1930s, with the figures increasingly disfigured by anguish within a mounting hallucinatory atmosphere. His intense exhibiting activity culminated in 1939 when he was featured in his own room at the Rome Quadriennale. After the war and also thanks to the suggestions of the critic Lionello Venturi, Pirandello returned to the cubist analysis of geometrical shapes, never however embracing abstraction to the full.
M.M.

Michelangelo Pistoletto
Biella 1933

In the late 1950s Pistoletto began painting self-portraits in oil where the mirror theme that was to occupy him entirely throughout the 1960s appears in embryonic state. From 1962 he started his *quadri specchianti* (mirrored painting) series of pictures. This was the result of a continued study on mirrored surfaces and on the reflected vision of the human figure. Pistoletto also took into account the relation between time and space as well as the position of the viewer. The novelty of these works was not the way in which the characters reproduced on the surface blended into their surroundings but in the unprecedented relation between the work and its surrounding environment, which became an integral support to the work itself. This series was first presented at Pistoletto's solo exhibition in 1963 at the Galatea gallery in Turin. In 1964 Pistoletto completed and exhibited his *Plexiglas* at the Sperone gallery in Turin. In 1967 he took part in the Roman art show *Lo spazio degli elementi - Fuoco, immagine, acqua, terra* at L'Attico gallery, as well as in the Foligno show *Lo spazio dell'immagine* (The Space of Image). In 1968 Pistoletto was featured with his own room at the Venice Biennale, where he exhibited works that used basic materials such as rags, paper, newspapers, bulbs and candles. The same year he exhibited with Celant's group of Arte Povera artists. Also the same year Pistoletto established the Zoo group in Turin, with whom he organised a number of performances in various cities that involved the public in much the same way as with his mirror series. Pistoletto continued his research on action in space, therefore privileging his involvement in theatrical events throughout the 1970s. The thematic nuclei of his work are *Plexiglas* (1964), *Gli oggetti in meno* (Lacking Objects, 1965–66), *Gli stracci* (Rags, 1968), *Le stanze* (The Rooms, 1975–76). The artist also completed a series of twelve exhibitions in 1989 entitled *Anno bianco* (White Year), in which he recorded the year's most significant events.
R.C.

Armando Pizzinato
Maniago (Pordenone) 1910

Pizzinato started painting at a very young age, strongly influenced by the expressionism of Gino Rossi. He attended painting classes with Virgilio Guidi at the Academy of Arts in Venice. His first exhibition was in a group show of young artists at the Milione gallery in Milan in 1933. In 1936 Pizzinato won the Marangoni Foundation art scholarship and moved to Rome, where he stayed until 1940. He followed an expressionist line of research, concentrating on Scipione and the tonal painting of the Roman School of Via Cavour. In these years Pizzinato was close to the political views and social awareness of the magazine *Corrente*. He employed a dry pictorial language, painting objects from poor every-day life with few richly chromatic brush strokes. In 1940 he won the Premio Bergamo with his *Composizione con figure* (Composition with Figures). In 1942 he returned to Venice, frequenting artists from the Cavallino gallery such as Arturo Martini, Carlo Scarpa, Santomaso, Afro and Dino Basaldella, Turcato and Vedova. In 1943 Pizzinato's first solo exhibition at the Milione gallery brought him to the attention of critics. From 1943 to 1945 he actively participated in the Resistance. He took up painting again towards the end of 1945 with a more mature, realistic style. In April 1946 with Vedova he exhibited a series of temperas featuring partisans at L'Arco gallery in Venice, enjoying a moderate success. In 1947 he joined the Fronte nuovo delle Arti (New Arts Front), exhibiting with the Venetian group first at L'Arco gallery in Venice, then at Il Milione gallery in Milan and the following year at the Venice Biennale. Pizzinato also drew on his experiences with cubist art for the renewal of his artistic language, always socially active. In paintings such as *Macchine* (Machines) and *Cantiere* (Building Site) the canvas is divided into several levels, with colour used as a structuring element. With *Bracciante ucciso* (The Killed Labourer) and the triptych *Un fantasma percorre l'Europa* (A Ghost Travels Europe), Pizzinato marked the end of his period with Fronte nuovo delle Arti and his beginnings with figurativism, promoting neo-Realism alongside Guttuso. Between 1953 and 1956 he worked on a series of frescoes at the Palazzo della Provincia in Parma. Pizzinato has held a number of solo exhibitions in Italy and abroad, until his anthological

shows in Moscow and Berlin in 1967 and 1968. As well as taking part in editions of the Venice Biennale Pizzinato was also featured at the VIII Rome Quadriennale in 1968. In 1981 a major anthological show was organised in Venice.
M.M.

Arnaldo Pomodoro
Morciano di Romagna (Rimini) 1926

In 1954 Pomodoro moves to Milan together with his brother Giò, with whom he has often had a parallel history. His show in 1955 in Milan at the Naviglio gallery featured his first sculptures, 'abstract and mobile, with totemic allusions and symbolical-magical motifs according to a stylistic repertoire based on volume and vacuum already experimented in his jewels and now brought to spatial pregnancy' (Calvesi 1963). In 1957 he joined the Gruppo Nucleare, with which he signed the *Manifesto contro lo stile* (Manifesto Against Style). Pomodoro's artistic research gained much from his experience with *Informel* art, which brought a 'surrealistic/naturalistic vein to his sensitive and outstanding pictorial variety of materials […] lead, zinc, tin, either melted or dripping and shaped either by hand or with rags' (Calvesi 1963). In 1959 he created his first *Colonna del viaggiatore* (Traveller's Column). In 1960 he was a member of the Continuità group presented by Argan at Rome's Odyssia gallery as an alternative proposal to *Informel* art. In 1963 he produced his first sphere. His thematic repertoire remained limited and simple, centred around ancient symbols and archetypes such as spheres, cubes, columns and wheels. That same year he was honoured with his own room at the XXXII Venice Biennale, where he was awarded the Italian prize for sculpture. He began work on a number of large-scale sculptures for squares both in Italy and abroad. In the 1980s his work extended from sculpture to include urban design, along with frequent commissions to design sets and costumes for the theatre. His numerous awards include: 1963 in São Paulo, 1964 at the Venice Biennale, the Henry Moore Grand Prize in Japan in 1981, the Imperial Prize for Sculpture in 1990 granted by the Japan Art Association. In 1992 he was awarded an honorary BA from Trinity College Dublin and became an honorary member of the Brera Academy in 1994. His spheres stand in a number of important public areas, such as the Cortile della Pigna

of the Vatican Museums, the square in front of the Foreign Ministry in Rome and in the United Nations Square, New York.
R.C.

Enrico Prampolini
Modena 1894 - Rome 1956

Highly active as a painter, Prampolini was also a set designer, art critic, furniture designer and illustrator. With the publication in 1913 of *La cromofonia e il valore degli spostamenti atmosferici* (The Chromophony and Value of Atmospheric Movements) he approached the futurist movement. In 1924 he made his debut with thirteen paintings alongside other futurists at the Sprovieri gallery in Rome. These works owed much to the plastic dynamism of Boccioni, although later Prampolini would move closer to Balla. In 1916 he met Tristan Tzara, with whom he would collaborate intensely. Between 1917 and 1920 Prampolini was one of the few Italian artists to be active in Dadaism. In 1917 he exhibited at the Galerie Dada in Zurich, as well as collaborating with the magazine *Dada* and founding the magazine *Noi* with the sculptor Bino Samminiatelli. The same year Prampolini designed the costumes for Leonid Andreieff's *La vita dell'uomo* (The Life of Man) at the Teatro Argentina, thereby beginning a lengthy career as costume designer, set designer and dramatist. In 1918 he organised an exhibition at the Epoca gallery in Rome, where he exhibited alongside artists of the metaphysical current. The same year Prampolini and Mario Recchi founded the Casa d'Arte Italiana (Italian Art House), an exhibition centre, bookstore and concert hall in which all the furnishings, carpets and ceramics were designed by Prampolini himself. Between 1920 and 1923 he took part in a number of futurist shows both in Italy and abroad, including an exhibition at the Galerie Reinhardt in Paris and one he curated in Prague. At the beginning of the 1920s Prampolini was in contact with many exponents of Europe's avant-garde movements and was up on all the latest trends from De Stijl to second Cubism. In 1922 Gropius asked him to prepare the Italian chapter for the graphic section of Bauhaus. At this time his painting was in line with contemporary research in Europe and classifiable as 'mechanic art'. Along with Vinicio Paladini and Ivo Pannaggi he published the manifesto *L'Arte meccanica* (Mechanical Art) in the mag-

azine *Noi* in May 1923. While continuing to exhibit alongside the futurists at the III Rome Biennale in 1925, the same year Prampolini sat on the committee and exhibited at the Exposition Internationale des Arts Décoratifs et Industriels Modernes in Paris, a city where he remained for roughly twelve years. In 1926 Prampolini featured in the first Novecento show in Milan and at the Venice Biennale, where he also presented applied art works. In 1928 he designed the futurist pavilion at the exhibition in Turin to celebrate the 10th anniversary of the Italian victory in the First World War. At this time Prampolini abandoned his 'mechanical' painting phase in favour of what he himself defined 'cosmic idealism', in reality a disguised form of Surrealism. In 1929 he subscribed to the *Manifesto dell'aeropittura futurista* (Futurist Aero-Painting Manifesto). For Prampolini the term aero-painting did not refer to aerial views but dealt with surrealist-derived spatial and cosmic suggestions. This new phase in the work of Prampolini was documented by the works he presented at the Venice Biennale in 1930, the Rome Quadriennale in 1931, and at the exhibition *Enrico Prampolini et les Aéropeintres Futuristes Italiens* at the Galerie de la Renaissance in Paris. In 1933 he completed a fresco for the V Milan Triennale. In 1934 he took part in the *Plastica Murale* (Plastic Mural Painting) exhibition in Genoa, which was repeated in Rome in 1936, and subscribed to its manifesto *La plastica murale*. From 1934 to 1936 he co-edited with Fillia the magazine *Stile Futurista*, where he published his theoretical essay 'Al di là della pittura verso i polimaterici' (Beyond Painting Towards Multi-Material Works). Research in this field occupied Prampolini's activity until the end of the 1930s to then converge in his essay 'Arte polimaterica (verso un'arte collettiva?)' (Multi-Material Art -Towards a Collective Art?), published in Rome in 1944. In 1939 at the Rome Quadriennale Prampolini presented over thirty paintings divided into the sections 'I miti dell'azione' (Myths of Action), 'Pitture solari' (Solar Paintings), and 'Pitture cosmiche' (Cosmic Paintings). In 1941 the Galleria di Roma organised a vast retrospective featuring mostly works from the 1930s. In the 1950s Prampolini went totally abstract, with developments into *Informel*. In 1955 he joined the MAC Movimento Arte Concreta (Concrete Art Movement).
M.M.

Antonietta Raphaël
Kovno (Lithuania) 1895 - Rome 1975

After the death of her father Simon, a rabbi, Antonietta Raphaël's family moved to London where she graduated in piano and took drawing lessons.
After her mother's death Raphaël spent some years in Paris before moving to Rome in 1925. She followed lessons at the Academy of Arts, where she met Scipione and Mafai and dedicated herself to painting. In 1927 she went to live with Mafai, whom she married in 1935, in a house on Via Cavour. Along with Scipione and Mazzacurati the couple thus started what Longhi was to term the Scuola di Via Cavour. During this early phase of her work Raphaël painted views of Rome and half-length figures. She first exhibited at the I Sindacale Fascista artists guild show in 1929. That same year she took part in group shows at the Bragaglia gallery and at the Camera degli Artisti (Artists Chamber). Reviews of Raphaël's work in this period underlined the archaic, Russian influence in her work. Besides her typically Roman School chromatic tonalities her portraits have an iconic, static and precious quality that is decidedly oriental. Raphaël's Roman landscapes on the other hand use dark, deep colours and display expressionist distortions. In 1930 she moved with Mafai to Paris where, apart from a few brief absences, she lived until 1933. In this time she met Chagall and Soutine, and frequented de Chirico and Savinio. On her return to Rome at the end of 1933 Raphaël became interested in sculpture and worked a while in the studio of Ettore Colla. Her sculpting debut was at the IV Sindacale show in 1936 under the pseudonym De Simon, after her father. In 1937 she again took part in the Sindacale show, with *Le tre sorelle* (The Three Sisters), and in 1938 with *Miriam che dorme* (Miriam Asleep) and *Adolescente* (Adolescent).
To escape from racist persecution in 1939 the Mafai family moved to Genoa, where they could rely on support from the collectors Alberto Della Ragione and Emilio Jesi. Obliged to remain inactive, Raphaël did not take part in any exhibitions for several years. In 1947 she had her first solo exhibition as a sculptor at the Barbaroux gallery in Milan. In 1948 she was admitted for the first time to the Venice Biennale, and in 1951 at the Rome Quadriennale where she was awarded a prize

163

for sculpture. This important official recognition was followed by a major retrospective of her paintings and sculptures at the Zodiaco gallery in Rome.

Since the 1950s critics have underlined the prominent role Antonietta Raphaël played on the Italian art scene between the two wars.
M.M.

Mimmo Rotella
Catanzaro 1918

After graduating from the Naples Academy of Arts in 1944 Rotella settled in Rome, where his first solo exhibition of abstract-geometric art in 1951 found little favour with critics. After a short stay in the United States he exhibited his first collages in the spring of 1955 at a group show organised by Emilio Villa on a boat on the Tiber which featured seven other artists. All young, these artists worked with a variety of materials and were close to the Origine group and influenced by Burri. Rotella's works were in fact a kind of reversed collage in which the resulting image was obtained from tearing glued paper, largely stratified fragments of advertising posters taken from the city. 'Rotella brings into the privileged world of art a particular fragment of the world: the colour and signs of mass visual communication that fill the urban landscape' (De Marchis 1982). Rotella therefore takes up the collage of Cubism and contaminates it with the desecrating Dada *objet trouvé*. In 1958 Rotella met Restany in Rome, with whom he cemented a long-standing alliance. In 1959 one of his works was featured in the magazine *Azimuth*, founded in Milan by Castellani and Manzoni. In 1960 he joined Restany's Nouveau Réalisme group, participating in exhibitions until 1963. Subsequently his interest in the image prompted him to use other mediums such as photography and printing, while his association and intellectual exchange with the French critic continued. In 1964 he was invited to the Venice Biennale. In the 1960s Rotella invented a new system of serial production based on projecting negative film onto an emulsified canvas. The artist termed this operation 'Reportage'. Through printing processes he produced his *Art-typo* between 1967 and 1973, in which printed proofs are liberally reproduced on canvas. Rotella moved to Milan in 1980, where he lives and works.
R.C.

Luigi Russolo
Portogruaro (Verona) 1885 - Cerro di Laveno (Varese) 1947

In 1901 Russolo moved to Milan where he frequented the literary avant-garde circles gathered around Filippo Tommaso Marinetti's magazine *Poesia*. Russolo's first works, a series of etchings, display a strong symbolist influence from the painting *Il trionfo della Morte* (The Triumph of Death, 1909) by Gaetano Previati. In December 1909, during an exhibition featuring his etchings, he met Umberto Boccioni. Russolo's friendship with Boccioni was to prove influential in his first divisionist paintings featuring urban suburbs, a recurrent subject in his forthcoming artistic production such as *I lampi* (Lightning), in its first version of 1909–10. In 1910 Russolo undersigned the *Manifesto dei pittori futuristi* (Manifesto of Futurist Painters), the *Manifesto tecnico della pittura futurista* (Technical Manifesto of Futurist Painting) and *Contro Venezia passatista* (Against the Passé Venice), as well as taking part in futuristic evenings in Milan, Venice and Padua. He exhibited alongside Boccioni and Carrà at the first *Esposizione d'Arte Libera* (Exhibition of Free Art) at the Salone Ricordi in Milan. A dream-like and symbolic atmosphere remained in his paintings between 1910 and 1911, along with the Boccioni-inspired theme of the modern city and linear dynamism, exemplified in works such as *Profumo* (Perfume), *Il lavoro* (Work), *Treno in corsa nella notte* (Train Speeding Through the Night). Between 1911 and 1912 Russolo's artistic production became more strongly influenced by Giacomo Balla and by his principles of speed, dynamism and penetration of the planes in works such as *Dinamismo di un'automobile* (Dynamism of a Car, 1911), *Compenetrazione di case + luce + cielo* (Compenetration of Houses + Light + Sky, 1912), *Solidità nella nebbia* (Solidity in Fog, 1912). Alongside Boccioni, Carrà and Marinetti, Russolo was featured at the important 1912 futuristic exhibition at the Bernheim-Jeune gallery in Paris. Although Russolo continued to feature in the itinerant futurist exhibitions throughout Europe, as from 1913 he became preoccupied with the aesthetics of the musical avant-garde. He wrote the letter-manifesto *L'arte dei rumori* (The Art of Noise) dedicated to the musician Francesco Balilla Pratella and a series of articles on the subject for the

magazine *Lacerba*. At the basis of new futurist music was the *intonarumori* (noise tuner), an instrument invented by Russolo and for which he composed music. His *Primo concerto futurista* (First Futurist Concerto) for *intonarumori* was performed at the Teatro Dal Verme in Milan in 1914. Along with Boccioni, Marinetti and Carrà he undersigned the *Programma politico futurista* (Futurist Political Programme). After demonstrating in favour of intervention in the war they were all arrested in Milan. While in prison the futurists wrote their manifesto *Sintesi della guerra* (Synthesis of War). While fighting on Mount Grappa in 1917 Russolo suffered a severe head injury. He returned to exhibiting in 1920 at the *Exposition internationale d'art moderne* in Geneva. In 1921 he conducted three futurist concerts at Théatre des Champs-Elysées in Paris. He was featured in the futurist room of the XV Venice Biennale in 1926. In 1929 Russolo followed oriental philosophy and esoteric studies in Paris, that were to become the focus of his strong new interests in literature and art. He published theosophical works such as *Al di là della materia* (Beyond Matter) and *Dialoghi tra l'Io e l'anima* (Dialogues Between the Self and the Soul). In 1942 he returned to painting figurative-style works featuring dream-like and visionary landscapes bathed in a timeless atmosphere.
M.M.

Giulio Aristide Sartorio
Rome 1860–1932

Sartorio studied drawing with his father Raffaele, a painter and sculptor. For a short time he attended the Accademia di San Luca and improved his technique by copying the old masters in museums and the ancient monuments of Rome. Sartorio began to produce small genre paintings with figures in 18th-century costume inspired by the Spanish artist Mariano Fortuny, who at the time was enjoying considerable market and public success in Rome. After being invited to illustrate several editions of the magazine *Cronaca Bizantina*, Sartorio frequented Roman literary circles and in particular the poet Gabriele d'Annunzio, with whom he became close friends. Sartorio's literary contacts prompted him to deepen his culture and broaden his field of research. He started painting from life and once again copying the old

masters, particularly painters of the Renaissance and the 17th century. At the 1883 International Exhibition in Rome Sartorio abandoned his Fortuny subjects and style in favour of his first attempt at a verist theme in *Malaria*, 'worried of seeming Caravaggio or Ribera'. In 1889 he exhibited in Paris and was awarded the gold medal with his literature-inspired painting *I figli di Caino* (The Sons of Cain), probably taken from Leconte de Lisle's *Quain*. Enthused by the landscape painting of the Barbizon School which he saw in Paris and encouraged by his friend Francesco Paolo Michetti, Sartorio completed his first real-life studies of the Roman countryside. Its solitary nature and abundance of antique remains were to act as a constant source of inspiration. He frequented the In Arte Libertas group and, as from 1890, took part in exhibitions organised by the group, where the pre-Raphaelite painters Dante Gabriele Rossetti and Edward Burne-Jones exhibited for the first time in Rome. At this time Sartorio was interested in pre-Raphaelite painting and in French and German Symbolism, from Moreau to Böcklin, himself becoming an original interpreter of literary and mythological Symbolism.

Having matured a vast knowledge of late 19th-century art in his frequent trips, Sartorio now turned to the study of classical and Renaissance art. He also became involved in supporting a new 'national' Italian art rooted chiefly in the Renaissance and promoted large-scale decorative art for public places. In 1907 in fact Sartorio completed the frieze *La Luce, Le Tenebre, L'Amore, La Morte* (Light, Darkness, Love, Death) for the central hall of the Venice Biennale. In 1908 he started work on the frieze for the Parliament in Palazzo Montecitorio, that features an unprecedented and complex historical and allegorical representation of the salient moments in Italian history up until the unification. The difficult task took until 1912 to complete and was to act as a model in the decoration of public buildings at the time. Sartorio went directly to London to study the reliefs of the Parthenon and the cartoons of Mantegna in order to complete the work.

When the First World War broke out Sartorio went to fight as a volunteer on the front. After the conflict he was invited by King Fuad to visit Egypt, Syria and Palestine, where he made a large quantity of sketches and landscape studies. His

late work featured the Roman countryside and the coast at Fregene. In 1929 Sartorio was named a member of the Accademia d'Italia.
M.M.

Alberto Savinio
(Andrea de Chirico)
Athens 1891 - Rome 1952

Brother of Giorgio de Chirico, Andrea de Chirico adopted the pseudonym Alberto Savinio in 1914, Savinio being an anagram of the term *in savio*, meaning 'wise'. Although his activities as musician, writer and painter were strongly tied throughout his life, Savinio did not dedicate himself systematically to painting until 1926. After a staying with his mother and brother in Munich and Milan, in 1910 Savinio moved to Paris where he frequented avant-garde artistic and literary circles (Breton, Picasso, Picabia, Guillaume, Cocteau, Brancusi) and in particular the poet Guillaume Apollinaire. In 1914 Savinio conducted one of his own compositions in which there is an unusual combination of voice and sounds. Savinio himself defined this piece as the 'musical equivalent' of contemporary poetry (Apollinaire) and painting (de Chirico). Again influenced by Apollinaire, Savinio published his poem *Les chants de la Mi-Mort*, for which he also designed the costumes and sets. When the war broke out he returned to Italy along with his brother. Together they performed their military service in Ferrara with Carrà and De Pisis. This experience was to prove formative for Savinio's successive painting career and resulted in a series of essays on the theories of Metaphysics that appeared on the magazine *Valori Plastici* between 1918 and 1922. These writings are essays on the philosophy of art and constitute a fundamental reference point for understanding the artistic debate going on in Italy in the 1920s. In line with the painting of Giorgio de Chirico, Savinio underlined the priority of intellectual knowledge whilst introducing irony as an instrument for revealing reality. At this time Savinio also wrote *Hermaphrodito*, published in 1918. Between 1919 and 1920 he also wrote the autobiographical novel *Tragedia dell'infanzia* (Tragedy of Childhood), published in 1937. In the early 1920s he produced the ballet *La morte di Niobe* (The Death of Niobe) in Rome, with sets designed by Giorgio de Chirico. In 1925 he returned to Paris, where he was part of the

varied and stimulating cultural clique composed of expatriate Italian artists and the group of surrealists. Although his paintings from this period display the influence of his brother's formal language, Savinio turned to autobiographical elements from his childhood, as he had already done in his novels, reliving his memories with an ironical and visionary eye. His encounter with the critic Waldemar George took place in 1928. Between 1928 and 1930 he and his brother worked together decorating the Paris home of the art dealer and collector Léonce Rosenberg. Savinio decorated a room with a monument to toys. He exhibited at the 1930 Venice Biennale and the same year in Milan and in Paris in 1932 and 1933. Savinio's work during the 1930s featured the theme of metamorphosis between man and animals. His portraits with bird's heads also date from this period, in which Savinio gave an ironical slant to the influences of Surrealism. Some examples are *I genitori* (The Parents, 1931), *Ruggero e Angelica* (1932), *Autoritratto* (Self-portrait, 1936). At this time Savinio also painted his series of petrified forests, toys, and fantastical landscapes such as *I Dioscuri, Edipo e Antigone, Il figliol prodigo* (The Prodigal Son). In 1933 he founded the magazine *La Colonna* in Milan, which featured articles by Sironi on Novecento and mural painting. In 1940 he exhibited at the Milione gallery in Milan. As well as an introduction by Giorgio de Chirico, the exhibition catalogue also contained a self-presentation by Savinio in which he clarified the main points of his pictorial research and his theories on art. During the Second World War Savinio returned to writing and published many of his most important works such as *Dico a te Clio* (I Say to You Clio, 1940), *Infanzia di Nivasio Dolcemare* (The Childhood of Nivasio Dolcemare, 1941) *Narrate o uomini la vostra storia* (Tell Your Tale O Men, 1942), *Casa 'La Vita'* ('The Life' House, 1943), *Sorte d'Europa* (The Destiny of Europe, 1945). In 1954 the Venice Biennale dedicated a retrospective to Savinio's work.
S.F. - M.M.

Scipione (Gino Bonichi)
Macerata 1904 - Arco (Trent) 1933

After moving to Rome in 1909 Scipione contracted pleurisy that soon developed into tuberculosis. Aged twenty, Scipione and his friend Mario Mafai joined the Scuola Libera del Nudo. In 1926 he adopted

the pseudonym of Scipione, evocative of his strongly Roman and baroque inspiration. Scipione and Mafai were soon joined by Antonietta Raphaël. The three friends thus formed what Roberto Longhi would term the Scuola Romana di Via Cavour, a definition that came from the name of the street where their studio was but which also indicated a common artistic ideal. Scipione's circle of friends included poets and writers such as Ungaretti, Mazzacurati, De Libero, Sinisgalli and Falqui. During his spells out from hospital Scipione worked intensively. In 1927 he exhibited at the Bragaglia gallery and then in 1929 at the Circolo Artistico in Palazzo Doria, at the first Sindacale Fascista artists guild show and at the third Mostra d'Arte Marinara (Exhibition of Marine Art). The same year Scipione was obliged to take a health cure at Collepardo, near Frosinone, where he drew considerably and collaborated as illustrator for *La Fiera Letteraria*. His direct contact with the work of Goya, El Greco and Velázquez at an exhibition organised in Rome by Longhi in 1930 contributed considerably towards a maturing of his style towards a lively expressionism and dissolving of form. Scipione's successive work was markedly calm and contemplative in atmosphere, both in his treatment of subject matter and particularly in his use of delicate tonal passages, as well as in his fluid and vibrant brush strokes. Throughout 1930 and in 1931, the years during which he produced his most important works, Scipione continued to take part in exhibitions. In the spring of 1931 tuberculosis forced him to stop working and to enter the San Pancrazio sanatorium at Arco, in the Trentino region, where he died in 1933. The 1935 edition of the Rome Quadriennale featured a retrospective show of Scipione's work.
M.M.

Gino Severini
Cortona (Arezzo) 1883 - Paris 1966

Born in Cortona, Severini moved to Rome in 1899 where he met Boccioni and Balla, from whom he was to learn the divisionist technique used in his early works. In 1904 he presented two paintings at the annual Amatori e Cultori show and the following year took part in the *Rifiutati* (Rejects) exhibition held at the Teatro Costanzi. In 1906 Severini moved to Paris where he frequented Modigliani, Picasso, Braque,

Utrillo, Juan Gris and Max Jacob, and where he exhibited works at the Salon des Indépendants and at the Salon d'Automne. In 1910 Severini adhered to the *Manifesto della pittura futurista* (Manifesto of Futurist Painting) and a year later to the *Manifesto tecnico della pittura futurista* (Technical Manifesto of Futurist Painting). Severini himself declared that his version of Futurism had more in common with the French avant-garde movements, in particular with the post-impressionist thought of Signac. He was also attracted by Cubism, in particular by the geometrical imprinting of its composition. In 1912 Severini took part in the exhibition of futurist artists organised by Marinetti at the Bernheim-Jeune gallery in Paris. In 1913 Severini married Jeanne Fort, daughter of the poet and playwright Paul Fort, and returned to Italy. As soon as the war broke out, however, Severini moved back to France. He painted works inspired by the war that combined Futurism and Cubism, which he exhibited in 1916 at the Boutet de Monvel gallery. The same year, during an exhibition of futurist artists he organised, Severini held a conference on the theme 'Les arts plastiques d'avant-garde et la science moderne' (Avant Garde Plastic Arts and Modern Science), in which he outlined the new direction taken by his art. This phase was characterised by the idea of a 'scientific' method in artistic representation, according to the purist formalist theories of Ozenfant and with a renewed interest in Classical and Renaissance art. His paintings *Ritratto di Jeanne* (Portrait of Jeanne) and *Maternità* (Motherhood), both from 1916, in fact display a return to classical figurativism. In February 1916 *Mercure de France* published Severini's article 'Symbolisme plastique et Symbolisme littéraire' (Plastic and Literary Symbolism), in which he highlighted the 'realist' side of Cubism. Between 1917 and 1919 Severini returned to Bergson's spatial duration theory and studied mathematics in search of a universal equilibrium based on mathematical and geometrical relations. In 1917 he held an important one-man show at the Stieglitz Gallery in New York. In 1919 Severini signed a three-year contract with the art dealer Léonce Rosenberg and his gallery L'Effort Moderne. The same year he edited the second issue of the magazine *Valori Plastici* with Rosenberg. In 1921 Severini published his essay *Du Cubisme au Classicisme - Esthétique du nombre et du compos* (From Cu-

bism to Classicism - Aesthetics of Number and Composition), in which he advocated a return to illusionist realism and classical harmony through mathematical laws. In 1921 he returned to Italy to fresco a hall at Montefugoni, the castle owned by Osbert and Sacheverell Sitwell, with strictly figurative themes taken from Commedia dell'Arte. Severini then underwent a religious crisis after which, thanks also to the philosopher Jacques Maritain, he rediscovered Catholic values and the mysticism of religious painting. Through Maritain he was commissioned to fresco the churches of Semsales in 1926 and La Roche between 1927 and 1928, both in the Swiss canton of Fribourg. In 1928 Severini took part in the Venice Biennale. A year later he was featured at the second Novecento show in Milan. Also in 1929 Severini completed a series of decorative panels for Rosenberg's house in Rome on the theme of Pulcinella and the ruins of Piranesi. Between 1929 and 1930 he worked on a series of still lives that feature objects taken from classical iconography such as theatrical masks, fish, amphorae, doves, shells, ancient ruins. In 1933 he completed the *Arti* (Arts) mosaic for the Salone delle Cerimonie at the V Milan Triennale. In 1935 Severini took part in the II Rome Quadriennale. He was awarded a prize at the International Decorative Arts Exhibition held in Paris in 1937 and held a one-man show at the Cometa gallery in Rome. In 1938 he went to New York. Throughout the 1940s and 1950s Severini continued to take part in editions of the Rome Quadriennale and the Venice Biennale with themes from his past work. Between 1945 and 1946 he made the preparatory sketches for the Via Crucis mosaics in the Duomo of Cortona. A major retrospective of his work was held in Rome in 1961, after which he returned to live in Paris.
S.F. - M.M.

Mario Sironi
Sassari 1885 - Milan 1961

Sironi grew up in Rome as from 1886 with his engineer father. He interrupted his engineering studies and enrolled in the Scuola Libera del Nudo (Free School of Nude). He frequented the studio of Balla, where he met Boccioni and Severini. Largely destroyed by Sironi himself, his early works were inspired by the divisionism of Balla. Between 1906 and 1911 he travelled on several occasions to Germany and Paris, where along with Boccioni he deepened his studies in French painting. After joining the futurists, Sironi exhibited sixteen works at the Sprovieri gallery in Rome. When war broke out he volunteered for the Volontari Ciclisti and Automobilisti battalion. Between 1917 and 1918 Sironi experimented for a short period with Metaphysics in art. In 1919 he held his first solo exhibition at the Bragaglia gallery in Rome and took part in the important futurist exhibition in Milan, where he moved. In 1920 he signed along with Dudreville, Funi and Russolo the manifesto *Contro tutti i ritorni in pittura* (Against All Past Returns in Painting), which marked the beginning of a poetic expression based on formal order and creative rigour. Sironi gradually strayed from Futurism towards a new stylistic phase centred on suburbs and the industrial landscape. In 1922 he collaborated as an illustrator with *Popolo d'Italia* and later as art critic. The same year Sironi was among the founding members of the Sette Pittori del Novecento (Seven Painters of the Novecento) movement, which later grew into Novecento. This Milanese-born group, promoted by Margherita Sarfatti and backed by the gallerist Lino Pesaro, advocated a return to 'pure' Italian art. Sironi took part with the group in the 1924 Venice Biennale with several works including *L'architetto* (The Architect) and *L'allieva* (The Pupil), both later considered one of the finest examples of Novecento artistic expression. In the 1920s Sironi introduced more earthy tonalities to his painting, inspired by the idea of exalting an archaic and heroic dimension of work. In 1932 he published his article 'Pittura murale' (Mural Painting) in *Popolo d'Italia* in which he saw art in a socially educational function, advocating a return to mural painting and architectural decoration. Along with Funi, Carrà and Campigli he drafted in 1933 the *Manifesto della pittura murale* (Mural Painting Manifesto). He designed the *Il lavoro* (Work) cycle of cartoons for the glass wall of the Corporations Ministry in Rome. In 1932 Sironi oversaw preparations for the exhibition of the fascist revolution in Rome. In 1933 he directed the mural decoration by the best known artists of the moment at the V Milan Triennale, himself contributing with the fresco *Le opere e i giorni* (Works and Days) and some bas-reliefs. This was followed by commissions to decorate the Palazzo delle Poste in Bergamo (*L'agri-coltura, L'architettura,* Agriculture, Architecture, 1933), frescoes for the Aula Magna of the University of Rome (*L'Italia tra le arti e le scienze,* Italy Between Arts and Sciences, 1935), and mosaics for the VI Milan Triennale (*L'Italia corporativa,* Corporative Italy, 1936), exhibited in 1937 at the World Paris Exhibition. Other commissions included the mosaics for the Milan law courts *La Giustizia tra la Legge, la Verità, l'Impero e il Fascismo* (Justice Amidst Law, Truth, the Empire and Fascism, in 1936) and his fresco *L'Italia, Venezia e gli studi* (Italy, Venice and the Studies) for the Ca' Foscari University in Venice in 1937. In 1939 he started work on the large marble relief for the façade of *Il Popolo d'Italia* in Milan. In 1943 he exhibited twelve large temperas at the Milione gallery in Milan which he considered preparatory studies for murals, an art form that was by now losing its favour. During the war Sironi returned to easel painting of urban views, nudes and mountains. Steeped in a metaphysical atmosphere, these works focused on the relation between classical architecture and mannequins. After the war Sironi continued to work as set designer for theatre and illustrator. He also decorated the halls of a number of ocean liners with painted panels and tapestries. He took part in the IX Milan Triennale and was invited to the Venice Biennale in 1952 but refused to exhibit. In 1954 he was awarded the Luigi Einaudi Award from the Accademia Nazionale di San Luca, of which he became a member in 1956. Eight of his futurist works were on show in the exhibition on Futurism at the 1960 Venice Biennale. In 1961, the year of his death, Sironi was awarded the Premio Città di Milano.
M.M.

Grazia Toderi
Padua 1963

Grazia Toderi studied in Bologna where she experimented with video and photography. In her first important group exhibition, at the Nuova Officina Bolognese (New Bolognese Workshop) section of the Galleria d'Arte Moderna in Bologna, Toderi presented some enlarged photographs of magnified plant matter within a science-fiction installation. In 1992 she moved to Milan but did not attract the attention of critics until 1993 when she took part in the *Aperto 93* section of the Venice Biennale with her video *Nontiscordardimè* (Forgetmenot). In this work a fixed video camera films a small plant under a violent, prolonged and obsessive spray of water, while across the screen runs the text 'non ti scordar di me', almost as if to underline the passage of time. The fundamental elements that make up the work of Toderi are her minute details and her attention to the small world of every-day life enlivened by small objects and events. Once she has chosen her subject Toderi films it at length through a stationary camera without any particular concession to technical effects. Images such as the doll swirling inside the washing machine in *Soap* (1993), or the artist herself smoking under a drier at the hairdressers in *Autoritratto* (Self Portrait, 1995) acquire a hypnotic quality and a self-referential value that belong to Toderi's own personal microcosm.
Through her innovative use of video, her rich lyricism and unique formal linearity, Toderi emerged internationally. Between 1995 and 1996 she took part in several important group shows at the Institute of Contemporary Arts in Boston, the Serpentine Gallery in London and Frac in Montpellier. In 1997 she was invited to represent Italy at the Istanbul Biennale. While in her early videos Toderi concentrated her attention on every-day domestic details (*Soap,*1993 or *Nata nel '63,* Born in '63), her more recent work features evocative aerial footage in which Italian squares and stadiums became hypothetical runways (*Il decollo,* The Take Off, 1998). In 1999 the video *Il fiore delle mille e una notte* (The Flower of the Thousand and One Nights) designed to function as the sets for a play performed by the Virgilio Sieni company was awarded the Leone d'Oro at the 48th edition of the Venice Biennale.
A.M.

Giulio Turcato
Mantua 1912 - Rome 1995

In 1943 Turcato exhibited for the first time at the Rome gallery Lo Zodiaco, alongside Scialoja and Vedova. He came into contact with the Corrente artists but did not join the group. Between 1943 and 1945 his painting was still undecided between figurative and abstract, as in *Natura morta con radici* (Still Life with Roots, 1943), *Natura morta con pesci* (Still Life with Fish, 1945). After the war Turcato pursued an active role in the renewal of art in Italy, keeping in touch with the lat-

est artistic currents in Europe. In 1945 he was among the founders of Art Club along with Prampolini, Jarema, Savelli, Fazzini, Mafai, Dorazio, Corpora, Perilli and Consagra. Progressive artists of this period were divided by a heated debate among supporters of Realism on the one hand and Formalism on the other. Within this context in March 1947 Turcato established the Forma 1 group along with Accardi, Attardi, Consagra, Dorazio, Guerrini and Sanfilippo. Forma 1 artists declared themselves 'formalist and Marxist', upholding the need for abstraction. In April the same year Turcato published his article 'Crisi della pittura' (Crisis of Painting) in which he declared the importance of modern figurative art following the line of Cézanne and Matisse towards Cubism as opposed to a realism based on figurative expression of reality that was backed by the Italian Communist Party. In June 1947 he exhibited in Milan, in the Fronte nuovo delle Arti (New Arts Front) show featuring a phenomenon that had initially comprised both the opposing factions. In 1948 the Fronte nuovo delle Arti was invited to the Venice Biennale but the definitive split between figurative and non-figurative artists within the group took place soon after. In the autumn of the same year Turcato took part in an exhibition in Bologna, after which Palmiro Togliatti, then secretary of the Italian Communist Party, launched criticisms against the new 'formalist' tendencies in art. From this moment onwards Turcato created non-geometric, abstract compositions with forms that were placed alongside one another chromatically. These works were partly indebted to Picasso and Balla, and partially to Magnelli, such as the series *Rovine di Varsavia* (Ruins of Warsaw) and *Rovine di guerra* (Ruins of War), painted after Turcato had taken part in the 1948 Warsaw Peace Congress. Up until the mid-1950s his work was marked by its abstract nature and his political activism as in the *Bandiere* (Flags) cycles completed between 1949 and 1950. In 1952 he took part in the Venice Biennale with the Gruppo degli Otto (Group of Eight) artists backed by Lionello Venturi and was awarded a prize for his work *Miniera* (Mine). A trip to the Far East in 1956 and a momentary interest in the Action Painting promoted by Michel Tapié brought Turcato towards freer compositions, with hints of gestual graphism and more atmospheric backgrounds. In 1958 the Venice Bi-

ennale dedicated him his own room. Between 1960 and 1962 he joined the Continuità group with Accardi, Dorazio, Perilli, Novelli and Consagra, which supported structural rigour against *Informel* art. As from 1962 Turcato dedicated himself to the study of colour he defined as 'beyond the spectrum'. During a trip to the United States in 1963 he encountered the work of Mark Rothko, Clifford Still and Barnett Newman. These experiences resulted in the cycle *Ricordo di New York* (Souvenir of New York). Between the late 1960s and the early 1970s Turcato experimented with new materials and artistic techniques, as in *Gommepiume* (Rubber Foams), exhibited at the 1966 Venice Biennale and his *Oceaniche* structures of ridged canvases evocative of the totems he saw during a trip to Kenya in 1972.
S.F. - M.M.

Cy Twombly
Lexington (Virginia) 1929

After living in Europe and North Africa in 1957 Twombly definitively settled in Rome, where he became a leading light of the city's cosmopolitan life. His background in American Action Painting led Twombly to define his own personal style made up of graffiti on monochrome canvases, suggestive of natural phenomena or simply an indication of his own emotional state. 'His painting apparently has something of Dada improvisation, in the writing traced like the scribbles of a distracted student on a classroom desk in a vaporous emotional state of mind...' (Volpi 1961). Only apparently scattered over the surface of the canvas, these signs are in fact organised in highly balanced compositions. In 1960 Twombly started a collaboration with Leo Castelli in Manhattan, where after his first solo exhibition in 1961 he continued exhibiting in the following years. The larger paintings of those years featured 'colour, often squeezed directly out of the tube on the white background of the painting. The grafitism [...] assumed a more narrative, romantic and expressionistic quality' (Pinto 1968). Simultaneously his paintings became full of mythological references. Italy, Greece and the Mediterranean are perceived as places of classical serenity. Twombly lives and works between Italy and the United States.
R.C.

Emilio Vedova
Venice 1919

Vedova began studying in Rome in 1936 and then joined the strongly expressionist artistic group Corrente in 1943. In 1946 in Milan he subscribed to the *Oltre Guérnica* (Beyond Guérnica) manifesto, the first contact made by the Italian artistic milieu with the international situation, particularly through the work of Picasso. That same year he signed the manifesto of the Nuova Secessione Artistica Italiana (New Italian Artistic Secession), which later became the Fronte nuovo delle Arti (New Arts Front). These were the years of Emilio Vedova's collages, of his experimentation with materials, of his first *Geometrie nere* (Black Geometries) and of his meeting with Peggy Guggenheim in Venice. At this time he abandoned his expressionist phase in favour of a new orderly and geometric vision, in a neo-cubist key. After the 1948 Venice Biennale he became one of the most fervent opponents of Italian neo-realism, supporting the abstractionists. At the 1950 Biennale he exhibited works clearly reminiscent of Umberto Boccioni. Vedova remained ideologically and politically committed throughout his activity, from his first cultural struggle against Fascism. As Maurizio Fagiolo wrote in 1966, his social protest was 'above all of a formal, linguistic and structural nature'. In 1952 he joined the Gruppo degli Otto (Group of Eight) promoted by Lionello Venturi. In his *Scontro di situazioni* (Clash of Situations), *Scontro della protesta* (Clash of Protest) and *Scontro della natura* (Clash of Nature) cycles completed early in the 1950s Vedova abandoned his rigid positions in favour of gestural violence, which was to become the hallmark of all his work and in which conflicting forces nonetheless attain an equilibrium. Between 1960 and 1961 he collaborated on Luigi Nono's opera *Intolleranza '60* (Intolerance '60). The same year he embarked on a new line of research which led him to *Plurimi* (Multiples), painted constructions with movable component parts in dialogue with the surrounding space.
During the 1960s Vedova spent considerable time in Berlin and Salzburg. In 1960 he won first prize for painting at the Venice Biennale and participated actively in the 1968 student movement.
R.C.

Gilberto Zorio
Adorno Micca (Turin) 1944

Zorio was born in 1944 at Adorno Micca, near Turin. His first exhibition was at the Sperone gallery in Turin in 1967. By the end of the same year he was already one of the Arte Povera group of artists presented by Celant at La Bertesca gallery in Genoa. In his early works Zorio created unusual combinations of industrial materials such as cement, asbestos lumber and scaffolding poles, in which he saw a component of potential energy. In his metaphorical use of these materials Zorio was searching for their secret properties rather than some mysterious aspect. As Zorio himself declared, 'I feel attracted by the vital energy of these materials. The total adherence to the material is for me an adherence to the most authentic reality'. His works are a symbiosis between art and life in which the objects are arranged in such a way that they can release their potential strength without control, 'just letting them be what they are'. In 1969 Zorio was invited to the exhibition *Nine Young Artists: Theodoron Awards* at the Solomon Guggenheim Museum in New York. At the same time Zorio started work on a new cycle entitled *Per purificare le parole* (To Purify Words), placing alembics full of alcohol next to figures emblematic of tension such as a javelin, a five-pointed star made from a variety of materials such as terracotta, copper, leather and a laser, and a canoe. In this way Zorio meant to create the conditions for an energetically balanced process between elements so different from one another.
In 1976 the Kunstmuseum in Lucerne dedicated a solo exhibition to Zorio, shortly followed by another at the Stedelijk Museum in Amsterdam. In 1986 retrospective shows of his work were organised by the Musée National d'Art Moderne in Paris and the Centre d'Art Contemporain in Geneva. In 1992 another retrospective was held at the Centro per l'Arte Contemporanea Luigi Pecci in Prato.
A.M.

Bibliographic Indexes

**Alphabetical Index
of Quoted Bibliography**

Airò, Mario (interview by C. D'Orazio), in Sandra Pinto and Anna Mattirolo (eds.), *Migrazioni e multiculturalità, premio del Centro 2000*, exhibition catalogue, Rome, Centro Nazionale per le Arti Contemporanee, 15 December 2000 – 18 March 2001.

Amman, Jean-Cristophe (ed.), *Alighiero Boetti*, exhibition catalogue, Basel, Kunsthalle, 5 March – 2 April 1978, Basel 1978.

Appella, Giuseppe and Guido Giuffrè, *Pirandello*, exhibition catalogue, Macerata, Rome 1990.

Argan, Giulio Carlo, *Capogrossi*, introduction to the exhibition, Brussels, Palais des Beaux-Arts, 1959.

Argan, Giulio Carlo, *Capogrossi*, Rome 1967.

Brandi, Cesare, *Burri*, Rome 1963.

Bucarelli, Palma, *Cy Twombly*, Rome 1958 (reprinted in *Gli anni originali*, Quaderni d'arte e letteratura de La Tartaruga, Rome 1989).

Bucarelli, Palma, introductory essay in Nello Ponente (ed.), *Modigliani*, Rome 1959.

Bucarelli, Palma, Giorgio De Marchis and Sandra Pinto, *Cento opere d'arte italiana dal futurismo ad oggi*, exhibition catalogue, Galleria Nazionale d'Arte Moderna, Rome 1968.

Bucarelli, Palma, *La Galleria Nazionale d'Arte Moderna*, Rome 1973.

Calvesi, Maurizio, "Alberto Burri", in *Quadrum*, no. 7, 1959.

Calvesi, Maurizio, *L'informale in Italia*, in *Aspetti della ricerca informale in Italia fino al 1957*, exhibition catalogue, Leghorn 1963.

Carluccio, Luigi, *F. Casorati*, Turin 1958.

Celant, Germano, *Giuseppe Penone*, Milan 1989.

Celant, Germano, *Carla Accardi*, Milan 1999.

Celant, Germano, *Enrico Castellani*, exhibition catalogue, Milan 2001.

Corà, Bruno (ed.), *Luciano Fabro: Nord, Sud, Est, Ovest giocano a Shanghai*, exhibition catalogue, Naples, Museo di Capodimonte, October–November 1989, Naples 1989.

Corà, Bruno, *Le porte di Palazzo Fabroni*, Milan 1995.

Courthion, Pierre, *Gino Severini*, Milan 1946.

Crispolti, Enrico, *Lucio Fontana. Catalogo Generale*, Milan 1986.

Crispolti, Enrico, *Evola pittore tra Futurismo e Dadaismo*, in *Julius Evola e l'arte delle avanguardie*, Rome 1998.

De Dominicis, Gino (quotes by Gino De Dominicis 1969–96 collected by Cecilia Torrealta), in *XLVII Esposizione Internazionale d'Arte La Biennale di Venezia. Sezione Futuro Presente Passato*, general catalogue, Venice 1997.

De Marchis, Giorgio, "Emilio Vedova, Scontro di situazioni n. 4", in *Bollettino d'Arte*, October–December 1964.

De Marchis, Giorgio and Sandra Pinto, *Colla. Catalogo delle opere*, Rome 1972.

De Pisis, Filippo, "Un pittore allo specchio", in *Rivista del Comune*, Ferrara, 15 December 1933.

Di Bosso futurista, exhibition catalogue, Galleria Fonte d'Abisso, Modena 1988.

Guzzi, Domenico, *Il percorso di Carrà. Costanti e variabili della pittura*, in A. Monferini (ed.), *Carlo Carrà*, exhibition catalogue, Rome, Milan 1994.

Kounellis, Jannis, "Le parole per dirmi", in *L'Espresso*, 1 August 1996, pp. 102–3.

Mantura, Bruno, *Alberto Burri*, exhibition catalogue, Galleria Nazionale d'Arte Moderna, Rome 1976.

Marchiori, Giuseppe, *Osvaldo Licini. Con 21 lettere inedite del pittore*, Rome 1960.

Martini, Arturo, *Colloqui sulla scultura 1944–45* (collected by Gino Scarpa), ed. by N. Stringa, Treviso 1997.

Menna, Filiberto, *Enrico Prampolini*, Rome 1967.

Misler, Nicoletta, *La via italiana al realismo*, Milan 1973.

Osvaldo Licini. Dipinti e disegni, exhibition catalogue, Ascoli Piceno, Milan 1988.

Pasquali, Marilena, *Giorgio Morandi 1890–1990*, exhibition catalogue, Bologna, Milan 1990.

Perocco, Giovanni, *Arturo Martini. Catalogo delle sculture e delle ceramiche*, Treviso 1966.

Pinto, Sandra, *Grazia Toderi*, in *Milano Europa 2000. Fine secolo. I semi del futuro*, exhibition catalogue, Milan 2001.

Risaliti, Sergio, *Espresso, Arte oggi in Italia*, Milan 2000.

Rubiu, Vittorio, *Pascali*, with an introduction by Cesare Brandi, Rome 1976.

Russoli, Franco, *Modigliani*, Milan 1958.

Scarpa, Gino, *Colloqui con Arturo Martini*, Milan 1968.

Scotti, Aurora, *Catalogo dei manoscritti di G. Pellizza da Volpedo*, Tortona 1974.

Trucchi, Lorenza, "Burri", in *Il Momento*, Rome, 16 January 1952.

Vitali, Lamberto, *Morandi. Catalogo generale*, 2 vols., Milan 1977.

Vivarelli, Pia, *Gastone Novelli*, exhibition catalogue, Galleria Nazionale d'Arte Moderna, Rome 1988.

Volpi, Marisa, "Cy Twombly dalla Virginia a Roma insegue i suoi ideali neoclassici", in *Avanti*, 23 November 1961 (reprinted in Marisa Volpi, *Artisti Contemporanei. Interviste*, Rome 1986).

Volpi, Marisa, *Malevic è un proiettile*, introduction to the exhibition *Dieci progetti di Maurizio Mochetti* at the Galleria La Salita, Rome 1968.

Volpi Orlandini, Marisa, *Artisti Contemporanei. Profili*, Rome 1986.

Essential Bibliographical Guide

Corrado Maltese, *Storia dell'arte in Italia, 1785–1943*, Turin 1960.

Giulio Carlo Argan, *L'arte moderna 1770–1970*, Florence 1970.

Cesare Brandi, *Scritti sull'arte contemporanea*, Turin 1976.

Lea Vergine, *L'altra metà delle avanguardie*, Milan 1980.
Il Novecento, vol. VII of *Storia dell'arte italiana*, Turin 1982.
Emily Braun (ed.), *Italian Art in the 20th century, Painting and Sculpture 1900–1988*, exhibition catalogue, London 1989.
Giorgio De Marchis, *Scusi ma è arte questa? Guida illustrata all'avanguardia e alla neoavanguardia*, Milan 1991.
Carlo Bertelli et alii, *La pittura in Italia. Il Novecento*, vols. I–III, Milan 1992–94.
Maurizio Calvesi and Natalia Ginzburg (eds.), *Novecento. Arte e storia in Italia*, exhibition catalogue, Rome 2000.

Modernity and the Avant-garde

M. Drudi Gambillo e T. Fiori (eds.), *Archivi del Futurismo*, Rome 1958.
Maurizio Calvesi, *Le due avanguardie*, I ed., Milan 1966.
Massimo Carrà, Patrick Waldeberg and E. Rathe, *Metafisica*, Milan 1968.
M.W. Martin, *Futurist Art and Theory 1909–1915*, Oxford 1968.
Gianna Piantoni and Anne Pingeot (eds.), *Italie 1889–1910. Arte alla prova della modernità*, exhibition catalogue, Rome-Paris 2000–1.

Between the Wars

Umberto Silva, *Ideologia e arte del Fascismo*, Milan 1973.
Fernando Tempesti, *Arte dell'Italia fascista*, Milan 1976.
Rossana Bossaglia, *Il "Novecento italiano"*, Milan 1979.
Paolo Fossati, *Pittura e scultura tra le due guerre*, in *Il Novecento*, vol. VII of *Storia dell'arte italiana*, Turin 1982.

The Fifties and Sixties

Giulio Carlo Argan, *Salvezza e caduta nell'arte moderna*, Milan 1964.
Maurizio Fagiolo dell'Arco, *Rapporto 60. Le arti oggi in Italia*, Rome 1966.
Giorgio De Marchis, Sandra Pinto and Livia Velani, *Due decenni di eventi artistici in Italia 1950–1970*, exhibition catalogue, Prato 1970.
Maurizio Calvesi, *Le due avanguardie. Dal futurismo alla pop art*, Bari 1971.
Nicoletta Misler, *La via italiana al realismo*, Milan 1973.
Francesco Arcangeli, *Dal Romanticismo all'Informale*, Turin 1977.
Giorgio De Marchis, *L'arte in Italia dopo la seconda guerra mondiale*, in *Il Novecento*, vol. VII of *Storia dell'arte italiana*, Turin 1982.

Around Arte Povera

Germano Celant, *Arte povera + Azioni povere*, exhibition catalogue, Salerno 1969.
Achille Bonito Oliva, *L'arte negli anni Settanta*, in the catalogue of the XXXIX Biennale di Venezia, 1980.
Germano Celant, *Identité Italienne. L'art en Italie depuis 1959*, exhibition catalogue, Paris 1981.
Nello Ponente (ed.), *Linee della vicenda artistica in Italia 1960–1980*, exhibition catalogue, Rome 1981.
Carolyne Christov Bakargiev, *Arte Povera*, London 1999.
R. Flood and F. Morris (eds.), *Zero to Infinity. Arte Povera 1962–1972*, exhibition catalogue, travelling to London, Minneapolis, Los Angeles and Washington, London 2001.

Postmodern and Beyond

Achille Bonito Oliva, *Avanguardia Transavanguardia*, Milan 1982.
Gianni Vattimo, *La fine della modernità. Nichilismo ed ermeneutica nella cultura postmoderna*, Milan 1985.
Antoine Compagnon, *Les cinq paradoxes de la modernité*, Paris 1990 (trad. it. Bologna 1993).
Alessandra Mammì, *Nati dopo il 1960 / Born after 1960*, in Sandra Pinto and Anna Mattirolo (eds.), *Il Premio del Centro 2000*, exhibition catalogue, Rome 2001.